KT-522-884

KA 0337991 4

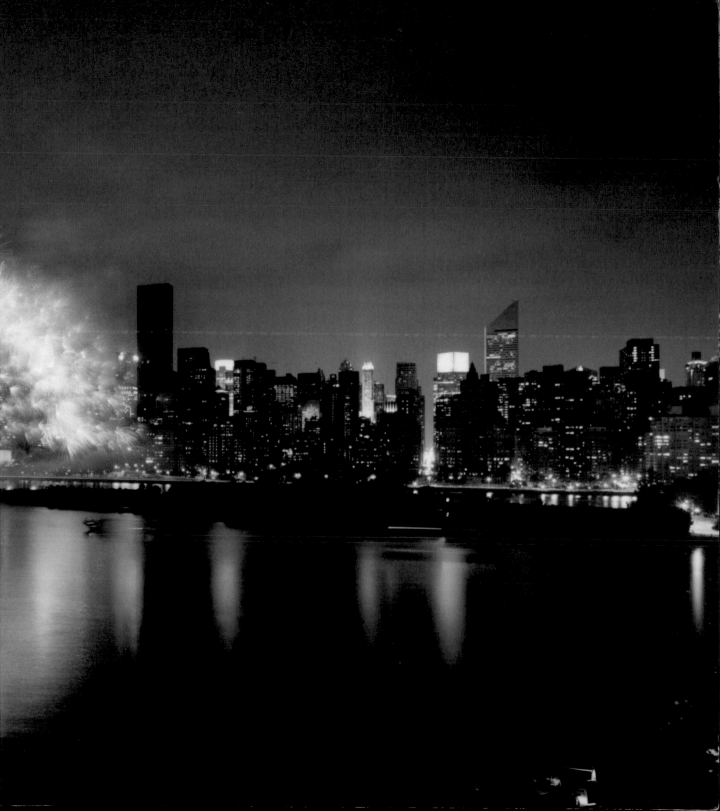

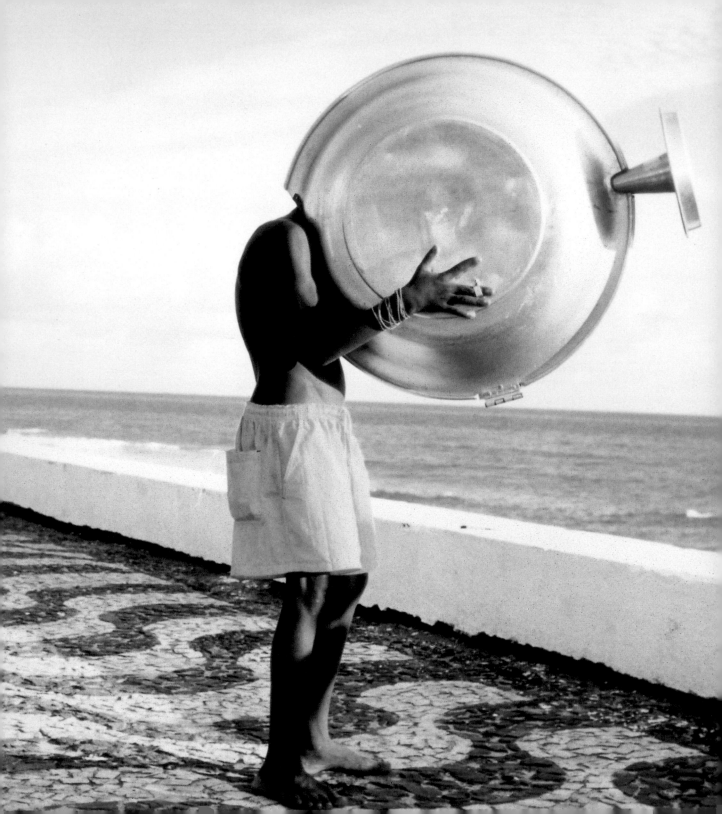

ART WORKS

PERFORM

JENS HOFFMANN AND JOAN JONAS

With 329 illustrations, 278 in colour

Thames & Hudson

I would like to thank all the artists who have participated in the book, especially those who made special art work contributions. In addition, I would like to acknowledge all those who took part in the 'Talk' for their generous cooperation. Finally, grateful thanks to all the galleries, foundations, estates, collections and other organizations that supplied us with visual material and offered valuable advice throughout the book's production. I am particularly indebted to Monira Kleineidam, who tirelessly worked on getting the images for the publication together and who assembled all the artists' biographical and bibliographical material. Above all, I have to thank Sophia Lambri-Hoffmann and Luisa Lambri for all their inspiration, encouragement, support and love.
Jens Hoffmann

I would like to thank Jens Hoffmann for all the time and effort he has dedicated to this book. I would also like to thank everyone who participated in the discussion. Much of this complex history exists as memory, and much information is revealed in conversations here and there, making connections between the past and the present, and between different people and events. This represents a fraction of what could be spoken about by those involved in the history of performance in all its many forms.
Joan Jonas

Any copy of this book issued by the publisher as a paperback is sold subject to the condition that it shall not by way of trade or otherwise be lent, resold, hired out or otherwise circulated without the publisher's prior consent in any form of binding or cover other than that in which it is published and without a similar condition including these words being imposed on a subsequent purchaser.

First published in the United Kingdom in 2005 by
Thames & Hudson Ltd
181A High Holborn
London WC1V 7QX

www.thamesandhudson.com

© 2005 Jens Hoffmann and Joan Jonas

All rights reserved. No part of this publication may be reproduced or transmitted in any form or by any means, electronic or mechanical, including photocopy, recording or any other information storage and retrieval system, without prior permission in writing from the publisher.

British Library Cataloguing-in-Publication Data
A catalogue record for this book is available from the British Library

ISBN 0-500-93006-6

Art direction and design by
Martin Andersen / Andersen M Studio

Printed and bound in China by C & C Offset Printing Co Ltd

CONTENTS

opposite

**Klassische Frikasseedekapitation
des Logekommissars auf der
Melasseplatte**

John Bock, 2002

ENTRANCE

ON PERFORMANCE (AND OTHER COMPLICATIONS)

'The line between art and life should be kept
as fluid, and perhaps indistinct, as possible.'
Allan Kaprow

The word 'performance' seems to be on everybody's lips these days. It is used in a wide variety of fields and areas of the contemporary world, from the realms of economy, business, technology, science and medicine to art, popular culture, sports, politics and academia. At the same time, even though everyone is using it, it seems difficult to settle on a clear and precise definition for the term. It is exactly this circumstance – the way in which performance resists classification – that makes it such an interesting field in the arts.

The principal idea of this book is to challenge ordinary ways of looking at art and common forms of categorizing it. By taking the word 'perform' as a contemporary alteration of what we have come to know historically as 'performance', the book seeks to tackle the complications of categorization. This book will show how it is possible to group artists and works of art in creative, open-ended and associative ways, which might reflect the connections and links between the works in an artistically more appropriate way than a classic historical overview.

Performance is dead! Long live performance! This declaration reflects the paradoxical situation in which we find ourselves when we consider a contemporary understanding of performance within the sphere of visual art.

Most dictionaries offer a fairly wide definition for performance. Merriam-Webster's Dictionary, for example, defines it simply as 'the execution of an action, the accomplishment of a task or the manner in which something functions and operates'. Obviously,

this can mean many different things. In the world of business, for instance, 'performance' is used to describe the so-called productivity of an employee, the way a particular stock is developing on the market, or the degree of efficiency with which a company is producing its goods. In sports, we use the term to speak about the level of success an athlete achieves during a competition, and in technology we use it to address the utility of a technical device. In politics, we mean the actions of a particular politician, or a specific party, or simply the effectiveness of a certain political idea. We also use the term to discuss how well or poorly a piece of antique furniture, an item of jewelry or a painting fares during an auction. Within the sphere of the arts we might address an opera singer's ability to sing by talking about his or her performance. We can also use the term to discuss the actual occurrence itself, the opera being a temporary event staged for an audience, a public and provisional form of artistic action. These are only a handful of examples that come to mind, out of a tangled web of possible ways of deploying the term. The more we read and hear about performance, the more confusing it seems to become. Suddenly activities as diverse as cooking or joke-telling seem to qualify as performance, as do TV talk shows or hot-dog-eating contests. What is this all about? Society as performance? The world as a stage?

The idea of performance has been seriously re-examined during the past decade through the so-called 'performative turn' described in numerous theoretical discourses applied to visual art, as well as to theatre and dance. In particular, academic fields such as philosophy, sociology, linguistics and anthropology have revisited performance as a means of examining core issues of social science, shifting their focus from structuralist methods to the study of processes. Witnessing a hot-dog-eating contest suddenly became a form of anthropological experience, in which a social structure was created that would tell us something about the process of civilization. Similarly, cooking came to be seen as a performative ritual involving central elements in the creation of our society. Culture – in particular the connection between ritual practice, staged situations and the overall process of civilization – is now viewed as performance.

In his book *The Presentation of Self in Everyday Life*, published in 1959, US-based sociologist Erving Goffman speaks of the process of socialization – the process of establishing a social identity based on everyday acts and ways of social interaction shaped through the contact we have with our daily environment – as a form of performance. He employs terms that are mainly related to the realm of theatre ('stage', 'audience', 'props', etc.) with the aim of articulating the concept of a theatre of life, on the stage of which we all perform our roles.

Around the time that Goffman was publishing his most influential texts, the British philosopher John L. Austin began to develop his now-famous 'speech-act theory'. It was during a radio talk show in 1956 that Austin first used the term 'performative'. He was initially describing a form of speech, the so-called 'performative utterance', in which the issuing of a performative is also the performance of an action. We therefore talk about performatives as words that *do* something rather than *describe* something. Familiar

Remote Production

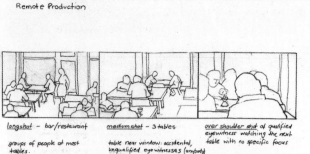

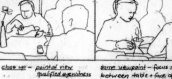

longshot – bar/restaurant

groups of people at most tables.
people talking, music in background

medium shot – 3 tables

table near window: accidental, unqualified eyewitnesses (anybody)
table in front: accidental, qualified eyewitness (artist + friend)
table in the middle: young artist and curator in a meeting

over shoulder shot of qualified eyewitness watching the next table with no specific focus

maybe in between:
counter shot, over shoulder of unqualified eyewitnesses

close up – point of view
qualified eyewitness

young artist pulls out photographic material from a plastic bag.
curator watches silently.

same viewpoint – focus shifts between table + face of young artist. (q.eyewitness watches with growing interest)
young artist seems a little nervous but bold at the same time.
curator sometime nods or makes brief comments while listening.

same viewpoint – face of q.e.'s friend comes in from left side:
"what's happening?"
– "she's showing photos."
"will they get together?"
– "he's still indifferent. I don't think they have met before."

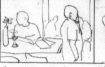

– "now his phone rings."
" does she get nervous?"
– "she stares at the flower on the table while he's talking."
"she really wants to be in the exhibition, right?"
– "I'm not sure."

point of view – young artist
countershot!

because the curator got up to talk on the phone, she can see the other table.
someone is looking at her, knowing. (the qualified eyewitness)

same viewpoint

curator sits down again, looks at his watch and apologizes.
the person at the other table disappears behind his back again.

point of view – qualified eyewitness

"he asks for her address + phone-number now!"
"will she give it to him?"
– "I'm not sure, but she probably will."

– "she's doing it!"
"and... what does that mean?"
– "nothing much. it's a formal thing. they might stay in contact, they might not."

zoom out – over shoulder
qualified eyewitness

curator leaves. they shake hands and smile at each other.
young artist packs her things, finishes her drink and leaves as well.

Remote Production
Natascha Sadr Haghighian, 2002

examples are the utterance 'I do' in the context of a marriage ceremony, and the biblical line 'Let there be light: and there was light'. Austin's book *How To Do Things with Words* (1959) became a classic in the fields of linguistics and the philosophy of language, and it had a tremendous influence on social science in the following decades.

While Austin connects performativity and language, Goffman, who focuses on the construction of identity as a performative process, paved the way for the US-based feminist theorist Judith Butler, who is probably the most influential writer to have connected identity, performativity and gender. Influenced by Jacques Derrida's idea of citational processes as identity-constructing modes, Butler applied the term 'performative' in her most influential book, *Gender Trouble* (1990), to her theory of 'doing' gender when she speaks of it as the identity-constituting process of gendering based on the repetition of acts rather than natural or inevitable absolutes. Her argument that gender is nothing but a form of 'relation among socially constituted subjects in specifiable contexts', rather than a fixed attribute in a person, triggered widespread interest in the notion of performance and its relationship to cultural studies.

Examining the connection between performativity and the discipline of anthropology brings us closer to the sphere of art, particularly when we look at the work of Richard Schechner. He holds a significant and unusual position in the discussion of performance, since he has been one of the few who have been able to bridge the gap between the spheres of theory and artistic practice.

Schechner is a highly regarded academic, who founded New York University's distinguished performance studies department, but also worked as an influential theatre maker during the 1960s and '70s with his legendary Performance Group. Schechner's practice essentially revolves around the connection 'between theatre and anthropology', words he used that became the title of one of his most influential books, co-authored with anthropologist Victor Turner. Schechner is best known for what he called 'Environment Theatre' – theatre that abandoned the separation between the audience and the performers and promoted the idea of audience participation as he had observed it in various cultural performative practices, such as those found in certain religious rituals. Turner, on the other hand, basing his work on Goffman's idea that the world is a stage, emphasized the concept of what he called 'social drama', which would be made up of certain crisis situations that stand out from regular everyday life and follow particular patterns.

Looking at the above, we see that the terms 'performance' and, especially, 'performative' have been widely used to examine culture at large. When focusing particularly on the realm of art we see that the term 'performative' is being used in a less and less specific sense. It is often used simply to describe, identify or quantify a certain work of art as having a relation to performance or performance-like attributes. A look at the large variety of art works that are associated with these terms quickly affirms that performance is anything but a precisely formed discipline. It seems to be more like a heterogeneous net that gathers together concepts and artistic

approaches from various media, artistic fields and cultural backgrounds.

Performance art does not present the illusion of events, but rather presents actual events as art

In the field of visual art the term is mostly linked to what we have come to know as 'performance art', which could be defined as an art form that is based on representation by action. It is generally executed by an artist or a group of artists in front of a live audience at a specific time and at a specific place. In contrast to theatre, performance art does not present the illusion of events, but rather presents actual events as art. Yet the specific term 'performance art' relates particularly to work made during the late 1960s and early '70s and is still mainly identified with this period.

In her seminal book *Performance: Live Art 1909 to the Present* (1979), RoseLee Goldberg describes performance in a more open sense, stating that it can be any artistic manifestation or action that is presented in front of an audience, although, in contrast to theatre, it is not based on a predetermined set of dialogues. Goldberg reaches back to the early days of the twentieth century and identifies the Futurists and their anti-bourgeois critique as the first to effectively bring the idea of performance into the sphere of visual art in acts they would describe as 'dynamic sensations'. She moves on to Constructivism, Dada, Surrealism and the Bauhaus as a chain of art movements that developed a multidisciplinary approach to art and the world at large, at whose core we can

discover a common fascination for provisional artistic articulations going beyond traditional divisions between art and audience.

What is challenging in Goldberg's approach is that it keeps the definition of performance open-ended, presenting it as an interdisciplinary cluster of diverse artistic expressions related to dance, theatre, literature, music, poetry, architecture and, of course, visual art. This notion of performance stems from two main points of reference, a modernist and post-modernist one: on the one hand, the European avant-gardes of the early twentieth century who worked in a variety of fields and disciplines and were interested in challenging the common understanding of what art was at that time; on the other, the development of post-war art in the United States and the interdisciplinary spirit of the 1960s, into which different disciplines – particularly dance, theatre, music and visual art – seemed almost to disappear as independent entities. Important examples are the first Happenings by Allan Kaprow, the Judson Church dance performances, John Cage and his work at Black Mountain College, Richard Schechner's Performance Group and, arising from a radically interdisciplinary ambition, Billy Klüver's legendary E.A.T. (Experiments in Art and Technology), which brought together art and science.

It is crucial, however, to look also at a more obvious but apparently more restricted definition of performance, one that sees the body as the nucleus of its artistic investigation and expression and that is analogous to the term 'body art'. Especially important here is Lea

Vergine's book *Body Art and Performance: The Body as Language* (1971), which was the first to bring together a wide range of artists who worked with or on the body. This definition of performance as being purely centred on the body has to this day very much defined our conception of what performance is. When we hear the word 'performance', many of us immediately think of work by classic practitioners of this genre, all of whom have used the body as the object for their work, including artists such as Marina Abramović, Vito Acconci, Chris Burden, Otto Mühl, Bruce Nauman, Dennis Oppenheim and Carolee Schneemann. Consequently, what many of us today identify with performance are often clichés of beaten, abused and naked bodies generally crawling in mud, blood or even excrement. Certainly body art reaches far beyond these stereotypes. In fact, anything and everything connected to one's own existence and identity can be utilized in a wider understanding of the term 'body art', thereby uncovering a wide range of possible ways to creatively engage aspects of life. Ultimately we discover that 'body art' is also, in fact, a broadly inclusive term that cannot be reduced to one particular idea.

Other explorations of the history of performance – especially those in the United States – have begun their inquiry with a study of Jackson Pollock's 'Action painting' as the apotheosis of an art of action. Not only are the traces of the artist's action in his coloured-drip canvases responsible for connecting Pollock with ideas of performativity but, even more so, the documentation of their creation in the well-known photographs and films by Hans Namuth. In Namuth's documentation we see Pollock in the midst of his work, almost ecstatically revealing the physicality of painting as it was literally going over the edge. This connects in

an interesting way to the openness of performance and its unrestricted character. As Allan Kaprow wrote in his 1958 essay, 'The Legacy of Jackson Pollock', 'We do not enter a painting of Pollock's in any one place (or hundred places). Anywhere is everywhere, and we dip in and out when and where we can....' The idea that Pollock was going beyond the dimensions of his art work, the territory of his medium, the rectangular field of the canvas, into all possible directions far beyond the limits of a painting, inspired Kaprow tremendously. He saw this as a symbol for the eagerness to break new ground and to overcome the restriction of one's own field, something that strongly connects to performance's unrestricted character.

Kaprow related his thoughts to his experiences with the work of John Cage and the writings of the American philosopher John Dewey to find what he called 'extensions into time and space'. He began to work with his environments in 1957 after giving up painting. Activating them by a variety of effects, he turned them into what he called Happenings, in which the audience was asked to participate directly. His *18 Happenings in 6 Parts*, which was shown at the Reuben Gallery in New York in 1959 and reflected Kaprow's belief that everyday life was fundamental to any form of artistic reception, not only had a powerful effect on the development of art in the United States but also influenced artists in Europe and Asia, particularly artists associated with the Fluxus movement. Kaprow's Happenings foreshadowed performance art in various ways, as they brought together a set of attributes unknown in art of that time. They were freely planned, provisional and spontaneous artistic events that directly related to everyday life. In particular, the desire to

locate, explore and bridge the gap between art and life was key to Kaprow's artistic and theoretical inquiries. His overall approach, and especially his Happenings, are central to the development of performance and visual art in general, as they prefigured a new understanding in the relationship between art and life that would become more and more visible in art works created in subsequent decades – art that would begin to observe, interpret and engage with the social, cultural and political circumstances of the world it was made for and exposed to.

It seems evident that all of the possible views on performance presented above are somehow connected, and that maybe only together do they appear to really give us a picture of what performance can mean in the context of art. All of them describe something infinitely open and unrestricted.

This book can therefore be understood as a collection of thoughts and questions stemming from an inclusive and transitional notion of performance, rather than a systematic look into the history of the art form, or a strict consideration of any of the possible definitions or meanings that might be found in the realm of theory. It proposes, rather, an associative look at a wide range of contemporary art works that contain and involve performative elements. It is an extension of a process that has been laid out by artists interested in participatory, ephemeral, process-oriented, provisional and conceptual strategies, all of which could be called 'performative' in a loose understanding of the term.

overleaf
Meeting #29
Jonathan Monk, 2003

The Lion Enclosure Lon London 12th May 2014

don Zoo Regent's Park
unch time

Within the general structure of the book we have intentionally incorporated this openness and avoided using common terms, such as 'body', 'identity', 'multiculturalism' or 'gender', which have been used repeatedly as a means of classifying performance-related work. The sections of this book – the rooms of the exhibition – follow fragmented and open-ended arrangements of links and affinities among the various

Many performances leave traces, while others are specifically engaged with performance's ephemeral nature

artistic positions presented. It will become clear that many of the works in a particular section could be present in other sections of the exhibition, and in many different arrangements. This potential flux and instability mirrors the extended exploration and volatility that are imbedded in performance, and it was one of our main objectives when putting together this publication.

Central for the investigation in this book are the artists. Most of the time their work expresses itself outside of any of the common categories we use when talking about performance-related work. We will see that artistic practices as diverse as sculpture, painting, film, video, installation and many others can be considered performative, as can classic stage practices such as dance and theatre. Most of the works propose a direct link to everyday life. They are presented in eight different chapters, each revolving around a number of artists whose positions clearly relate to the topic of the room.

Around these artists other, mainly younger, artists have been grouped, whose positions in various ways connect to the issue at hand: these often, however, extend further into different directions. Throughout the book a cross-generational and cross-cultural range has been one of the main aims and has allowed us to include lesser-known as well as well-known artists of all ages, from all around the globe, working in a wide variety of spheres of contemporary art.

The first room, 'Inside the Box/Outside the Box', begins an investigation of the relationship between the space for art, the art institution, and the physical and social space in which we all live. Central to this particular examination are artists such as Dan Graham, as well as younger protagonists such as Michael Elmgreen and Ingar Dragset, whose work has in addition managed to oscillate in a unique way between the genres of performance, sculpture and social commentary. In the second room, 'Performing the Object', we see what might appear at first to be classical sculpture. We quickly realize, however, that the artists in this section have challenged the traditional notion of what sculpture is and has been. The objects begin to *perform* in various ways – either by being highly ephemeral, as in the work of Felix Gonzalez-Torres or Cai Guo-Qiang; by being very conceptual, as in the work of Victor Burgin; or by being activated through the artist or the audience, as in pieces by Robert Morris, Evan Holloway, Marepe and others. Room Three, 'Exchange and Transform', focuses on two main subjects and their possible overlaps. On the one hand it investigates work that could be related to what we have come to know as

'identity politics', exemplified by artists such as Cindy Sherman and Elke Krystufek; on the other hand it explores conceptual transformations of identity-shaping structures and their economy. Room Four, 'Still Life/Tableaux Vivants', explores performance in relation to images and figures as well as to staged photography and sculptures of the human body. Key positions in this section are taken by artists such as Jeff Wall and Duane Hanson, as well as Yinka Shonibare and Sam Taylor-Wood. The next room, 'Provoking the Everyday', connects to ideas familiar to us from the Situationists with their interventions into the sphere of everyday life. Most of the artists in this section question the traditional order of our contemporary urban context and formulate temporary, often spontaneous, interference within the configuration of the everyday. These interventions range from conceptual pieces by artists such as Vito Acconci to politically engaged forms such as in the work of Jens Haaning. Many performances leave traces, while others are specifically engaged with performance's ephemeral nature and are meant to dissolve as quickly as they have appeared. This is what Room Six, 'Traces/Oblivion', explores. While many artists produce their work by executing a performance beforehand to create a sculpture, an installation or even a painting, as in the pieces by Andreas Slominski, On Kawara or Delia Brown, other artists – such as Allan Kaprow or Trisha Donnelly – have almost refused to leave evidence of the existence of their work. Room Seven, 'Narrate/Withhold', brings us to artists such as Janet Cardiff or Peter Land who develop narratives in their work, some like continuous stories, some like one-liners, others rather fragmented and cryptic such as those by

Matthew Barney, Anna Gaskell or Markus Schinwald. The final room of the exhibition, 'The Performer is in All of Us', returns us to the beginning of this introduction. It presents works of art in which the public, the audience, becomes, in numerous ways, the main protagonist and element of a particular piece. Whether it is through directly integrating the audience in a piece, as in projects by Rirkrit Tiravanija and Carsten Höller, or through integrating non-artists into an artistic process, as in the work of Carlos Amorales or Richard Billingham, the artists share authorship and amplify the artistic potential of the world around us.

It remains only to say a few words about the works that accompany this introduction. All have been commissioned for the book, and they form a separate room of their own – an annexe, if you will. Each one attempts to translate performance to the conditions of the printed page and turn the publication into a site of production. Together, they point towards the principal idea behind *Perform* as a whole: that the performative in art can be found in extreme physical acts like those of John Bock but also in more unexpected places and in subtler ways, if only we looked. Natascha Sadr Haghighian's carefully planned storyboards; Jonathan Monk's proposed meeting in the distant future; Tino Sehgal's piece that makes us move across the page; and Mark Roeder's alternative uses for the very book you're holding – they all suggest that every action, in art as in life, is a performance.

overleaf and pages 23–31
this sentence
already performed
Tino Sehgal, 2003

THIS SENTENCE

ALREADY

HOWEVER MUCH IT MAY BE THE ERASURE OF ANOTHER
ERASURE

FULL OF BLANKS

HAS
 induced

 demand

 for
 zero
 point
 zero two millilitres
 of black ink until

 here

 and zero
 point

one two millilitres until its end considering the
fact that this book is published
in twenty thousand copies

the amount adds up to two

and a half litres of black ink whose production necessitates the

production of
soot by the

furnace of natural gas and petroleum and

their extraction

and transport as well as the

UNIVERSITY OF WINCHESTER
LIBRARY

PRODUCTION

of heat
set oil

consisting of hard resin

and of

mineral oil in

total Numbers which cannot be

exact
extraction transports
and
production of
two and a half *l* of
ink have
used zero point zero
seven

kilo watt hours

generated from fossi*l* and
nuc*l*ear sources disregarding quantities

of *l*ime stone pesticides phosphate

minera*l* potash
rape seed invo*l*ved

and
emissions of
as cd ch$_4$ c$_6$h$_6$ co co$_2$ cr hc*l*
hf nh$_3$ nmvoc unspecified

no$_x$ pcdd pcdf

And for
10 pages or
100000 sheets or
1663 kg of matt art paper or 1470 kg wood

thinnings 397.3 kg kaolin 454.1 kg

pulp 50 kg latex
30.4 kg cull wood 55 kg

starch 20 kg water-

glass 25' *l*
water and
to transform

THE LATTER

and others into

THE FORMER

4708

kWh

and 3057 kWh to

provide them adding up to

7764.07 KWH

GENERATED

from various sources plus 220 kWh for the

PRINTING PROCESS AGAIN IT

neglects sources quantities of chemicals
for the
film proportionate use and maintenance of

FACILITIES IT

cannot be complete and does not comment

ON POETRY IT

PERFORMED

Upon

m a

r

c

e l b

r o o

d t

h a

e r s

**Suggested Use
(Good and Evil)**
Mark Roeder, 2003

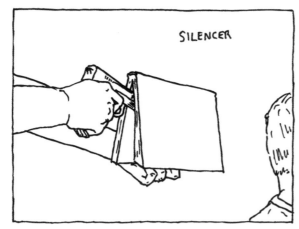

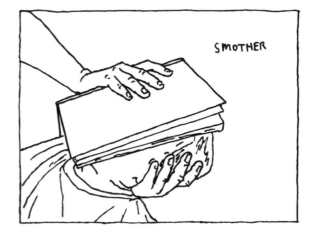

INSIDE THE BOX /
OUTSIDE THE BOX

By exploring the relationships between viewers in spaces, and between viewers and art objects, the artists in this room establish new social situations that make us aware of the roles we assume when encountering the world and each other. They present and create very distinct contexts to make us think about the ways in which we relate to others, to works of art and to ourselves.

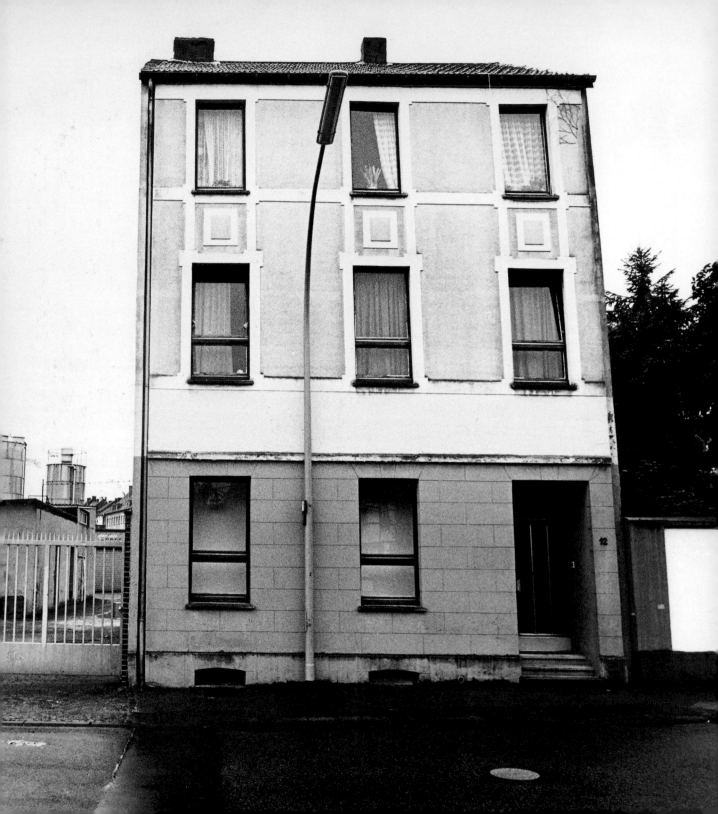

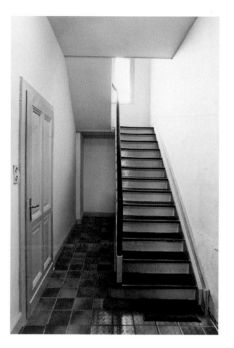 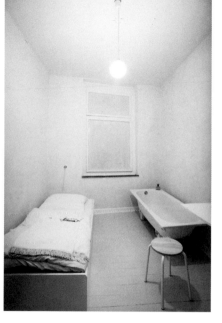

The German artist Gregor Schneider began work on
the transformation of his house sixteen years ago and
has continued ever since. Constantly developing,
constructing and reconstructing, he has moved walls,
built rooms within rooms, blocked up windows, until it
seems as if the whole house has been transfigured into
an endless labyrinth of floors, stairs, doors and holes.
What is important is not only the transformation of the
house, but also the physical experiences the visitor
undergoes when inside it. The atmosphere is intense,
and everything seems out of proportion and subtly
irregular. The false walls and rooms, which get smaller
and smaller with every floor, absorb all noise, creating a
creepy silence. The visitor soon becomes disorientated
and is left with the question, how many more rooms,
how many more inserts, can this house take before it
finally implodes?

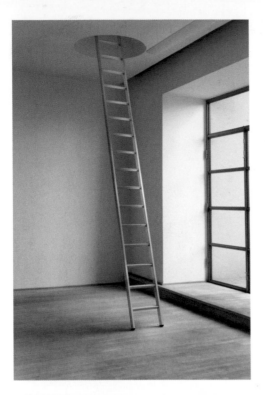

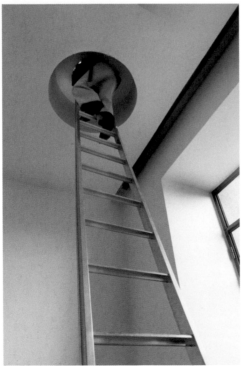

For their 2002 exhibition 'How Are You Today?' at the Massimo de Carlo Gallery in Milan, Michael Elmgreen and Ingar Dragset left the exhibition space apparently empty. It was only at a second glance that visitors saw a small opening in the ceiling, just big enough to stick one's head through. An ordinary ladder from a construction site was placed underneath the hole to enable visitors to climb up … and discover on the other side the kitchen of an ordinary Milanese apartment inhabited by a friendly lady and her occasionally visiting friends.

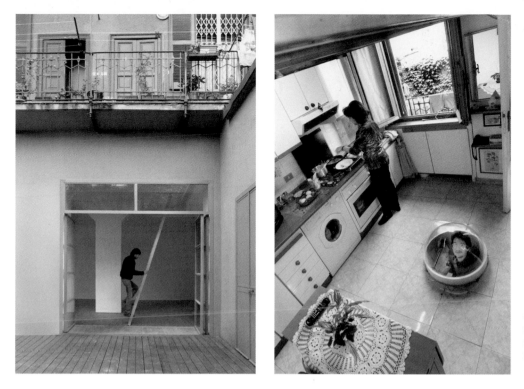

opposite and left
How Are You Today?
Michael Elmgreen and
Ingar Dragset, 2002

'Throughout the last century a lot of effort was put into developing a completely neutral architectural environment for art presentations, something which is obviously not possible. By just re-organizing the very materials that these spaces consist of, we question their objectivity.'

Michael Elmgreen and Ingar Dragset

Dan Graham is widely acknowledged as one of the major protagonists of the Conceptual art movement of the late 1960s and '70s. In the ensuing period, like many artists of his generation, Graham started to work in a wide interdisciplinary manner, combining work in photography, writing, performance, film and, above all, a coalition of art and architecture, which resulted in a number of pavilions and architectural structures. *Public Space/Two Audiences* was originally presented at the 'Ambiente' exhibition as part of the Venice Biennale of

Public Space/Two Audiences
Dan Graham, 1976

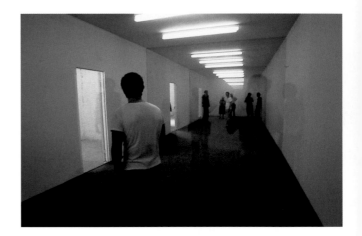

'Psychologically, in *Public Space/Two Audiences*, for one audience, the glass divider is a window showing, objectifying the other audience's behaviour (the observed, second audience, becomes, by analogy, a mirror of the outward behaviour of the audience observing); simultaneously, the mirror at the end of one space allows the observing audience to view themselves as a unified body (engaged in looking at the other audience or at themselves looking at the other audience). A parallel, but reversed, situation exists for that second audience. In looking at the other audience, both audiences seek objective confirmation of their receptive subjectivity experienced social situations. […] The complexity of this relation of the spectators to their image, and to the image of the other, reciprocal spectators, is echoed in a second reflection (in addition to that of the mirror). Because glass is itself partially reflective, observers in the room distant from the mirror, looking in the direction of the mirror through the glass divider, see a double reflection of their image, first in the glass then, smaller size but better delineated, in the mirror.'

Dan Graham

1976. Since the theme of the exhibition was related to concepts surrounding the modern environment and modern architecture, the artist wanted to create a piece that could function as a work of art but also as an exhibition pavilion. He created a space that consisted of two identical containers connected by soundproof glass. The only distinction between the two spaces was that one room had a mirror on its far wall. Members of the audience were able to see each other and observe each other's behaviour in multiple ways and, through the soundproof glass, they became profoundly aware of their own voices due to the intensification of sound.

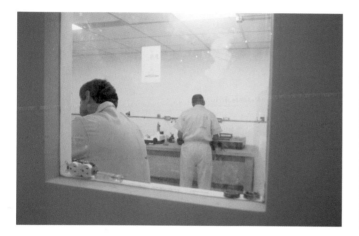

Workshop 69
Alexander Gerdel, 1997

The Venezuelan artist Alexander Gerdel works in response to the environment of his home town of Caracas, which is marked by noticeable economic and social differences. In his dramatized 'urban conflicts', as he calls his pieces, Gerdel combines architecture, performance, audio, film and installation in order to connect the institutional space of the museum with the everyday reality of the city. For his piece *Workshop 69*, he built a self-contained room – a white cube – inside the museum. He brought from his home several damaged electrical appliances, including a washing machine, oven, television monitor, VHS player and water heater, and hired two professionals to mend them. When his appliances had been repaired, he invited the audience to bring their own broken radios, television sets and so on to the museum to have them fixed for free. In doing this he was responding to the difficulties that many inhabitants of the so-called *barrios* (shanty towns) of Caracas, where he had grown up, had in getting repair people to come to their notoriously dangerous neighbourhoods. '69' is the name of the repair company that Gerdel set up for the piece, which he calls an 'elliptic action', symbolizing the relationships and dependencies between the different individuals that form society, and their various conflicts.

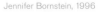

Projector Stand #3 by Jennifer Bornstein consists of several independent but interrelated elements. The fixed components of the overall piece are a film, a wooden seating arrangement for the audience, five photographs and the presence of a projectionist. In the film we see the artist, after she has turned on the camera, running into the frame, only to stand silently, looking into the lens. All the elements echo the central themes of Bornstein's work – the performative representations of issues relating to appearance and disappearance in connection to identity. These themes are repeatedly linked to the ambiguity of gender and social stereotypes, and are presented with a stimulating awareness of the irony of human existence. Ultimately Bornstein is trying to extend the performative space of the photographs and the film into the present, and to continue it within the gallery space, using visitors as accomplices. The very basic physical interactions among viewers of the films – sitting next to each other on the benches, interacting with the projectionist by requesting her or him to screen the films – echo the physical interactions captured in the photographs on the walls. The disposition of the benches transforms the gallery into a stage, forcing visitors to become both performers and objects of observation.

The distinctive quality of the Finnish artist Eija-Liisa Ahtila's work is that it stands directly on the cusp between cinema and visual art, combining two of today's most prevalent forms of artistic expression. The drama of the everyday is amplified in two different, yet connected, directions. On the one hand it is the space – the physical and social sphere – in which we live, that is taken into the gallery or art institution by means of her installations. On the other hand it is the mental space in which our feelings and emotions come alive that is brought to the silver screen. The artist is searching for a reconciliation of the two, the inside and the outside of a person's life – not solely those of the characters in her films, but above all those of the spectators experiencing her works. In her film *The Wind*, we view the story of a woman who is apparently depressed and suffering from occasional psychotic attacks. We witness the outset of one such attack and experience the shift in the character's relationship to the outside world. Capable of talking to other people at the beginning of the film, the character begins to bite her hands until they bleed, unable to express her anxiety as the film unfolds.

Paul McCarthy is best known for his highly provocative, shocking and sexually charged installations, films, sculptures and performances. His work reflects the unconscious anxieties of his home country with often brutal straightforwardness. This rage was already apparent in early pieces such as *Plaster your head and one arm into a wall* (1973) and *Whipping a Wall and a Window with Paint* (1974). Even though McCarthy's works have grown in complexity over the years, with more and more props, extravagant sets and use of narrative in works such as *Bossy Burger* (1991), *Painter* (1995) and *Salon* (1996), the force and violence of his pieces have remained constant. That the rage might not only be a twisted travesty of the violence we encounter in mass-media culture but also a symbolic expression of our own fears and memories becomes clear in *Pinocchio Pipenose Householddilemma*. The piece includes a wooden tunnel and box into which the audience must enter, a video in which a dysfunctional costumed family enacts an absurd domestic drama and, most importantly, Pinocchio costumes that the audience must wear if they

'The dilemma is our inability to understand. The dilemma is so alien to us that it smells of insanity.'
Paul McCarthy

want to watch the film inside the box. McCarthy wants us to assume and share the role of the leading player in his film, who in turn is facing a transformation from a wooden puppet to a seemingly more elevated state. But we are left bewildered. Why have we been asked to dress up? What is the connection between the family and Pinocchio? And why are they fighting, apparently without reason or motive? By forcing us to take part in this way, McCarthy encourages us to recognize the nonsensical nature of the violence in the film and, by extension, the absurdity of all violence in the media and in the wider world.

Pinocchio Pipenose Householddilemma
Paul McCarthy, 1994

The Dutch artist Aernout Mik choreographs and stages installations that include three-dimensional elements, objects, real people and film projections to create environments that invite the viewer into a deliberately undefined atmosphere, somewhere on the border between sleeping and waking. His films, usually silent, seduce the viewer with their tranquillity and the slow motion of their actions, as well as with their seemingly endless and ineffectual repetition. Mik's moving images are often projected onto architectural interiors in order to combine the fictitious space of the film with the real, physical space of the exhibition room. Whereas in traditional cinema, spectators participate only in spirit, these works make them aware of the relationship between their own body and the film, the architecture and the other spectators. At times inexplicable or disquieting, Mik's installations examine the dynamics of social, political and aesthetic relationships in everyday life. *Glutinosity* shows a slow-moving, blue-lit struggle between a crowd of young activists and policemen. Upon close inspection, it becomes difficult to distinguish between the oppressor and the oppressed. We see people moving in an apparently chaotic way, being pushed and pulled about, but through the continuous loops of the film we begin to participate and create a mental and physical relationship with the work, which soon reveals a system behind what at first appeared to be very strange and uncontrolled behaviour.

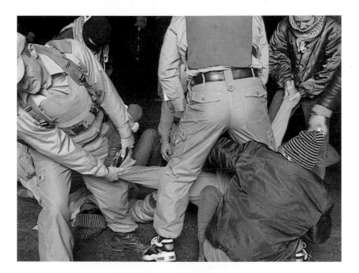

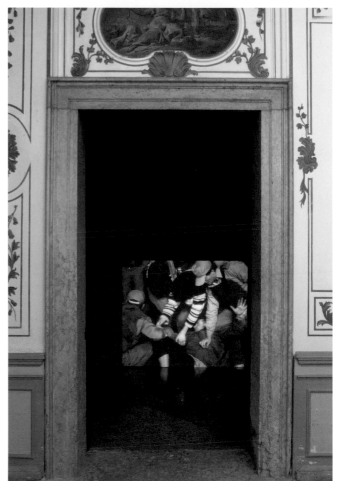

Glutinosity
Aernout Mik, 2001

Monumental Garage Sale
Martha Rosler, 1973

Martha Rosler's work connects theory with such media as video, performance, photography and critical writing, and often expands art to take in the anxieties of society outside the context of art. Whether Rosler is exploring issues such as globalization, war or the commercialization of all aspects of daily life, she always returns to the ubiquity of alienation by embracing motifs and experiences from the everyday and the domestic, so as to challenge them. *Garage Sale* took place for the first time in the early 1970s at San Diego University. It connects feminist issues and critiques of institutionalization with questions regarding the fetishization and commodification of art.

'I was introduced to performance art … through the female students at Cal Arts, where Allan Kaprow had taught before moving down to San Diego. It was the West Coast women who had revived performance art, including some, like Barbara Smith, who seem to have been doing performances before Allan Kaprow appeared on the West Coast scene. Women in the Feminist Art Program and at the new Women's Building had a robust performance practice, and at the time male artists were not attracting a lot of attention, at least not from me or other women. Soon, however, there were some men whose work seemed to follow the thematic paths laid out by the women who went before. However, Kaprow's theory was that artists should not seek a broad audience, and I don't think most of the women found that idea appealing, since they had a useful, if perhaps imaginary, audience of all women.'

Martha Rosler

top
Garage Sale
Martha Rosler, 2000

Traveling Garage Sale
Martha Rosler, 1977

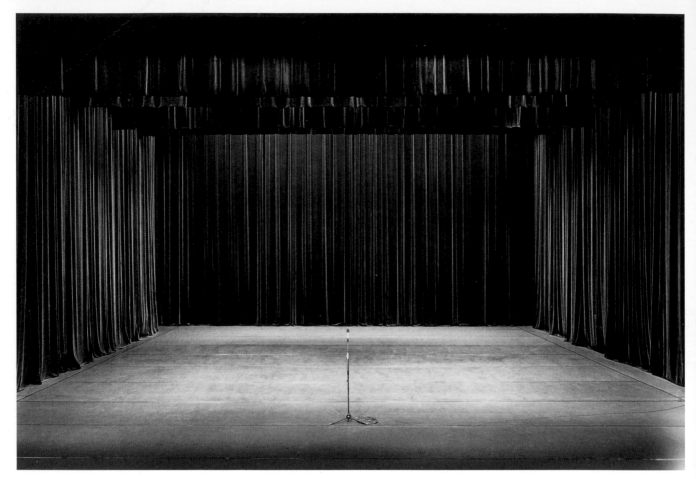

Frenchman Jérôme Bel belongs to a group of choreographers who came to attention in the mid-1990s for taking apart the most fundamental elements of traditional dance and radically reconceiving the medium. His work is probably best described as what fellow choreographer Xavier Le Roy once called 'choreography after dance'. In *Le Dernier Spectacle*, Bel examined issues of identity, representation, truth and make-believe through four dancers. The first played himself, the second tennis champion Andre Agassi, the third Shakespeare's Hamlet and the fourth German choreographer Susanne Linke. Each character appeared on stage four times and repeated exactly the same routine, after which they disappeared behind the curtain to leave the stage empty. Or almost empty: a Walkman attached to a microphone was left behind, playing the sounds of the previous performances. Bel

'It is the spectator who makes the performance.'
Jérôme Bel

then handed the stage over to the spectators, who were asked to complete the piece in their mind and to draw images from their memory of what they had just seen.

PERFORMING THE OBJECT

We tend to think of a sculpture as a static thing, perhaps placed on a plinth like a public monument or positioned on the ground like a Minimalist structure. But all the artists here challenge this traditional idea by making their objects perform in various ways. Some take everyday items and transform them into art by changing their original function or by displacing them to unlikely contexts; others use them as triggers for actions to be executed by the viewer. A number of artists question the permanent nature of art by producing short-lived or ephemeral pieces, while some even turn themselves into the living, performing objects of their work.

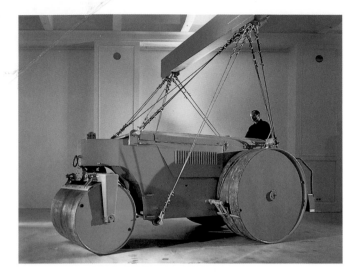

'How do you know what it is like to be shot if you have never been shot?'

Chris Burden

Since the early 1970s many of Chris Burden's works have dealt with situations of violence and danger, in which he often forced the audience to witness an apparently life-threatening act. His *Shoot* (1971), for which he asked a friend to shoot at him in a gallery space from a 15-foot distance, is today among the classics of performance art. That same year Burden locked himself into a two-foot wide, two-foot tall locker at the university in Irvine, California, for the legendary *Five Day Locker Piece*. Over the course of the 1970s Burden did numerous performances, all carefully documented, which saw his body being either stabbed, cut open, electrocuted or drowned. Just like other performance artists of that era, such as Vito Acconci, Marina Abramović or Paul McCarthy, in the early 1980s Burden began to become increasingly interested in objects. He started to translate his actual physical presence within the performances into sculptures or monumental installations, carrying out actions by stressing the performative element inscribed in them. *The Flying Steamroller* is among the best-known works from this period. Burden created a device, similar to a merry-go-round, which would make it possible for a 100-ton steamroller to lift off the ground and fly through the air in circles in front of an audience. The aspect of physical danger, in the possibility of an accident, has similarities to Burden's early stunts but here the artist switches sides and no longer puts himself in danger, but rather the audience.

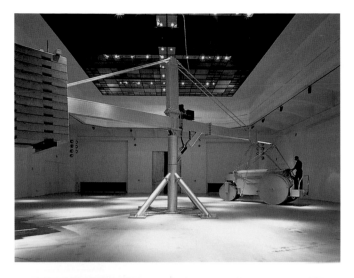

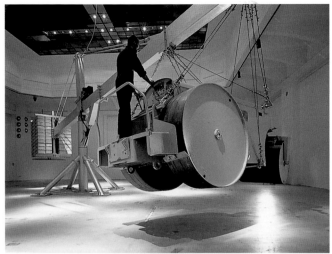

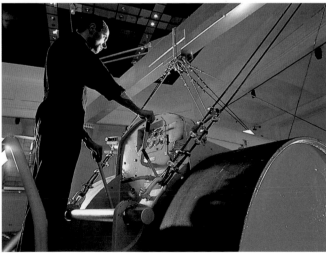

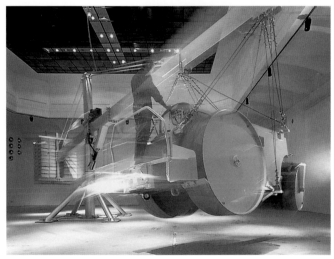

opposite and above
The Flying Steamroller
Chris Burden, 1996

As a graduate of UCLA's prominent art department, Eric Wesley has evidently studied the work of sculptors and installation artists of the generation of the landmark 1992 'Helter Skelter' exhibition: Paul McCarthy comes to mind, perhaps Jason Rhoades, certainly Mike Kelley. All three were, just like Wesley, highly influenced by Los Angeles's dark image, its cultural diversity and its position in the production of pop cultural phenomena. They related those influences to issues regarding a critique and a new formalization of traditional definitions of media such as sculpture and performance. Wesley also links those themes to questions about his identity as an artist, the concept of artistic creation, mass-production, and commercial and political aspects of the art system. Consequently, many of his recent works deal with ordinary, and yet occasionally grotesque, everyday phenomena of his hometown. For his New York exhibition 'Curb Servin'', Wesley created a brand of black-market tobacco products called New Amsterdam. The installation consisted of several elements, all of which could be taken apart to be put into the back of a standard-size U-Haul trailer, which was used as a transporter and was also another element of the exhibition, though only as a prop made out of painted wood. The installation incorporated the sale of tobacco seeds as well as the full-scale production of cigarettes, using all the necessary fabrication devices, including machines for rolling the tobacco into cigarette paper, and several boxes for the seeding, growing and drying of the plants and leaves.

Curb Servin'
Eric Wesley, 2003

Berlin Puddle
Kirsten Pieroth, 2001

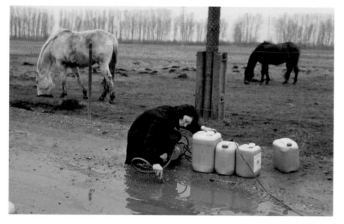

By carefully appropriating everyday items and sensitively changing their nature, or by simply displacing them to an unlikely context, Kirsten Pieroth's work seems to set out to find an 'in-between' of objects and subjects. One of her recent works, which perfectly illustrates this particular approach, is *Berliner Pfütze* (Berlin Puddle). For a similar piece, *Kreuzberger Pfütze*, Pieroth relocated the water of an ordinary puddle in Berlin's Kreuzberg area to an exhibition venue situated in a distinctly different part of town. Pieroth pumped the water and dirt from the puddle into several canisters. These were taken to the exhibition space, where she poured the water out onto the grey gallery floor. Some visitors to the exhibition might have thought that the cleaning staff had not taken care that day; others, knowing Berlin and the spaces in which art is sometimes exhibited there, might have thought the work was simply water coming from a leak in the ceiling. The idea of transporting and dislocating something as short-lived and migratory as a puddle questions Western society's belief in permanent objects, and their fixed and determined status, and defines the crossroads of strategies known from both performance and conceptual art.

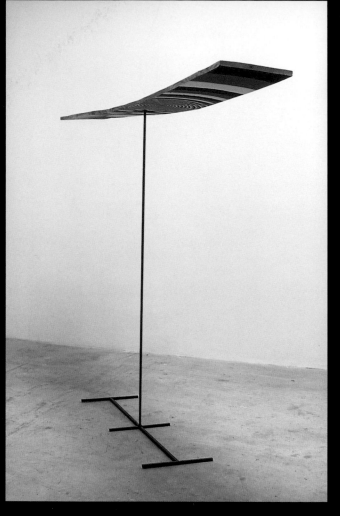

Wildly Painted Warped Lumber (#2)
Evan Holloway, 2000

While Pop forms and references to subculture seem to form the foundation of most of Los Angeles-based sculptor Evan Holloway's works, his sculptures in fact mostly revolve around issues specifically related to the medium of sculpture and its relationship to the viewer. The works often turn out to be triggers for actions executed by the viewers who come into contact with them. *Wildly Painted Warped Lumber* looks at first sight like a simple, Minimalist sculpture – some curvy wood on a metal stand. On getting closer one notices some eye-catching painting on the underside of the wood. When one tries to look at the painting on the bottom, one automatically stands with one's neck in an uncomfortable position, (per)forming a second stage of sculpture.

'I see object-making as one of the most radical ways to work today. Art audiences today easily assimilate nearly all the ways in which artists have tried to critique and avoid object-making. It seems to me like the way to really freak them out is to give them a sculpture.'
Evan Holloway

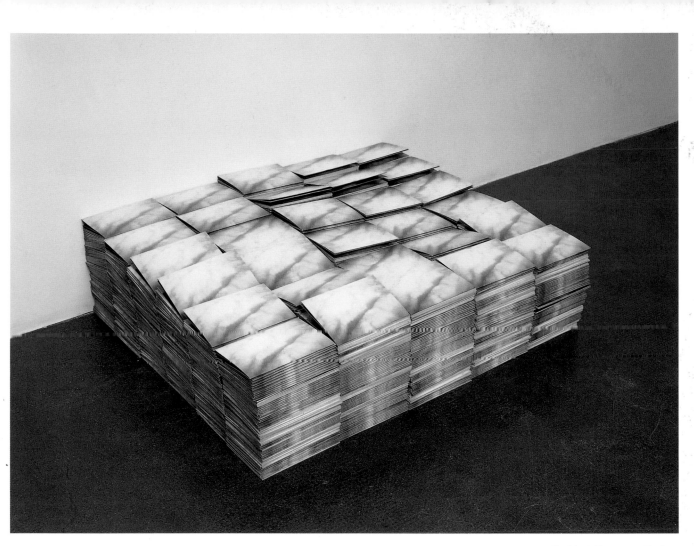

Untitled (Passport #11)
Felix Gonzalez-Torres, 1993

'I think, when you see a passport, really what you're seeing is a body there, because it's about a definition of a body. A body can travel from one place to another, only based on the fact that there's a passport that's defining us. That can sometimes be helpful, sometimes detrimental.'
Felix Gonzalez-Torres

'Without the public these works are nothing. I need the public to complete the work. I ask the public to help me to take responsibility, to become part of my work, to join in.'
Felix Gonzalez-Torres

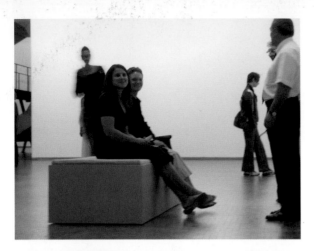

left
Moving Bench #2
Jeppe Hein, 2000

opposite
Moving Walls 180°
Jeppe Hein, 2001

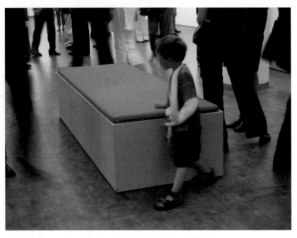

Pieces by the Danish artist Jeppe Hein do not simply function as representations of reality; they actually *produce* reality, in the case of his work *Moving Walls* by setting elements of the exhibition space in motion. The artist has created a set of walls that slide slowly through the exhibition space, continuously altering its supposedly predetermined configuration.

Hein's *Moving Benches* appear to be ordinary seating arrangements, such as one can find in any museum, but when the visitor sits down, the benches begin to move, gliding gently through the space and taking the audience on a ride, disrupting the solemnity of the gallery environment.

'Everything is in motion, everything is changing, everything is being transformed and yet nothing changes.'
Jean Baudrillard

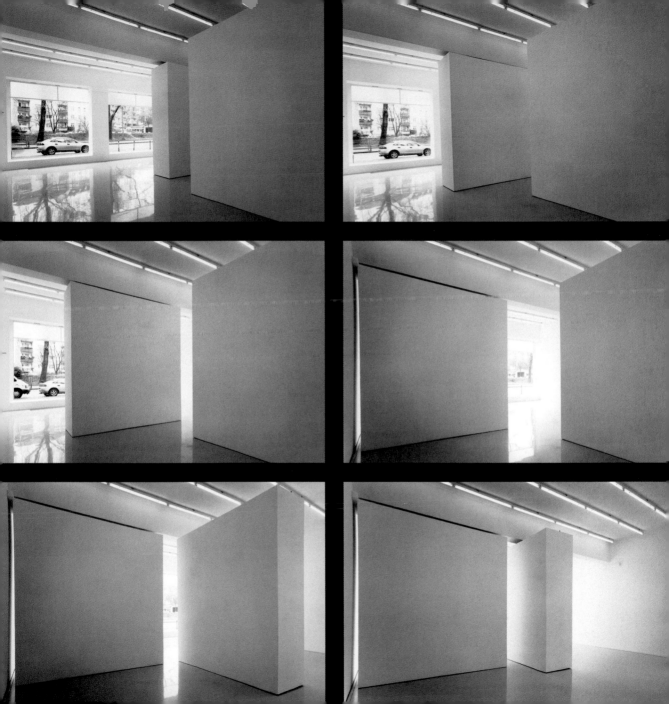

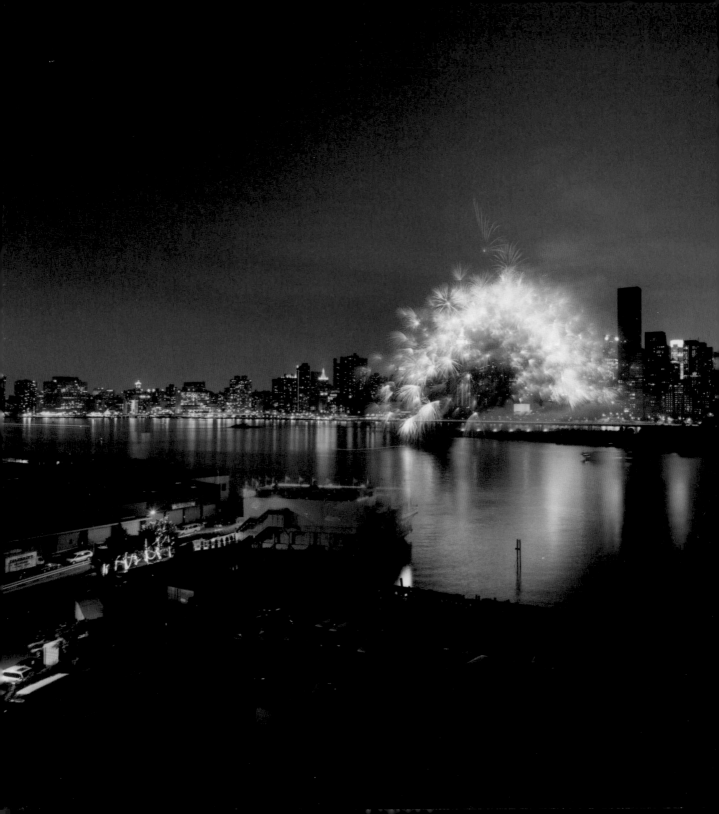

Transient Rainbow
Cai Guo-Qiang, 2002

In 1989, under the title *Projects for Extraterrestrial*, Chinese artist Cai Guo-Qiang began his public gunpowder performances, designed for particular sites around the globe and involving the transportation of Chinese fireworks and their related mythologies to the context of contemporary art in the West. *Transient Rainbow* was created for the Museum of Modern Art in New York and illuminated the Manhattan skyline for one evening in 2002, Qiang's largest and most dramatic performance to date.

'The moment of explosion creates chaos in time and space.'
Cai Guo-Qiang

Rio de Janeiro-based artist Franklin Cassaro is interested
in the idea of making 'life sculptures', connecting the
concept of sculpture with the active field of performance
through what he calls a 'sculptural act'. Cassaro is best
known for his large-scale, inflatable sculptures, which he
creates out of newspapers, magazines or plastic sheets.
These are bound with packing tape and have air blown
into them by a fan. The sculptures exist in various forms
and shapes and, despite their large size and volume, are
short-lived and ephemeral. Cassaro calls them *abrigos*
(shelters), since it is possible for the audience to enter

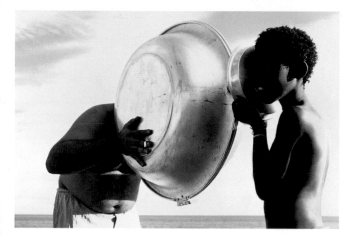

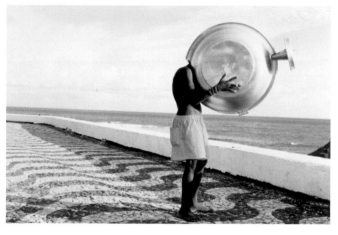

Acoustic Head
Marepe, 1996

'Go to the object. Leave your subjective preoccupation with yourself. Do not impose yourself on the object. Become one with the object. Plunge deep enough into the object to see something like a hidden glimmering there.'

Matsuo Basho

For *Acoustic Head*, tho Brazilian artiot Marcpc collcctcd two metal basins, used in Brazil to wash laundry, and joined them together with hinges and a casserole pan. One person can put their head into a large opening on one side in order to listen to the amplified singing of another person standing on the other side. Using the Western gesture of the readymade, Marepe selects everyday objects and transforms them into art. By releasing them from their original function, the artist creates new meanings and contexts, which are decisively affected and shaped by the daily rituals and traditions of north-eastern Brazil. Simple objects, such as bowls, filters, old clothes and fruit, are all part of Marepe's transformation of the everyday. By making use of such ordinary and accessible goods, Marepe questions traditional artistic media while revealing his sensitivity to and appreciation for his cultural environment.

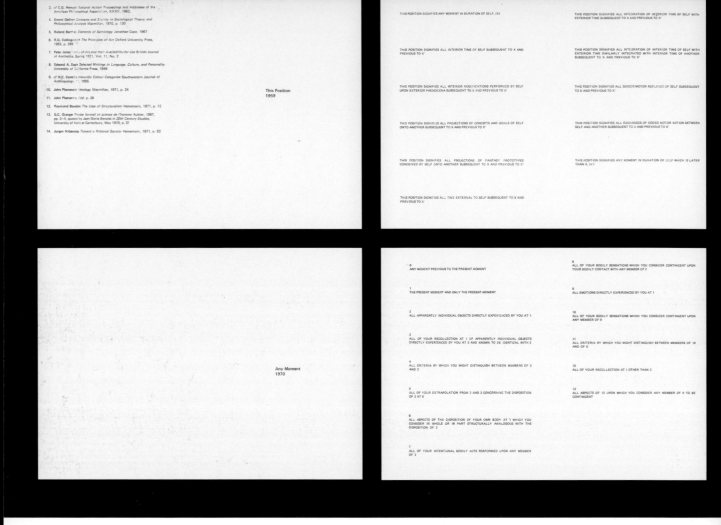

In 1969 Victor Burgin specified through a series of language-based pieces his idea for an art form that was no longer bound to any physical fabrication or representation of a material object, but purely information. Based on the connection of language and action, the works of this series include *This Position*, *Any Moment* and *All Criteria*. All three propose a set of abstract and temporary relationships, inviting viewers to visualize the reality that they describe and, through that, to build up a coalition between the pieces and themselves.

All Criteria
1970

opposite above
This Position
Victor Burgin, 1969

opposite below
Any Moment
Victor Burgin, 1970

left
All Criteria
Victor Burgin, 1970

'All those bent bits of metal and acres of canvas clogging up the basement of museums. A form of ecological pollution.'

Victor Burgin

Gilbert & George
1995

Since the beginning of their collaboration in the late 1960s Gilbert & George have, probably more than any other artist, defined what it means to be a living work of art. The pair first appeared in their classic British suits in the heyday of the hippie movement, clearly as a strong contrast to the wild and unpolished spirit of the time. In 1969 they began to become increasingly publicly visible. They achieved instant success with their graduation piece, *Singing Sculpture*, in which they moved in a strange mechanical manner, almost like anthropomorphic creatures, wearing silver/gold metallic make-up on their faces, while the 1930s dance-hall song *Underneath the Arches* sounded from a flimsy portable tape player. Gilbert & George clearly parodied England's obsession with class and proper behaviour, which they so perfectly personified, and declared themselves simultaneously the objects and the content of their work.

'Being living sculptures is our life blood, our destiny, our romance, our disaster, our light and life.'
Gilbert & George

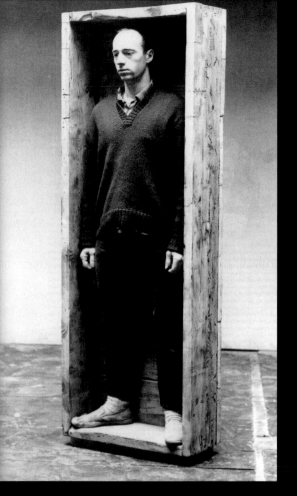

Untitled (Standing Box)
Robert Morris, 1961

The work of Robert Morris has strong connections with the new dance movements of the 1960s which developed around artists such as Simone Forti, Yvonne Rainer and other members of the Judson Dance Theater. Influenced by what he saw and experienced in the realm of choreography, Morris began, like Forti in dance, to work on ideas that took the human body and its measures as the source for most of the works – in Morris's case, from the 1960s onward, mainly pre-Minimal sculptures based on his own body measurements. For *Untitled (Standing Box)*, he created a wooden box, not unlike an inexpensively fabricated coffin, made exactly to his proportions, and he placed himself vertically inside it. In so doing, the artist, as he put it, 'performed' the box.

'The notion that work is an irreversible process ending in a static icon-object no longer has much relevance.'
Robert Morris

'How does a cell operating from the peripheral gain agency to navigate through a system, infiltrate it and infect it internally with its own virus, and get away undetected?'

Juan Capistran

Juan Capistran uses various forms of popular culture as they are found on the streets of Los Angeles, and other places with a diverse range of cultural influences, and applies them to infiltrate and challenge the art system. These forms can include musical performances, graffiti, spoken word presentations and movement-based interventions. For *The Breaks*, Capistran went into the Los Angeles County Museum of Art during regular opening hours and performed a break dance on top of a Carl Andre floor piece. By activating the sculpture, Capistran changes its meaning and function entirely and connects the piece to a world apparently locked out of museums and traditional art institutions.

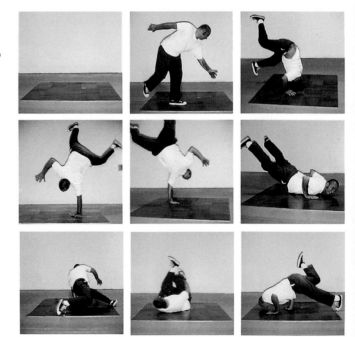

The Breaks
Juan Capistran, 2000

Many works by the Canadian artist Alex Morrison are inspired by an activity he has enjoyed since he was a teenager – skateboarding. His work *Guerrilla Ramp Building* deals with the subversive nature of skating: with its appropriation of urban space and architecture Morrison sees the skateboarders' performative actions as a critique of a well-protected system of values, a critique in which the functional meaning of urban objects is expanded and reassigned. Whatever is at hand – construction-site plywood, bicycle racks, safety cones, fallen street signs, abandoned cars, benches – can be used, arranged in various 'permutations' and fitted to existing architectural elements by the skaters. With *Guerrilla Ramp Building*, Morrison applied concrete to an existing curved structure to make a skating ramp. By so doing, he not only created an interference in the urban space by constructing an illegal ramp, but he also produced a hybrid sculpture by adding to a readymade structure rather than arranging autonomous objects in a new configuration.

'Skaters by their very nature are urban guerrillas: they make everyday use of the useless artifacts of technological burden and employ the handy work of the government / corporate structure in a thousand ways that the original architects could never dream of.'
Craig Stecyk

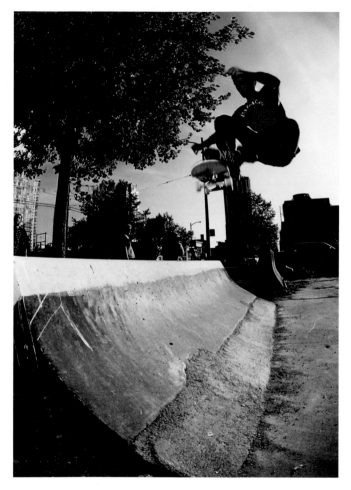

Guerrilla Ramp Building
Alex Morrison, 2000

'I CAN WALK YOUR DOG.'

Gob Squad

I can...
Gob Squad, 1998

The installation *I can…*, conceived by the British/German performance group Gob Squad, was created to bridge the gap between art object and performance. Asked to create an installation for an exhibition in a gallery, the group found itself confronted with the question of what they could contribute to the commercial aspect of the exhibition site. Their installation consisted of six television screens on which each member of the group could be seen offering to perform various actions, simply by saying things such as, 'I can cook a meal for six people', 'I can tell a funny story', or even 'I can fall in love with you'. Each offer had its particular price, so that what was seen on the monitors looked at first glance like a home-shopping network, with flashy letters saying 'Buy Now', 'Special Offer' or 'Back In Stock', and a toll-free number at the bottom of the screen. A real phone and a price list were placed next to the monitors. A direct line connected the audience with an operator who took the order and discussed the details of when and where the performance was to be delivered and the method of payment, cash or credit card. The unique way in which Gob Squad approached the situation, by making the object the prearranged part of a performance, makes *I can…* a convincing piece in relation to the discussion of active performance and art object.

EXCHANGE AND TRANSFORM

Most of us would claim with some confidence to know who we are, that our identity is fixed and stable. But can we be sure when so much else in life is in a constant state of flux? Many of these artists are forever swapping roles and adopting new personas as they explore the shifting nature of personal and collective identity. Some establish new social relationships as a way to improve people's ways of life. Others, conscious that our environment often has an effect on our behaviour, seek to change their surroundings or to transfer themselves to different contexts in order to reach a better understanding of what it means to be in the world.

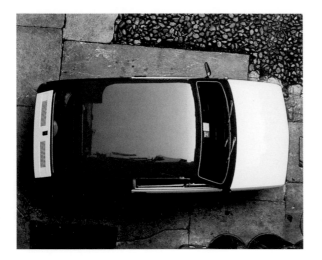

Simon Starling challenges the world as it appears to be when he focuses his work on the transformation of one object into another, and the process of that transformation. He alters or modifies everything he works with and usually transfers it to a different context in order to create new meaning with already existent materials. In many of his works he undertakes a particular form of historical reconstruction, based on close research, as can be seen in *Flaga (1972–2000)*, made in 2002. In the early 1970s the Italian car manufacturer Fiat designed a small car – the Fiat 126 – which then became, for many years, the quintessential Italian car for the working classes. The model was first produced in Italy and then later on in Poland, where inexpensive labour and materials allowed for low-cost construction. Starling bought one of the last cars to be made in Italy, a red 1974 model, and drove it from Turin to Warsaw. Along the way he bought several Polish-made body-parts in white and had them exchanged with their red counterparts, referencing the flag of Poland. He then drove his red-and-white car back to Turin, where it became part of an exhibition, drilled to the wall like an anthropological artifact from the early years of globalization.

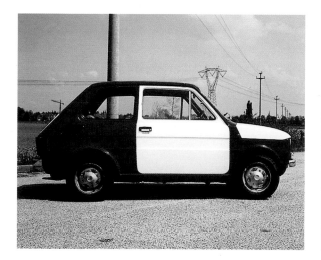
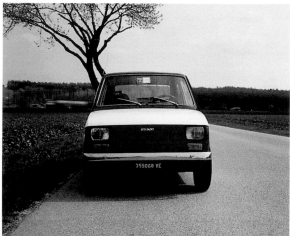
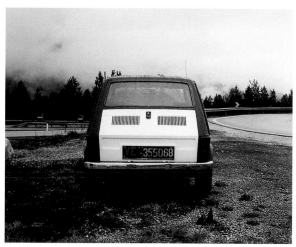
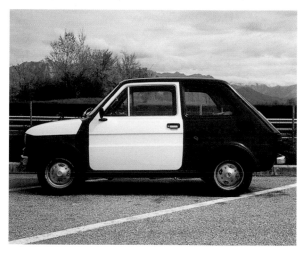

opposite and above

Flaga (1972–2000)

Simon Starling, 2002

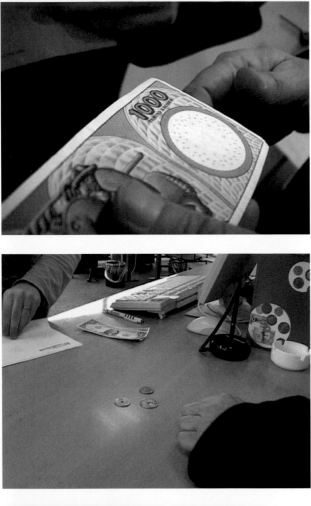

The Deal
Nedko Solakov, 2002

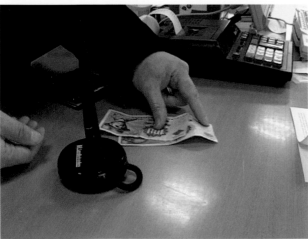

'On January 28th, 2002, in the small but prosperous Danish city of Herning, within the framework of the Socle du Monde (inspired by Piero Manzoni's famous base / pedestal supporting the world, created 40 years ago in this remote place), I – one of the participants in a business-meets-art-and-creates-thing-together event – asked Mr Niels Jorgen Hyldgaard, Head of Communications, Herning Institute of Business Administration and Technology, to take back part of the project budget in the form of a 1000 Danish Crowns bill and to convert this into US $ at a local bank. These US $ were then changed back into Danish Crowns, and back into US $ and so and so forth, until the money began to melt away into small change, eaten up by all the commissions and the buy-and-sell currency rates. During the course of these transactions, a few of the best students of the Business Institute took notes exactly observing the deal.'
Nedko Solakov

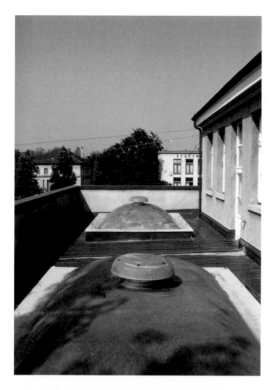

Among the main concerns of German artist Maria Eichhorn are the economic and political particularities of the art system. She investigates these mostly in relation to very precise conditions in individual exhibitions or art institutions. As part of her solo exhibition at the Kunsthalle Bern, Eichhorn analyzed in various ways the institution's economic circumstances. One part of her exhibition was based on the idea of using the exhibition budget to renovate parts of the Kunsthalle that had not been refurbished for years. These renovation works included the installation of a ventilator, the reinforcement of girders, the renovation of the chimney, and plumbing and electrical work, as well as the replacement of the skylights above the main exhibition space.

'Replacement of the dome lights: dismantling and disposal of the polyester dome including removal from the roof with a crane. Delivery and installation of polycarbonate barrel vault roof. The barrel vault roof units have a gable connection piece on the dace ends. Installation on a wooden frame construction supplied by the customer. Installation of a permanent ventilation system mounted in a frame construction in the face ends of the vaults. Work to be performed by the customer: dismantling of the carrier cables of the streetlight so that the crane work can be carried out unhindered. Location: east hall, west hall, and attic. Period: 29 October to 1 November 2001. Work performed by: Roger Koller, Ruedi Santschi, Hans Zeller; Real Ag, Thun. Costs: CHF 12 695.'
Maria Eichhorn

The Money of the Kunsthalle Bern
Maria Eichhorn, 2001

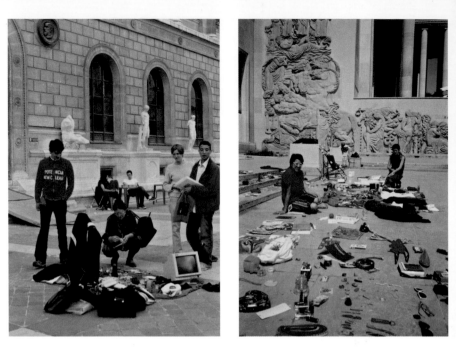

Street Museum
Colectivo Cambalache, 1998–2002

Colectivo Cambalache was founded in 1998 in Bogota, Colombia, by Carolina Caycedo, Adriana García Galán, Alonso Gil and Federico Guzmán. It considers itself to be an open and flexible collective with no fixed members. The collective's main project has been the so-called *Street Museum*, based on the idea of non-monetary exchange, and designed to recycle and provide new usage for various kinds of objects collected through trade and barter. The aim of the project is to capture present-day social relationships. The project has been developed in different versions throughout the world, from Bogota, where it took the form of a recycled car, to Slovenia, Puerto Rico, Spain, Switzerland, France, Italy and Turkey. In each location the methodology of investigation and appropriation was different according to the historical and immediate particularities of the various countries and cities.

Since the mid-1990s the Danish collective Superflex
has been engaged in a wide range of projects relating
to improvements in living standards. They have done
this by developing various tools and techniques that can
be easily transported and applied all over the world.
Probably their best-known project is *Supergas*, which
was begun in 1996. For this project Superflex
collaborated with Danish and African engineers to
construct a simple, portable, bio-gas unit that is capable
of producing sufficient gas for the cooking and lighting
needs of a single family. The system was originally
designed to meet the anticipated needs and resources
of small-scale economies, and in particular the demands,
as regards efficiency and style, of a modern African
consumer. The plant produces bio-gas from organic
materials, such as human and animal excrement. For a
modest sum, a family can buy a bio-gas system of this
kind and achieve self-sufficiency in energy. The plant
produces approximately four cubic metres of gas per
day from the dung of two or three cattle. This is enough
for the cooking purposes of a family of eight to ten
members, and can also run one gas lamp in the
evening. Together with the engineers and investors,
Superflex has formed the shareholder company
SUPERGAS Ltd. This company is responsible for the
further development of the bio-gas unit.

**USER/
MASSAWE FAMILY**

The pilot project for the biogas system was installed in the home of
the Massawe Family in Morogoro, Tanzania August 1997, and is being
used by them for cooking.

Supergas
Superflex, 1996–2001

In recent years the French choreographer Xavier Le Roy has made a huge impact in the world of dance and choreography, yet he only started to work in this field after finishing a dissertation in molecular biology. His approach as a choreographer goes beyond a purely artistic one and reflects a strong scientific urge to understand the body in different, seemingly unrelated contexts. His piece *Self-Unfinished* clearly expresses his interest in questioning the representation of the body in the practice of choreographic art, and formulates a strong critique in regard to social hierarchies and related political subject matters. Le Roy moved from the idea of the body as signifier to the idea of the body loaded with fewer and fewer signs; from a perception of representation that is usually recognition towards representation without any possibility of recognition, leading to confusion and disorder.

'Science plays a role in my way to question the body in my choreographic works but it is very difficult to make a clear distinction when science does it more specifically because it is already part of a context, how I experienced science.'

Xavier Le Roy

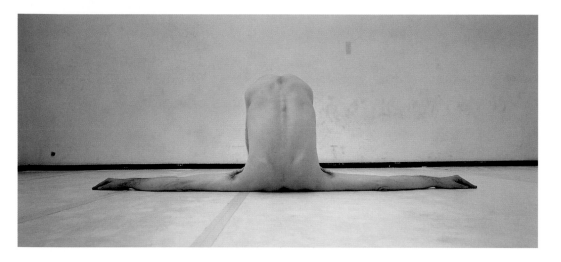

Self-Unfinished
Xavier Le Roy, 1998

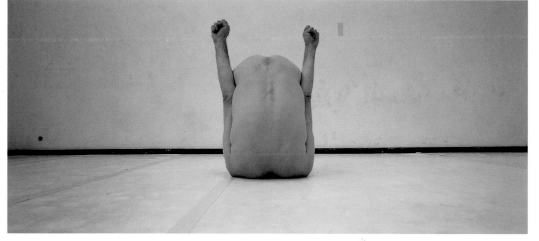

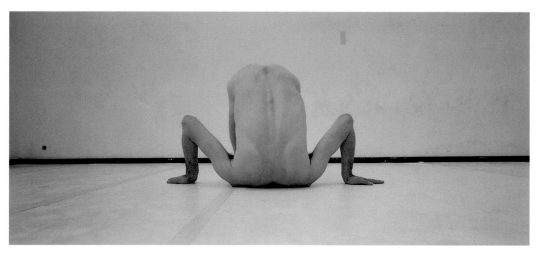

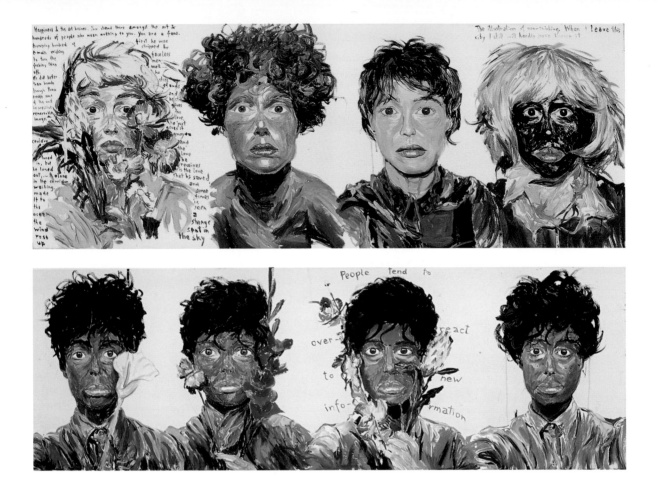

Viennese artist Elke Krystufek is an exhibitionist who allows us to enter every chamber of her body, mind and soul. Nothing is too private, nothing too personal, that it cannot be presented to a spectator. In her extreme self-portraits the artist primarily confronts issues of desire, voyeurism, intimacy and sexism. Her works seem centred around the use of her body, as when she exposes it in the thousands of photographs, paintings and collages she has made to explore various codes of gender and female identity. It is the prodigious number of pieces that she creates, with their brutal images and scenarios, that ultimately suggest a form of sexual denial rather than intimate veracity. Krystufek's work is deeply rooted in performance, not only due to its relationship to Viennese Actionism or the constant use of the body, but also because of her conflicting relationship with the psychological foundations of our inconstant world and the particular connection she establishes with her audience.

top
J'arrive/
Regard, Regard/
Life will not go away/
Allegory of flying
Elke Krystufek, 2001

above
Calla/
Quand on n'a que l'amour/
New economy/
Imagine god like yourself
Elke Krystufek, 2001

top
Living Together #12
Vibeke Tandberg, 1996

Living Together #8
Vibeke Tandberg, 1996

Like other female photographers of her generation, Norwegian artist Vibeke Tandberg clearly follows a direction of staged photography with regard to issues of female identity. In Tandberg's case these issues also have a strong connection to her own personal history, questioning the notion of a clear and stable identity. Throughout her work she has asked questions about the truth of photography, about histories created by photography, and especially about herself, her own identity as a human being as well as an artist. Many of her photographs are composites of other people's faces, or show the artist in social situations connected to male-dominated areas of life. In what is probably her best known work to date, *Living Together*, Tandberg herself is the model for a pair of twins. It does not take long to realize that her works are not casual snapshots, but rather carefully staged artifacts. In fact she has used a combination of conventional photography and digital technology to construct a non-existent family. The key is the perception that we as viewers have, believing in photography as a medium for representing reality, and believing that photography in some way acts in the confirmation of society, in terms of being a social rite which captures family histories.

'Everyone thinks of changing the world,
but no one thinks of changing himself.'
Leo Tolstoy

opposite, above and below left
The Schoolgirls Project
Nikki S. Lee, 2000

opposite, above and below right
The Exotic Dancers Project
Nikki S. Lee, 2000

The chameleon-like transformations of Nikki S. Lee remind one of Woody Allen's famous film character, Zelig, who constantly changes his appearance and behaviour depending on the context in which he finds himself. In contrast to Zelig, who was suffering from a rare personality disorder, Lee deliberately takes on a diverse range of identities. As an immigrant she has quickly learned how to fit into certain codified situations and her countless transformations are an excellent study of 'subcultures' existing in the US, many of which the artist has infiltrated. Her anthropological projects include appearances as a punk, a senior citizen, a Korean high-school student, a skateboarder, a yuppie and a stripper. But Lee does not simply slip into new clothes in order to take a quick snapshot; she carefully transforms herself over a period of many weeks in order to fit perfectly into the role she has to play. At first glance Lee's work appears to be close to Western identity politics, but in fact it connects rather to thoughts from Eastern philosophy, in which the self is understood to be a relative – a fluid – entity.

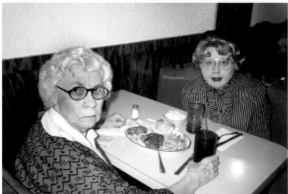

The Seniors Project
Nikki S. Lee, 1999

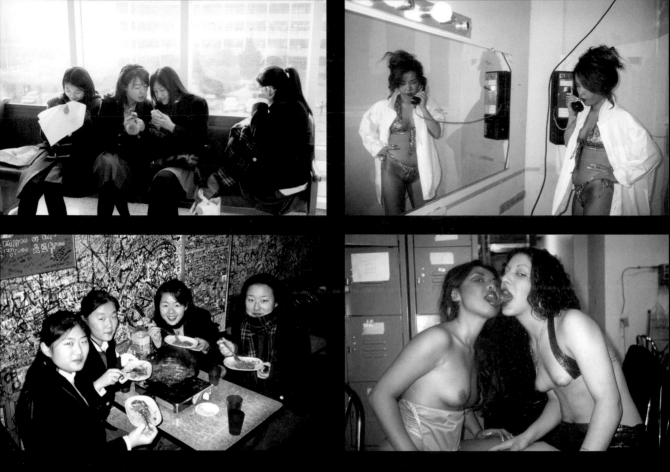

'The subject of my work is my identity and the performances that create the characters that compose that identity. This project is not about me searching for identity. It is a demonstration of how many characters can coexist within one single identity.'
Nikki S. Lee

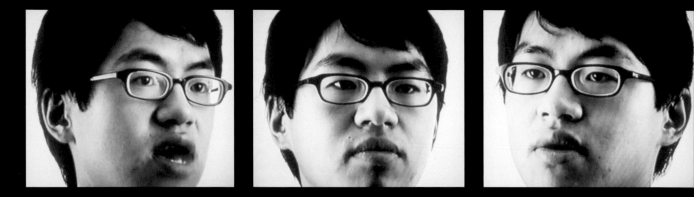

'In *The Move*, a simulacrum of race is being made indistinguishable – visual Asianness conflates with white text and coded black grammar to the point where no one race becomes dominant. Here, the artist adopts minimalist tactics – in a reduced, deadpan and mechanical look and performance – as a process of deracination that conflates a triple stage of racial identities. Minimalism acts as the great leveller. In the video everything gets reduced; the production is mathematical, the rhyming made deadpan, the "I" gets extinguished. By systematically rehearsing the tag-team to mechanical effect, the performance weirdly attempts to defeat a complex pattern of language by trying to articulate it. And, paradoxically, the monotone delivery makes the charged giddiness of hip-hop more strange, rational and foreign than ever.'

Tim Lee

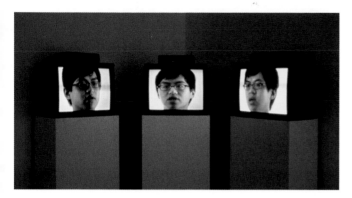

opposite and above

The Move, The Beastie Boys
Tim Lee, 1998

In 1998, the Beastie Boys released *Hello Nasty*, a hip-hop album loaded with old-school sentiment, nostalgic street hymns and a kind of retro rhythm. The band have emerged from the debate of their legitimacy – three white, upper-middle-class Jews fronting black culture – with enough cultural currency to be considered respected members of the hip-hop vanguard. The history of video art is just as short as hip-hop and, until very recently at least, video art most often meant performance. In the 1970s artists like Vito Acconci and Bruce Nauman used video primarily to capture and make available a performance on tape. For them, video was a new way in which to enact their psychological closet-dramas, so they filmed themselves in the studio dramatizing simple behaviour. In his work *The Move, The Beastie Boys* Tim Lee brings together the standards of old-school hip-hop with the early practice of video art. His installation consists of three separate monitors and VCRs, each screen featuring the artist assuming the identity of one of the Beastie Boys (Mike D, Ad-Rock and MCA) and his rhymes.

Untitled Film Still #37
Cindy Sherman, 1978

Untitled Film Still #4
Cindy Sherman, 1977

Cindy Sherman's *Untitled Film Stills* from the late 1970s show the artist in various outfits, situations and poses, as a critical homage to movie stills and magazine images of the 1950s and '60s and their stereotypes regarding female identity. Even though Sherman has clearly opened doors for a younger generation of female artists working today with photography on issues of gender and identity, she has never acknowledged the pure feminist reading of her works. It seems to be rather the joy of wearing someone else's clothes, getting dressed up and inventing a different personality for each of her images that is the motor behind most of her pieces.

'In some of [my portraits] I see a self that I could have been, if I had gone in a different direction than being an artist, like if I had become a real estate agent or taken those damn teaching classes my mother wanted me to.'
Cindy Sherman

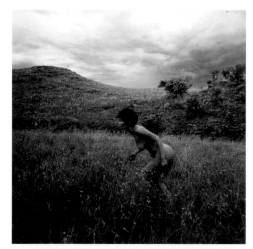

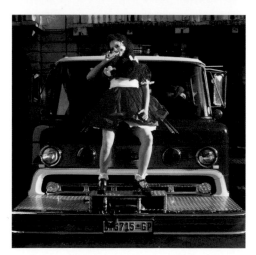

South African-born artist Tracey Rose has, over recent years, become one of the most powerful voices in the contemporary African art world. Her work is mostly related to questions concerning the constitution of identity and issues of racial politics in her home country. With her critical approach, Rose challenges common beliefs about the history and current realities of South Africa, juxtaposing the collective experience with her own individual social history as a coloured female. Many of her works contain elements of intense aggression and rage speaking about the violence and the widespread racial, social and political conflicts her country endures. Rose works with a variety of media, including video and photography as well as live performance. One of her best-known pieces to date is a thirteen-minute video, projected on three screens, entitled *Ciao Bella*, made for the 49th Venice Biennale in 2001. The film presents twelve female characters, all portrayed by Rose herself, seated around a table in a scene not unlike the Last Supper. However, Rose was not presenting heroines, but rather a set of awkward female stereotypes. She later went on to embody her burlesque cast individually in a series of photographic portraits.

left
Ciao Bella:
Ms Cast Series 'Bunnie'
Tracey Rose, 2002

far left
Ciao Bella:
Ms Cast Series 'Mami'
Tracey Rose, 2001

centre
Ciao Bella:
Ms Cast Series
'Venus Baartman'
Tracey Rose, 2002

below
Ciao Bella:
Ms Cast Series 'Lolita'
Tracey Rose, 2001

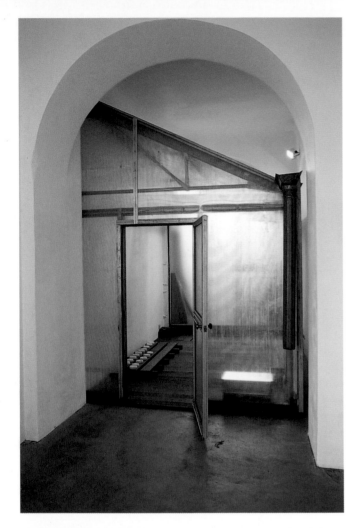

If one wants to consider performance as something which involves a temporal element, something which extends beyond the time frame of any given single exhibition, then nearly everything Chicago-based artist Dan Peterman does applies. Peterman is interested in the idea of the transformation and transposition of everyday goods and detritus. He converts, recycles and revitalizes these by producing objects and materials connected to actions that are based on the thought that nothing that is produced can ever in fact really disappear. From a performative perspective, *Finishing Room (Cheese)*, shown at the Gallery Klosterfelde in Berlin and later in Peterman's 2001 survey exhibition at the Kunstverein Hannover, is among the best examples. Peterman collaborated with ecological cheese producers from the region to follow the process of transformation of fresh goat's cheese over the period of the exhibition. The artist installed a greenhouse in the gallery space and placed the cheese on a specially constructed, shelf-like platform close to the floor in order to let it ripen. Over the course of the exhibition the cheese began to produce a very strong smell and to become hard, mouldy and inedible. What was then left became part of a collection and was placed into aluminium containers to form yet another product.

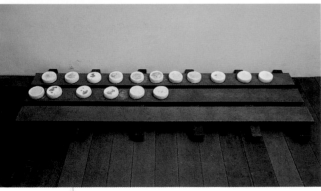

Finishing Room (Cheese)
Dan Peterman, 1999

STILL LIFE / TABLEAUX VIVANTS

All the artists in this room freeze the actions and performances of life in highly dramatized images or hyperrealistic sculptures. Oscillating between reality and fantasy, their well-staged spectacles present a disorientating world of uncanny and surreal drama in which motionless characters act out strange performances before our eyes. Some artists, on the other hand, choose literally to still life, holding a pose for hours as life continues around them.

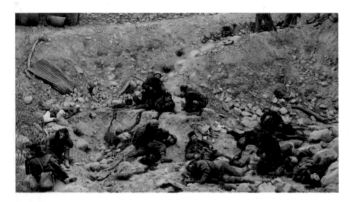

Dead Troops Talk
Jeff Wall, 1991–92

Vancouver native Jeff Wall has, probably more than any other artist in the last twenty-five years, established the medium of photography as one of the cornerstones of contemporary artistic practice, due to his radically different approach to the medium and the precision with which his works are executed. His staged scenarios, which he controls right down to the last detail, invoke settings by painters such as Goya and Manet while simultaneously referencing cinema and Minimal sculpture through the use of his trademark light boxes. It is the subject matter of Wall's images as much as the genre of stage photography that links it to the idea of performance, particularly the artist's continual interest in the undead. *The Vampires' Picnic* realizes this, as does *Dead Troops Talk*, and other works such as *Faking Death*, an early work made in 1977. All of these can be qualified as 'fantasy pictures', or scenes that exist somewhere between life and the afterworld. More particularly, if neither the real nor the virtual can be resolutely determined, then the scene can only be described within its own space of representation – the space between reality and the imaginary. It is important to bear in mind that *The Vampires' Picnic* and *Dead Troops Talk* are digital composites and not straight photographs, and that they are therefore more emblematic of the works' conception as fictional and utterly fantasized scenarios.

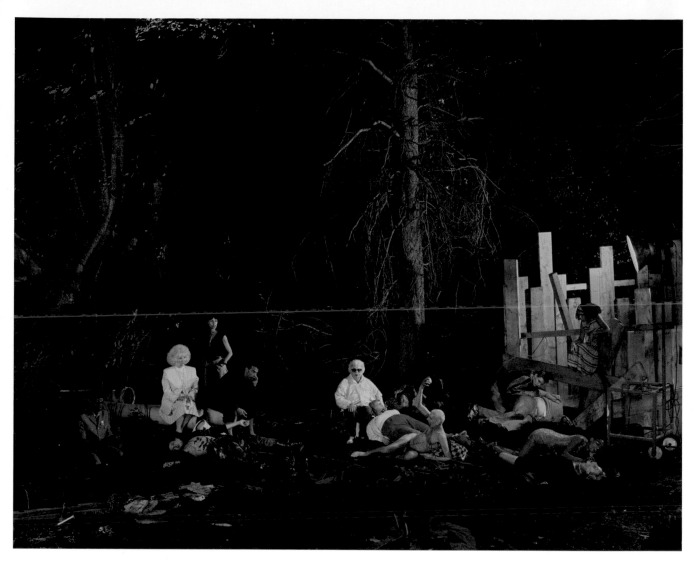

The Vampires' Picnic
Jeff Wall, 1991

Since the early 1990s British artist Sam Taylor-Wood has become widely known for her panoramic photographs, which deal with the affliction of being alive and the elemental ambiguity of human relationships. Her works from the series *Five Revolutionary Seconds* (1995–2000) are about emotional depth, and expose basic human conditions of loneliness, fragility, vulnerability, feelings of inferiority, indifference and isolation.

Using a photographic technique originally invented by the British military, the artist takes 360° shots, with a five-second exposure, of carefully staged scenarios that reveal conflicted psychological conditions. Taylor-Wood's protagonists appear to be relaxed and happy, and simultaneously aware and unaware of the camera. Involved in various repetitive activities, they manifest an often dreamlike and uncanny form of dramatic tension within their relationships.

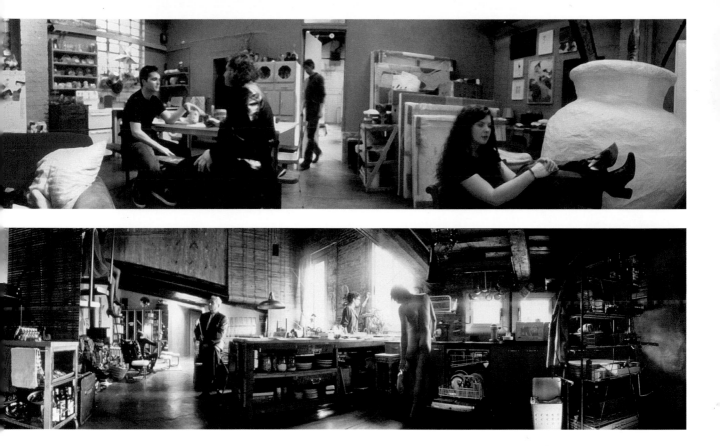

'You tend to look at photographs instantly and read them quickly. With the *Five Revolutionary Seconds* series, I set out to make photographs in which you created your own structure and narrative whilst working with different time frames because you can't physically take in the whole image at a glance.'
Sam Taylor-Wood

Five Revolutionary Seconds
Sam Taylor-Wood, 1996

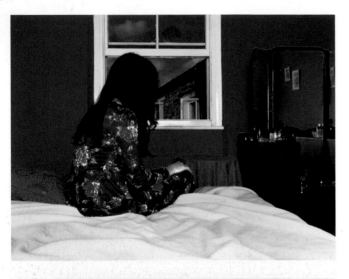

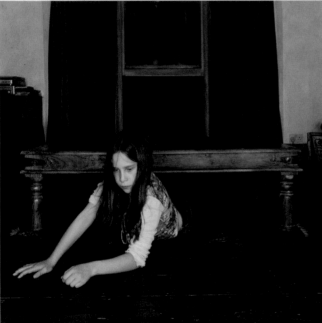

Sarah Jones's precisely staged and highly artificial photographs immediately seem to show something entirely separate from reality, even though they employ nothing unnatural. It is the careful way in which Jones works with light, how she arranges the elements in her precisely composed images, and how she chooses her environments, that make these portraits of girls, apparently temporarily trapped in between childhood and maturity, seem so unreal. The saturated colour settings appear like surreal dream worlds, with spooky gardens or mysterious domestic spaces, home to the melancholic and distressed minds of the artist's young protagonists. At first glance these uncanny images do not reveal much of a narrative. What makes them so powerful is the network of connections that the artist creates, which only slowly lets us comprehend the underlying principle. The symbolic and visual relationships between each image, between the different domestic and non-domestic elements in the photographs and, above all, the peculiarity of the girls, create an elaborate web of references oscillating between reality and fiction.

top
The Bedroom (I)
Sarah Jones, 2002

The Living Room (I)
Sarah Jones, 2002

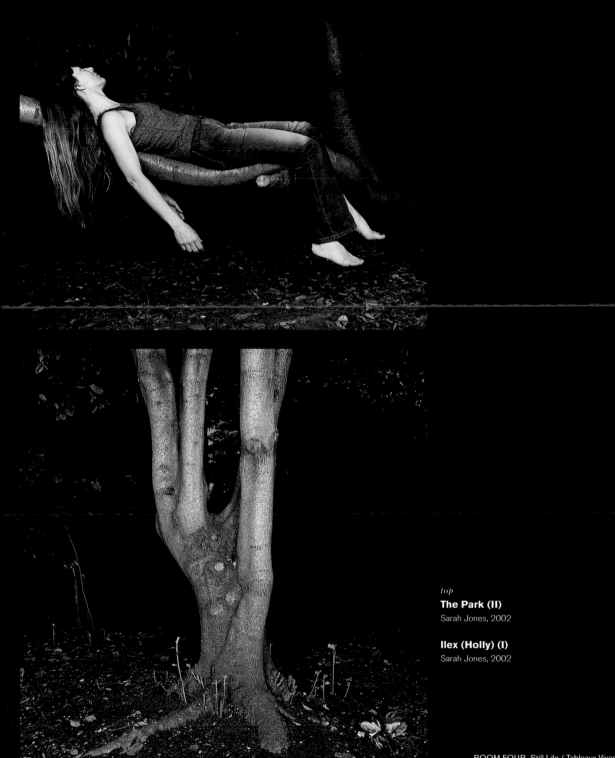

top
The Park (II)
Sarah Jones, 2002

Ilex (Holly) (I)
Sarah Jones, 2002

ROOM FOUR Still Life / Tableaux Vivants 91

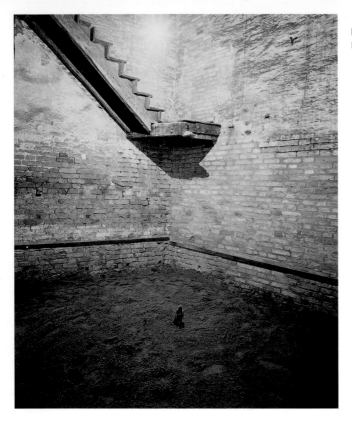

Mother
Maurizio Cattelan, 1999

Maurizio Cattelan loves to provoke and irritate, constantly shifting his position, joking around and constructing absurd situations full of often bitter irony. Yet Cattelan generally does all this with critical concerns in mind, and many of his pieces deal with a sharp deconstruction of the art system and its mechanisms. *Mother* is a subtle piece, though certainly employing the strategies of a well-staged spectacle. The artist asked a fakir to bury himself in the sand placed in an exhibition space during the first few days of the 48th Venice Biennale.
The audience was only able to see the fakir's hands: the remainder of his body was underneath the sand. The fakir would come out of the ground every five hours to get something to drink and eat, and to prove that this was no make-believe or circus trick but a real and dangerous act that the artist was exposing him to.

'It is not only for what we do that we are held responsible, but also for what we do not do.'
Molière

Oh! Charley, Charley, Charley...
Charles Ray, 1992

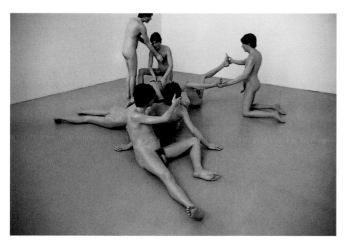

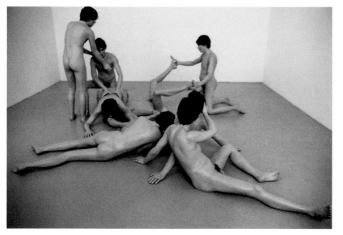

Ever since early works such as the *Plank Pieces* (1973), American artist Charles Ray has repeatedly used his body as a sculptural element, creating hybrids of sculpture and performance. In the early 1990s, Ray began to work more and more with mannequins and dummies. One of the earliest pieces in this sequence was *Male Mannequin* (1990), for which the artist used a generic male mannequin and fitted it with a cast of his own genitals. *Fall '91* (1992) presents a female mannequin enlarged by thirty per cent and wearing an outfit from the Autumn collections of 1991. *Oh! Charley, Charley, Charley...*, made for the Documenta 9 exhibition in Kassel, Germany, in 1992, is probably among the best known of his works. Here we see a sculpture of a sex orgy involving eight fibreglass figures, all of which are casts from the artist's own body. This sexual feast, in which the eight Charleys suck and fuck themselves, is a still life of self-referential eroticism, an orgy of loneliness.

'The mannequin is like a Greek statue, like their embellishment and idealization, and I saw it as our contemporary counterpart.'
Charles Ray

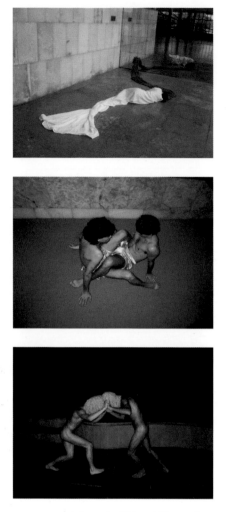

Dopada (Doped Woman)
Laura Lima, 1997

Quadris (Hips)
Laura Lima, 1996–97

Marra (Fighting)
Laura Lima, 1996–97

A term coined by Brazilian visual artist Tunga, and derived from Hélio Oiticica's practices with dance and performance, is *instauração*. It is often used to express the in-between of installation and performance in Brazilian contemporary art. It is exactly this 'in-between' that Laura Lima explores in her work, the crossroad of performance and sculpture. The artist never performs herself but directs the actions. During her survey exhibition at the Museu de Arte in Belo Horizonte in 2001, the artist presented probably the most extensive series of what could best be described as 'living sculptures', even though the artist herself rejects such a classification. Over the course of several weeks, audiences could see a whole array of sculptural performances taking place simultaneously in several spaces in the museum. What connects Lima's performances to sculpture is not only the constant presence of the pieces in the exhibition, which overcomes the usually inscribed temporality of performance, but also the highly artificial and often motionless, mechanical set-up. In her work, for example, we see a female performer lying silent and still on the floor, dressed in a maggot-like outfit, sleeping in the exhibition space for the whole duration of the show. Other pieces involve an almost psychotic form of repetition, such as two people who crawl on the floor over and over again, or others who push each other through the space with their heads joined by a specially designed hood covering their faces. Costumes are very important to Lima and an essential part of all her works. They can be understood as tools for the extension and transformation of the human body and are largely responsible for the creation of her unique hybrids. The costumes become the means to link the notion of motionless sculpture to the liveliness of the performers.

The wall of a gallery pulled out, inclined sixty degrees
from the ground and sustained by five people
Santiago Sierra, 2000

Mexico-based artist Santiago Sierra is best known for his highly controversial pieces that focus on the difficulties of capitalist economics and its social dynamics. Sierra has often been accused of exploiting the protagonists of his pieces when he asks them to perform often rather dangerous or humiliating tasks for very low wages. For his piece *Remunerated for a Period of 360 Consecutive Hours* (2000) at the P.S. 1 Center for Contemporary Art in New York, he asked someone to live behind a wall in the exhibition space for 15 days, 24 hours a day. An even more degrading piece was *160 cm line tattooed on four people*, which he made in 2000 for an exhibition in Spain. Four drug-addicted prostitutes were hired to get a simple line tattooed on their backs for the price of one shot of heroin. As much as Sierra's work is understood as an exploitative and cynical gesture, it is in fact a highly critical reaction to the hard realities of the capitalist system, particularly in Latin America where money can apparently buy anything. *The wall of a gallery pulled out, inclined sixty degrees from the ground and sustained by five people* was presented in 2000 in a gallery in Mexico City. A wall was taken out of its place and, over five days, four workers held it up for five hours, at exactly 60° from the ground, while a fifth worker made sure that the inclination was correct. Each of the workers received around US$65.

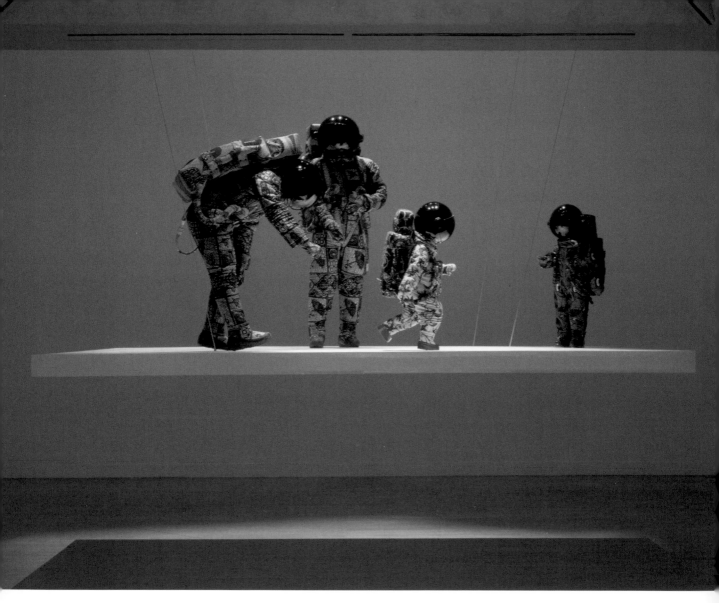

Vacation
Yinka Shonibare, 2000

It is his transcultural background that essentially informs the work of Yinka Shonibare. Born to Nigerian parents in London, Shonibare grew up in Lagos and returned to London in the late 1980s where he studied at Goldsmiths' College, University of London. His poetic installations and objects link to issues of (African) identity and question the concept of cultural authenticity. The artist creates a web of historical references when he utilizes, with the Western gesture of the readymade, popular African fabrics to question the stereotypical representation of African art and culture. The cloth, with its colourful decoration fabricated by applying a particular wax printing process, originated in Indonesia but was exported to Africa in the nineteenth century through colonial trade via the Netherlands and England, and ultimately became the signifier of post-colonial identity. In many of his recent works, Shonibare has set up scenarios based on portraits and genre paintings from the Victorian era but with the protagonists dressed in African garments. *Vacation* connects to ideas of colonial exploration, on-going migration and cultural exchange. It depicts a family dressed as astronauts, exploring the unknown territories of a newly conquered land, and it relates to the fact that the economies of many once-colonized countries still rely heavily on the tourism industry and are consequently, in various ways, still dependent on their former colonizers.

Chinese artist Zhang Huan has made the human body the central medium for his artistic undertakings, which often deal critically with the political and social situation in his home country. *To Raise the Water Level in a Fishpond*, executed in 1997, was a response to the incredible rural exodus that China experienced in the 1990s, and its consequences. Huan comments on the flood of farmers and workers from the countryside to the large, overcrowded, urban areas, a move that seems to promise prosperity but actually offers no solutions. For this highly symbolic work, the artist asked a group of itinerant workers to stand silently inside a fishpond on the outskirts of Beijing in order to raise the pond's water level.

'I invited about forty participants, recent migrants to the city who had come to work in Beijing from other parts of China. They were construction workers, fishermen and labourers, all from the bottom of society. They stood around in the pond and then I walked in it. At first, they stood in a line in the middle to separate the pond into two parts. Then they all walked freely, until the point of the performance arrived, which was to raise the water level. Then they stood still. In the Chinese tradition, fish is the symbol of sexuality while water is the source of life. This work expresses, in fact, one kind of understanding and explanation of water. That the water in the pond was raised one metre higher is an action of no avail.'

Zhang Huan

opposite and above

To Raise the Water Level in a Fishpond

Zhang Huan, 1997

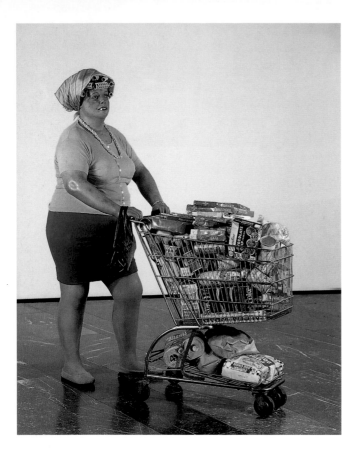

After a breakthrough one-man exhibition at the Whitney Museum of American Art in 1978, Duane Hanson became one of the most prominent sculptors of his generation. Standing in front of one of his hyper-realistic sculptures, we see ordinary American people and families come to life and perform their daily routines right in front of us. Ugly, overweight, dirty, unattractive people who might have just stepped out of their trailer are the artist's main protagonists. He depicted the masses – ordinary lower-middle-class America – and he did it with a great sense of melancholic humour, conscious of the amusing and yet often tragic aspect of his 'cast'. It has often been presumed that Hanson created his figures as doubles of real people, but this is not so. 'I'm not duplicating life,' he said. 'I'm making a statement about human values.'

'I'm mostly interested in the human form as subject matter and means of expression for my sculpture. What can generate more interest, fascination, beauty, ugliness, joy, shock or contempt than a human being. Most of my time involves concentrating on the sculpting aspect. Casting, repairing, assembling, painting, correcting it until it pleases me. That takes some doing as I'm rarely satisfied.'
Duane Hanson

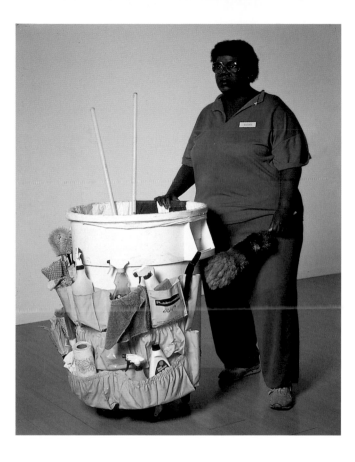

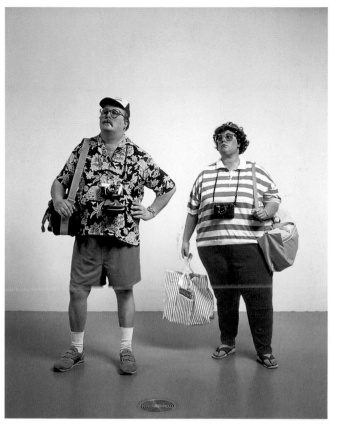

above left
Queenie II
Duane Hanson, 1988

above right
Tourists II
Duane Hanson, 1988

opposite
Supermarket Shopper
Duane Hanson, 1970s

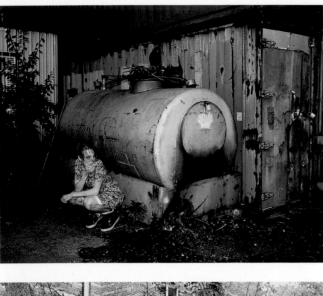

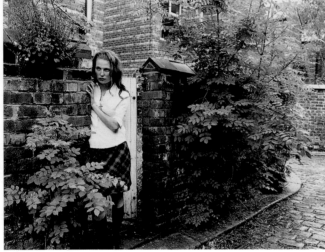

top
Untitled (woman smoking cigarette)
Aino Kannisto, 1999

Untitled (gate)
Aino Kannisto, 2001

The photographs by Finnish artist Aino Kannisto appear at first glance as if Cindy Sherman and Eskö Manikö have joined forces. They deal with issues of (female) identity as much as they depict particular cultural surroundings in a very individual way. As the artist has said, her images are fantasies representing an atmosphere or a mood through a fictional cast of characters. She sees her characters as the tellers of tales, rather than the protagonists of the story she is unfolding.

'Fantasy is a means to speak about emotions. I am influenced by the surrounding world, literature, cinema and photographs as well as by images more difficult to locate, such as memories, daydreams and nightmares. The individual pictures do not have names, as I do not want to define my pictures by naming. The physical side of the work, my own bodily presence in the pictures, and a careful building of the scenery before the moment of exposure have always fascinated me. Making pictures is a way to give meaning to life by sharing some part of the world which otherwise remains private.'
Aino Kannisto

PROVOKING THE EVERYDAY

For some artists, the city is one large and open studio, in which the materials and ideas for art can be found everywhere. They not only gather inspiration from the flow of urban life but also present their work in the public space of the street, disturbing the daily routines of all those who encounter it. Their interventions may be subtle and barely noticeable, or they may be direct and confrontational. But whatever form they take, their provocations question the norms and conventions of the city and propose alternative visions.

'My scenarios speak of trying to fit into standards and frameworks that are devised by others, situations devised for exclusions, set-ups for failure. I use humour and play to destabilize the unseemly, expressing the desire to analyze, change, fictionalize, creating alternative solutions for situations that are totally dominated by politics and market strategies.'

Robin Rhode

The South African artist Robin Rhode has created a unique way of combining elements of street culture with performance, drawing and photography. What he does is in fact rather simple, since most of the time he draws an object in chalk on a wall or a pavement and begins to interact with it. It is this straightforwardness of the concept, as well as the execution, that makes Rhode's work so attractive. One of his most stunning works to date is *Basketball* (2000), for which he drew a basketball net and a pole attaching it to the street. He positioned a camera on top of a house in such a way that it would shoot the street from above and the net would be seen from the side, giving the viewer the impression of looking straight at it. The artist then posed for several shots, pretending to fly through the air and do a heavy slam-dunk. The result is a sequence of images in which we see Rhode performing in a very acrobatic and spectacular way, as if he were a highly skilled basketball player. Other pieces include *Car Theft* (1999–2003), which involved an attempt to steal a car drawn onto a gallery wall, performed in front of a live audience, and *Untitled/Chase* (2003), for which Rhode mimicked an athlete high-jumping, with a high-jump bar drawn onto a wall approximately three metres (10 ft) high and ten metres (33 ft) long. Naturally the artist collided with the wall every time he tried to make the jump. The drawing was thereby made also by his footmarks on the wall. *Coat Hanger* is another set-up for photography to document a performance. It is a sequence of images Rhode took of a sketched coat hanger. People tried to hang their coats on it, only to find them on the floor a moment later.

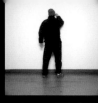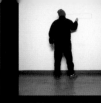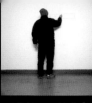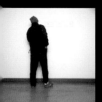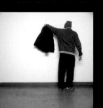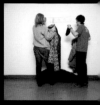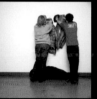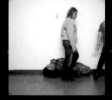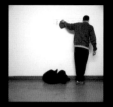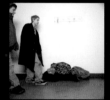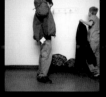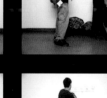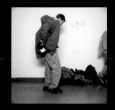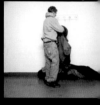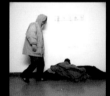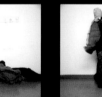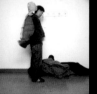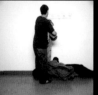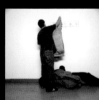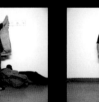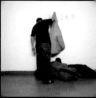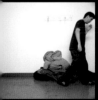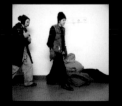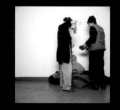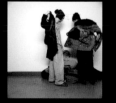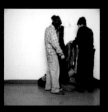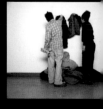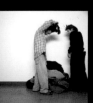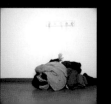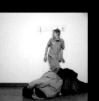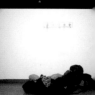

Roberto Cuoghi
2000

Although only a young man, the Italian artist Roberto Cuoghi appears to be in his late 50s, or even early 60s. Some five years ago he began to impersonate his father, imitating his gestures and his manners of speech. He learnt to simulate his father's appearance, his grey beard, his powerful physique (Cuoghi has gained thirty pounds in weight over the last few years), he smokes the same cigarettes, and wears clothing and accessories typical of his subject. The artist is thus skipping thirty years of his life, rejecting his youth and, in so doing, reflecting critically on one of Western society's most taboo subjects – age and, ultimately, death. The artist proposes a body and identity without age, a corporal existence beyond death. He transforms himself, his body and identity, into an older man, in contrast to what we see on television every day – the usage of the body as a tool to demonstrate eternal youth. But the artist has not found a way of presenting himself/his work to accord with the needs of cultural institutions such as galleries or museums. He is not a living sculpture, nor is his piece a solo performance in a theatre; none of the photographs or the videos made documenting his transformation are supposed to work as a piece of art. Although his critique is very serious, it also contains a lot of humour – necessary so that the piece is not just a cynical platitude about youth and age, but a well-balanced work of art.

Turning from poetry to visual art, and later from visual art to architecture, Vito Acconci belongs to a group of artists who in the early 1970s set out to transform the relationship between audience, artist and public space. Acconci first gained notice through a series of performances executed in the late 1960s and early '70s (he stopped doing performance in 1974). Best known is *Seedbed* (1972), for which he masturbated under a ramp constructed in a gallery space while fantasizing about the audience above him. *Following Piece* is one of his earliest performances, executed in 1969. The piece was carried out in various locations in Manhattan over a period of 23 days, and brought together the artist's interest in issues such as the dichotomy of the private and public, the relationship between the personal and the collective, and the space that controls those states.

'I follow a different person every day. I keep following until that person enters a private place (home, office, etc.) where I cannot get in.'
Vito Acconci

Re-enactment
Francis Alÿs, 2001

For over ten years Francis Alÿs has wandered around the streets of Mexico City and other places, directly connecting the complexity of everyday life, which he observes and occasionally manipulates, with the practice of art-making. Even though he uses a large variety of media, such as film, photography, video, painting and performance, the street and his walks are generally the forum for his artistic endeavours. The artist wanders between the seemingly trivial and the apparently important when he turns the street and its motifs into spaces for art and lets the audience wander through them. One of his earliest pieces is *The Collector* (1991–92), in which he walked through Mexico City's historical downtown district, pulling a magnetic toy dog behind him and with it collecting all the rubbish that was left on the street. Two years later he did a similar walk in Havana, this time with magnetic shoes. For *The Leak* (1995) Alÿs pierced a small hole in a can of paint and walked through the city till the paint was gone, leaving a thin blue line on the pavement, almost like a painted map documenting his stroll. Another poetic and metaphorical piece is *Paradox of Praxis* (1997–98), in which Alÿs pushed a large block of ice through the streets of Mexico City till it melted away. The artist has said of this work, 'Sometimes making something leads to nothing.' *Re-enactment* is one of his most provocative works. Documented on film, the piece shows the artist and the reactions of the people who encounter him while he is on another walk through the streets, this time holding a gun in his hand. The instruction for the piece says, 'Walk for as long as you can holding a 9mm Beretta in your right hand.'

Safety Pills
Minerva Cuevas, 2000

Most of Minerva Cuevas's projects stand in relation to to an organization she founded in 1998 called 'Mejor Vida Corporation' (Better Living Corporation). The organization is a one-woman, not-for-profit enterprise aimed at enhancing the quality of life of the citizens of the world. Among the corporation's projects are *MVC Student ID Cards* (1999) and *Safety Pills* (2000). *MVC Student ID Cards* are modelled on fake or homemade student ID cards and allow people to benefit from being able to travel or go to the cinema by simply paying the student fare. In another piece, *Safety Pills*, Cuevas distributed to passengers on the New York subway little bags containing caffeine pills in order to keep them alert and awake in case of robbery. Since a lot of people get robbed on the trains while taking a nap after a hard day's work, the project was in fact an official Metropolitan Transit Authority campaign, and included posters and flyers explaining the risks of falling asleep on the subway. Cuevas's works position themselves somewhere between Situationist interference into our daily routine and art works that provide various forms of services, from massages to conversations, from food to social interventions. Her work could be described as being part of an artistic practice that focuses on inter-human relationships, diverse forms of exchange, and links between the work of art and the social sphere in which it is produced, perceived and exhibited.

Adrian Piper's performances from her *Catalysis* series (1970–71) are among the classics with regard to artistic interventions into daily life. Piper's provocations and direct confrontations with the public took place in museums, department stores, buses and other public arenas. The series is based on a number of disruptive activities, predicated on the presence of the artist and designed to challenge behavioural norms within society as people are confronted with various forms of discrepancy. Piper understood herself to be a 'catalytic agent' within the public sphere, causing change but not changing herself. She would get onto a full subway car during rush hour wearing dirty, bad-smelling clothes, or walk on the street or sit on the bus with a towel stuffed into her mouth, or go into Macy's department store wearing clothes painted white while carrying a sign saying 'Wet Paint'.

above and left
Catalysis III
Adrian Piper, 1970

far left and centre left
Catalysis IV
Adrian Piper, 1970

'It begins between you and me, right here and now, in the indexical present.'
Adrian Piper

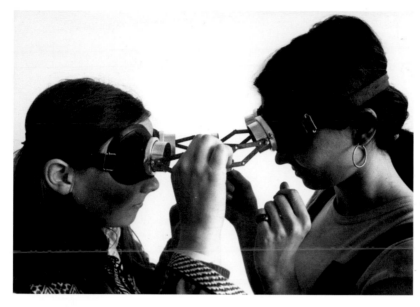

Lygia Clark is probably one of the most influential artists to have emerged from the so-called Neoconcrete movement in Brazil during the 1950s. Crucial to the understanding of her work is the connection she made between artistic and therapeutic practice. During the 1960s she began to create her *Objetos Sensoriais*, relational objects that the audience has to experience in an immediate way – both physically and psychologically – and which Clark has described as 'living organisms'. In her series *Arquiteturas Biológicas* (Biological Architectures) she began to explore the idea of the body as a living construct of biological and cellular architecture, and she related this idea to her therapeutic concepts, which set out to liberate repressed instincts and experiences. During the time of the Brazilian military regime in the 1970s Clark left for Paris, where she worked increasingly in collaboration with others and formed her ideas of the *Cuerpo Colectivo* (Collective Body), a collective therapeutic experience through artistic means. Clark escaped an art practice that could be related to the contexts of museums, commercial galleries or art criticism. Her work was no longer about individual notions of creation and fetishized objects but rather the transformation of experiences, capturing one of the most crucial aspects of Brazilian culture – the connection between the mind and the body, between rational reflection and pure intuition.

top
Dialogue Of Goggles
Lygia Clark, 1968

above left
The I And The You
Lygia Clark, 1967

above right
Collective Head
Lygia Clark, 1975

Film
Pawel Althamer, 2000

The Polish artist Pawel Althamer is probably best known for his subtle works dealing with issues surrounding an often personal area between art and everyday life, one that rejects common forms of artistic representation. One of his most famous pieces is *Film*, his contribution to the 'Manifesta 3' exhibition which took place in Ljubljana in 2000. For his contribution Althamer staged a seemingly everyday scenario in a busy square in the city – a scenario that visitors would in fact hardly even notice – and he later developed it into a film. On the square one encountered a homeless person, an old man sitting on a bench, a street musician (who was in fact contributing the film score), two teenage girls smoking a joint, a skateboarder doing his tricks, a policeman, and a young couple kissing. After thirty minutes all the characters left the square. This scene, almost a form of unannounced street theatre, took place on the square every day of the exhibition and was only noticeable to visitors who were observing very carefully – and even they had to come back several times to see every element of the piece.

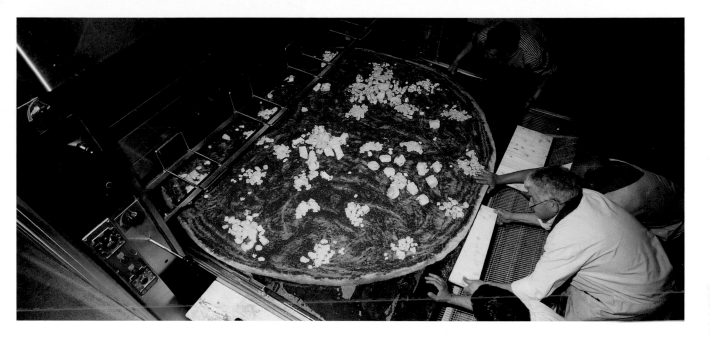

It is difficult to say what artistic principles the Italian artist Paola Pivi is following, as her work oscillates between sculpture, performance and installation. Most of her pieces present a challenge to the possibility of art production because they require an enormous amount of time, labour and money in order to be realized. One of her best-known pieces was created for the 48th Venice Biennale in 1999. With the help of a dozen technicians and a particular type of crane, Pivi positioned in the exhibition space an upside down jet-fighter plane, lying apparently helplessly on its back. Quantity matters to Pivi, as her work *Chinese* (1999) clearly demonstrates. For this the artist invited over one hundred members of a Chinese family, based in Italy, to come to her gallery in Milan and to stand in the exhibition space for the duration

of the opening, all dressed up in exactly the same clothing. For one of her earliest pieces, *Pizza*, Pivi asked a renowned pizza maker, who she contacted through the World Pizza Association in Milan, to make a pizza following her directions in terms of size and shape. A giant ball of dough was made that had to be kneaded for several hours, and a large pan was specially fabricated to hold the pizza. Pivi got in touch with a bakery that owned a large industrial bread oven and was able to produce her piece near the exhibition site. The final pizza was 232 cm (7ft 7in.) in diameter and was taken by truck straight from the oven to the exhibition space, covered with fresh tomatoes, basil and sizzling mozzarella cheese. The pizza remained there for little over a week before it began to go stale and had to be removed.

Pizza
Paola Pivi, 1998

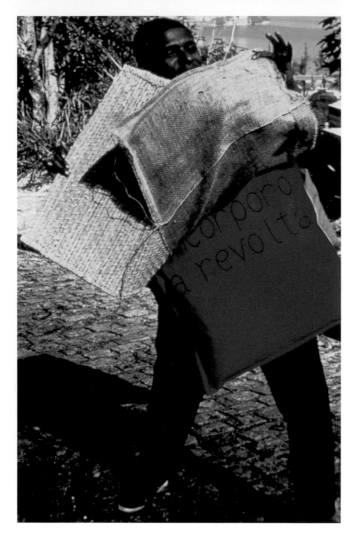

Parangolé
Hélio Oiticica, 1967

Originally part of the Neoconcrete movement in Brazil during the 1960s, Hélio Oiticica became increasingly interested in the relational and participatory possibilities of his art works, beginning with what he would call his 'trans-objects'. Oiticica's work was highly political and based on the assumption that cultural transformation and poetic practice were necessary for social change. His ideas are strongly connected to Oswald de Andrade's concept of *anthropophagia*, in which a culture appropriates and digests certain elements of another culture and connects them to cultural elements of its own. In Oiticica's case this clearly applied to the formation of a unique Brazilian cultural image in response to ideas of dominant American modernism. The artist increasingly began to take an interest in ordinary objects and common situations of daily life which he found on the streets and in the *favelas* of his hometown of Rio de Janeiro. Well known are his *parangolés*, which stem from his experiences as a samba dancer. These pieces of clothing, not unlike capes, represent a blank canvas, open to transformation. All the artist's *parangolés* had different colours and structures and were inspired by different subjects. When worn by a samba dancer, their silhouettes and shapes would constantly change, echoing the unstable constitution of cultural and ethnic identity, as well as of society in general.

Laranja
Ducha, 2000

The Brazilian artist Ducha is principally interested in provocation by using Situationist-like interventions into the routine of life in his hometown of Rio de Janeiro. For *Christ* (2001) he – illegally – removed the light illuminating Rio's famous Christ statue on the Corcovado and swapped it for a red light to comment on the bloodshed caused by the various battles between rival street gangs and the police. *Laranja* is a six-minute video filmed from the top of a high-rise building in downtown Rio looking onto one of the busiest street corners in the city, the intersection of Avenida Rio Branco and Rua Buenos Aires. In the video, while the traffic lights are green Ducha crosses the street carrying a paper bag full of oranges. When he reaches the middle of the intersection, he – apparently accidentally – drops the oranges. They roll in every direction and chaos breaks loose. Passers-by help Ducha to pick up the oranges while cars begin to drive on, creating confusion and drama in the already chaotic traffic of the city.

The Costa Rican artist Federico Herrero sees the streets of the world as one large and unrestricted studio space in which materials and ideas for art works can be found on every corner. Even though he would consider himself primarily a painter, Herrero has broken free from the limitations of canvas and classic studio practice. He sees the roads, squares, highways, parks and avenues of today's cities as reservoirs of paintings, which he simply has to uncover and expose to the public – commercial wall art, traffic signs, billboards, graffiti, coloured doors, cars and buses, or simply the walls of old houses. Herrero is well known for his large murals and wall paintings, such as *Landscape* made for the 49th Venice Biennale in 2001. These reflect on painting as a provisional and transitory medium within a constantly changing world. *Carefully Repainted Yellow Areas* is based on 'paintings' found in the urban environment and was the starting-point for a series of works executed inside gallery spaces and various places throughout the city. The yellow painted lines found on curbs and streets in his hometown of San José in fact indicate No Parking zones. While the artist highlights existing lines by repainting them, using the streets as his canvas, he also introduces unauthorized lines into the public sphere to trigger a diverse set of urban disturbances which point up his country's often contradictory (traffic) regulations. In addition, Herrero has started to integrate yellow areas into museum pieces, which reflect his distinctive relationship to the medium of painting along with the hierarchies, rules and power structures he encounters within art institutions.

Carefully Repainted Yellow Areas
Federico Herrero, 2002

The Danish artist Olafur Eliasson bridges the gap between visual art and natural science by reconstructing physical phenomena as known from nature within the discipline of art. The impulse of his work springs from his interest in conflicts between nature and culture. He connects these spheres by transporting the experience of nature's rules and its energy into the context of art. The starting-point for all his works is science. It is his intense study of the results of scientific research that he channels into aesthetic experiences of poetic simplicity. But Eliasson's objectives reach even further, as he starts to deconstruct our models of perception of our surrounding environment in order to question our perception of reality. Eliasson's work is remarkably diverse and includes large-scale installations and objects such as *Your Strange Certainty Still Kept* (1996), a model of a thunderstorm inside an exhibition space, as well as quite simple pieces made of ephemeral and provisional materials such as ice, steam and light. In *Untitled (green river project)* the artist turned the water of the Los Angeles River neon-green by pouring into it a pigment used in maritime biological research to study the movement of water. Eliasson did not notify the local authorities, but carefully poured the fine grains into the water from a bridge.

Untitled (green river project)
Olafur Eliasson, 1998

L'Aligneur de Pigeons
Boris Achour, 1996

The French artist Boris Achour is particularly interested in concepts of order and disorder, regularity and irregularity, especially in the context of the organization of urban environments. His series of works *Actions-peu* (1995–97), documented on video, shows numerous interventions into man-made constructs within the public sphere of his hometown, Paris. In one of these works Achour attached a line of found plastic bags to the top of an underground air-shaft and allowed the bags to flap wildly through the rising current of air. Other pieces are less spectacular, such as the artist disarranging the sequence of a row of flowerpots in front of an elegant building. Achour's work, however, goes further than creating these extremely minimal interventions within the public environment. He is attracted to the idea of a provisional form of sculpture. Most of the pieces he does originate in discoveries he makes while walking in the streets, observing the city. His works are found situations, which he merely emphasizes through a brief and minor act. In his piece *L'Aligneur de Pigeons* the artist observed a flock of pigeons on a pavement in Paris. In their search for food they were picking at the ground in an apparently disorderly manner. In response to this, Achour built a narrow metal trough, which he placed on the ground in the garden behind the Palais Royal, with its tidily trimmed trees and neatly arranged paths. He filled the trough with corn to attract the pigeons. After a while the birds came, lined up along the trough and began to eat from it, creating a peculiar form of momentary sculpture.

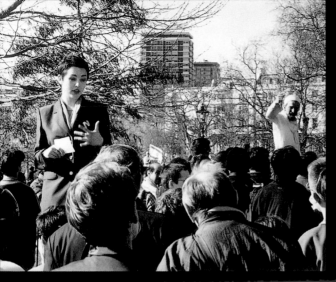

Everything You've Heard is Wrong
Carey Young, 1999

Everything You've Heard is Wrong is a six-minute video of a performance presented by the British artist Carey Young at the legendary Speakers' Corner in central London, the first place in the world where the right to free speech was guaranteed in law. One Sunday afternoon, amid many other speakers and dressed in an elegant business suit, the artist stood up and delivered a speech on how to become a successful public speaker. Based on the instructions contained within a generic corporate communication-skills manual, her speech outlined the basic abilities required to deliver a successful speech. By examining changes of public space, as well as the condition of public speech in contemporary society, Young critically investigated how self-presentation and the need for a good performance in today's world have become central conditions of our lives. In addition, she presents a model of communicating rarely experienced in today's information age, in which direct communication with others is often obstructed through the mediation of machines.

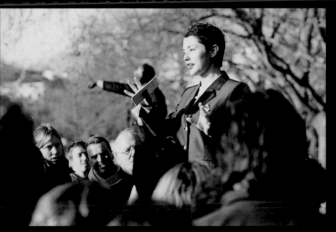

Beginning of video:
'Hello, my name is Carey Young and I'd like to teach you presentation skills.'

End of video:
'Once you have these skills you'll be a good public speaker. So you can see how easy it actually is. Now, does anyone have any questions?'

Turkish Jokes
Jens Haaning, 1994

'Life is the farce which
everyone has to perform.'
Arthur Rimbaud

In many of his works, the Danish artist Jens Haaning explores the circumstances and difficulties of being different. He deals with immigrants, the illiterate and the mentally ill, not out of pity for their disadvantages but to show that these people have a regular life that rarely corresponds with the public image ascribed to them. Haaning wants his audience to overcome their scepticism, or their ignorance about 'the other', in order to create acceptance for their way of life. In his piece, *Turkish Jokes*, Haaning installed a loudspeaker in a central Oslo square and played pre-recorded jokes in Turkish and with specific Turkish content. The people who understood, primarily the city's Turkish immigrants, laughed out loud, while the 'regular' Norwegian citizens, who did not understand a word, had no idea why the Turks listening to the speakers were having such a good time.

TRACES / OBLIVION

Every work of art is the trace of an action, a record of the maker's hand. For some artists, performing that action is as much a part of the art work as the finished object. But traces suggest absence, for they point to something that has once been – an action or a body – but is no longer present. We can find ourselves asking, 'Where is the art work? Where is the artist?'

ITHB: Guerilla Lounging no. 4
Delia Brown, 2002

The work of the American artist Delia Brown is the result of a rather unusual combination of painting and performance. The underlying principle is the artist's belief that all art, no matter how critical and progressive it may be, will sooner or later be appropriated by the mainstream. Consequently, she has chosen as her primary medium the one – painting – that is considered the most ordinary, the most common and the most traditional in order to enter the art world by stealth. Articulating a critique on contemporary society and art's public function, Brown's paintings investigate issues such as female identity and consumer culture in Western society, often in an amusing way. The pieces are in fact records of what Brown calls 'art acts', or interventions. In her *Guerilla Lounging* series, for instance, the artist and her friends sneak into Beverly Hills mansions and have lavish parties inside the houses or in the gardens. The flamboyant paintings Brown makes of the occasions ultimately become a mixture of documentation, traces of performances, and illustrative art works ready to be consumed by the market.

top
**GTFO: Guerilla
Lounging no. 4**
Delia Brown, 2002

**ITHB: Guerilla
Lounging no. 2**
Delia Brown, 2002

Paisagem do Leblon no Carnaval (Landscape of Leblon at Carnival) was commissioned in 2001 from Laura Belém for a private art collection organized around the theme of landscape. Belém's idea was to make a work that would deal with site-specificity and that would involve performance in the making process. For a week she walked along the beach at Leblon collecting objects and rubbish left by beach-goers, selecting items that she considered representative of the particular place and time of year – the carnival, the beach, Rio de Janeiro, Leblon. Her choices were also based on colour, shape and content (function, meaning and the possible story behind the object). She found, for instance, a lot of pink feathers, which were almost certainly part of a carnival costume. What happened to the rest of the costume? What happened to the person who was wearing it? Under what circumstances were the feathers left in the sand? Belém placed all the objects together on a table topped with glass and the work was positioned to face the beach.

below and opposite
Landscape of Leblon at Carnival
Laura Belém, 2002

'For me, the work is about the contemporary landscape of big Third World cities, but it is also quite playful. It shows rubbish, but it does it wanting to leave a space for many other connections as well, such as a look at simple things that surround us, or a look at the life that happens in the streets; or it may trigger in the viewer a whole narrative about each of those objects left behind that were collected and that arc now lying somewhere else and have become an art work. I'm very interested in stories. And that's also why I chose to walk for one week, and not just for one day.'

Laura Belém

A unique way of dealing with the question of the performative has been formulated by the German artist Andreas Slominski, who works on the relationships that tie actions to objects and to the complex set of legends and tales that comprise our oral history. For several years Slominski has been putting on performances in which an absurd story functions as the point of origin – stealing an air pump from a bicycle, for instance, by sawing the bit of the frame that holds the pump, instead of just taking it off the bike. These performances – or 'actions', as the artists calls them – are documented in films or photographs, and are occasionally shown in an exhibition situation or in an accompanying publication. Usually an object, such as the air pump, remains as a trace of the performance and later gets exhibited. The performance seems inscribed in the art object, but what makes it distinct is that the absurdity of Slominski's actions often triggers a unique way of story-telling: many of his performances have become legendary and have been told, almost like fairy tales, by visitors to exhibitions and by critics and fellow artists.

'I have always thought the actions of men the best interpreters of their thoughts.'
John Locke

Stolen Bicycle Pump
Andreas Slominski, 1998

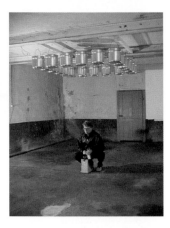
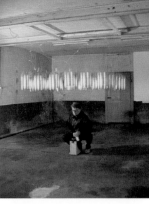
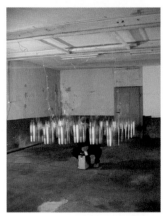
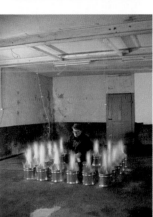
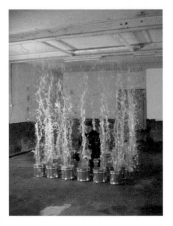
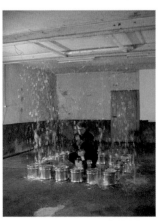

Roman Signer links commonplace items to art actions in order to create what he calls 'action sculptures'. His work is based on carefully controlled alterations of ordinary objects, mostly through explosives or fireworks, or through other physical modifications. Signer is concerned with the process of movement and material transformation, as when he blows up items such as balloons, buckets and bicycles. His so-called 'sculptural moments' are carefully arranged and meticulously planned processes that create a transitory but highly spectacular event. If executed in a gallery or museum, the traces are left as evidence of the performance and they become what one could describe as an accidental sculpture. Other pieces take place outdoors and are documented on video or in photographic sequences that are later shown in exhibition spaces or publications. The relationship of cause and effect in Signer's pieces can be compared to scientific investigations but his performances are set up to create an enchanting mess, since the outcome of the experiments is usually unpredictable. In *Bucket*, the artist crouches beneath rows of buckets arranged in a square. The buckets are filled with water and are attached to the ceiling. When Signer pushes a trigger, the buckets all fall to the ground at the same time, maintaining the shape of the square. When they hit the ground, they release the water like fountains, in powerful vertical trajectories.

Bucket
Roman Signer, 2002

List of Names
Douglas Gordon, 1990

The Scottish artist Douglas Gordon is best known for his work with, and about, the medium of film and cinema. Since the beginning of his career, however, he has embraced a much wider remit. His *List of Names* is a diary of personal contacts, containing the names of all the people he has met in recent years and had either private or professional contact with. Once confronted with the piece it is almost impossible to resist the temptation of reading all the names and searching for one's own, and the viewer inevitably begins to consider who they would have on their own personal list. The sheer number of names painted on the gallery walls makes the piece extremely powerful, as one starts to realize that behind each name is another human being, another life, another individual carrying another personal history with maybe a similar number of relationships. Gordon's piece currently contains over three thousand names and is still growing.

Cho Oyu
Hamish Fulton, 2002

In 1969 Hamish Fulton began his series of works
documenting the journeys and walks he had taken, by
means of words and figures setting out the exact date,
time and location of each excursion. While these walks
have remained the foundation of Fulton's works, his art
has taken different forms over the years, and includes
photographs or drawings that relate to the location
and/or duration of the walk, such as the photograph
of Cho Oyu, taken in 2002 in the Himalayas.

'Road walking leaves no footprints.'

Hamish Fulton

On 9 July 1975 the Dutch artist Bas Jan Ader took off
from the east coast of the United States in a little sailboat
headed for Europe across the Atlantic Ocean, as the last
part of his work *In Search of the Miraculous* (1975–76).
Three weeks into the journey, radio contact with him was
suddenly cut off. His brother reported: 'On about April
10, 1976, a Spanish fishing trawler found his boat about
150 nautical miles west-south-west of Ireland. It was
two-thirds capsized, with the bow pointing down. Judging
by the degree of fouling, it looked as though the boat had
been drifting around that position for about six months.'

In Search of the Miraculous
Bas Jan Ader, 1975

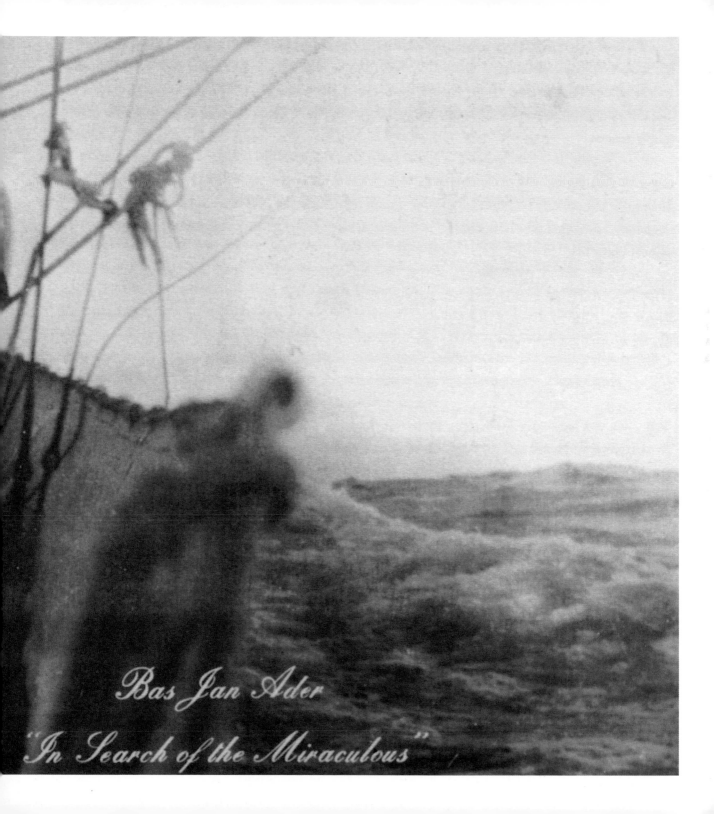

Bas Jan Ader
"In Search of the Miraculous"

Yard
Allan Kaprow, 1961

Allan Kaprow is widely acknowledged as the father of the Happening, and his influence on the development of visual art during the course of the twentieth century cannot be underestimated. Kaprow, who originally trained as a painter and was strongly influenced by action painting, and particularly the work of Jackson Pollock, radically questioned the medium of painting in the late 1950s and directed it into an assemblage of installation, performance and interactive environment. His now-legendary *18 Happenings in 6 Parts*, presented in 1959 at the Reuben Gallery in New York, was based on a form of script that Kaprow had prepared which invited the audience to take part in the action. It was, however, the influence of composer John Cage that ultimately empowered Kaprow to abandon the medium of painting for good. Witnessing Cage's experiments, Kaprow was inspired to integrate various simultaneous events and media such as light, sound and painted environments into his works. He did this in a completely non-linear manner, similar to the way in which everyday experiences unfold in a modern metropolis. Kaprow has maintained his experimental spirit throughout his career, making experience itself the medium of his practice. Constantly rejecting the idea of making art that is capable of yielding to any conventional interpretations, he has aimed towards moving art closer and closer to common experiences of daily life, thus provoking what he would later describe as the 'blurring' of art and life. Just as provisional as life, the Happening would come and go, appear and disappear, or as Kaprow wrote in 1966, 'The Happening? It was somewhere, some time ago.'

'To the extent that a Happening is not a commodity but a brief event, from the standpoint of any publicity it may receive, it may become a state of mind. Who will have been there at that event? It may become like the sea monsters of the past or the flying saucers of yesterday.'

Allan Kaprow

Yard

Allan Kap

The work of the Brazilian artist Rivane Neuenschwander aims, in opposition to an overly civilized and seemingly ordered world, to disclose a poetic existence within the most ordinary of objects. She makes diverse use of domestic materials in her quest for a particular form of being: indeed, when she uses materials that are mostly invisible to us in daily life, her work appears to be on the verge of disappearing. Substances and materials such as dust, soap, talcum powder, spices, insects, snail tracks and fruit are all part of Neuenschwander's artistic pieces, embodying the brief, ephemeral quality of our existence.

'Maybe it is unavoidable to think about notions of temporality when you live in Brazil. Reality here presents itself in such a fragmented way and we cannot rely upon certainties, whether they are economical, ethical or something else. Living in Brazil, with its difficult and unstable political, social and economic situation, can create the feeling of a transitory existence and a larger awareness of the moment. We have been kept considerably away from plans and dreams; the next second is always something unforeseeable for us, the imminence of loss is very close and it is a constant threat. The *Inventário das pequenas mortes (sopro)* (Inventory of Small Deaths [Blow], 2000) is about the passage from one state to another, real or imaginary, we do not notice them as a constant exercise of loss. They can be very simple changes, as when we open our mouths to speak, when we wake up and do not remember our dreams anymore, when we say goodbye to people and places, when we make love. For this project, we have filmed and edited a giant soap bubble that moves through a landscape for five minutes and never bursts. We know a soap bubble should disappear in a split second, because that is its nature. On the other hand, it keeps a blown breath inside, which comes from us, out of one's mouth: a mute speech. All that separates the breath inside from the world outside is a very thin skin of soap. I am always trying to alter the nature of things and, as a consequence, their time of near-death or of over-life. Over-life is a state that outlives another, a stretch of life beyond a certain deadline. I try to exercise loss, but that does not necessarily mean that I am able to accept it.'

Rivane Neuenschwander

opposite and above

Inventory of Small Deaths (Blow)

Rivane Neuenschwander, 2000

'Usually I talk with other people, and they will write, so the notes are always written by other people. For most people, this is a new experience. Some find it mildly disconcerting, others find it engaging. Ultimately it is less about writing than it is about finding another way of talking, finding another way of shaping the spoken word into a material form. Sometimes the words stay on the lines of the paper, sometimes they run off the lines. Sometimes there are gaps, sometimes there are drawings, and sometimes there is the unmistakable oddness of ordinariness, as when someone might write "Bye" or "Sorry, I have to go and pee". You would think that it is the weird elaborated stuff that is interesting, but to me it is the banal stuff that we say every day, but never write. This to me makes the difference between writing and talking.'

Joseph Grigely

The American artist Joseph Grigely, deaf since early childhood, has made communication and conversation the principal core of his artistic investigations.
His installations often consist of notes that he has collected. These contain conversations on intellectual topics, as well as mundane private issues and total nonsense. Written by friends and people Grigely has met over the years, the notes draw a portrait of his life, our time and those individuals the artist has encountered.

opposite
Nicole M.
Joseph Grigely, 1996

above
Jenny S.
Joseph Grigely, 1996

left
Conversations in Rotterdam
Joseph Grigely, 1996

At first glance most of the work of San Francisco-based Trisha Donnelly appears to be rather enigmatic. Many of her pieces do not seem to fit into any known category of art, and thus leave viewers confused and bewildered. Surprisingly, however, her works often employ quite traditional media, such as photography, audio, video and performance. The viewer feels able to connect with the pieces, only to be knocked back a minute later when their meaning does not reveal itself in any way. Donnelly keeps her viewers perpetually off-balance, as she constantly plays with the conventions of art and art-making. All of this happens, however, on a subjective and highly intuitive level, and is only distantly related to similar approaches as known from Conceptual art. For a performance at the Casey Kaplan Gallery in New York in 2002, the artist, dressed like a Napoleonic soldier, arrived in the exhibition space on a white horse in order to deliver the Emperor's surrender following the battle of Waterloo. The fact that Napoleon never actually surrendered plays as much a role in this fictive form of historical re-enactment as Donnelly's personal fascination for horses. The surreal performance lasted no longer than four minutes and, at the artist's request, was not documented in any way. All that is left is the memory of Donnelly's speech (left) and the cryptic surrender note she wrote (right).

'Be still and hear me. I am a courier. I am only a courier. But I come with news of destruction. I come to declare his end. If it need be termed surrender then let it be so. For he has surrendered in word not will. He has said, "My fall will be great but at least useful." The Emperor has fallen and he rests his weight upon your mind and mine. And with this I am electric. I am electric.'

Trisha Donnelly, as spoken in performance

Be still
and Hear me

I am the courier. I am just
the courier.

I come ~~to bring~~ news of disaster.
I come to declare his end.
If it need be termed surrender let
it be so. ~~For~~ he has surrendered
in word not will. He has
said "My fall will be great but
at the least, useful."

You know his charge as the
line between the future and the past.
We the separate will lose the beginning
that once was promised. He will
leave and become the nature of
all things. The long touch.
The emperor has fallen and rests
his weight upon your mind and mine,
the dark day has now come.
and with this I am electric
I am electric.

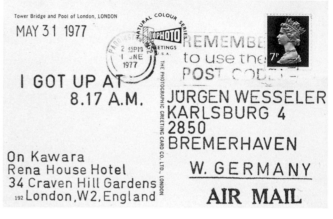

Tower Bridge and Pool of London, LONDON

MAY 31 1977

I GOT UP AT
8.17 A.M.

On Kawara
Rena House Hotel
34 Craven Hill Gardens
192 London, W2, England

REMEMBE
to use the
POST CODE

JÜRGEN WESSELER
KARLSBURG 4
2850
BREMERHAVEN

W. GERMANY

AIR MAIL

I Got up at (May 31, 1977)
On Kawara, 1977

On Kawara is well known for his on-going series of
Date Paintings. Started in 1966, these consist of dates
painted on canvas – the date being the date on which
the painting was made. Each work is archived in a small
grey cardboard box, generally together with newspaper
clippings from the same day. Another piece connecting
time, a generic system of documentation and the artist's
personal actions is *I Got Up At*, made between 1968
and 1979. Every morning, when the artist got up, he
would send a postcard to two of his friends to let them
know his whereabouts and the exact time he got up.
The time, date and the words 'I got up at' were stamped
on the postcard, together with the artist's temporary
address. On the front was usually the image of the place
in which he was then staying.

NARRATE / WITHHOLD

Modernism declared that narrative had no place in the visual arts. But every work of art tells a story, even if it's only the story of its own making. Each artist in this room explores the storytelling capacity of art. Some present complex and carefully planned storylines, performed by the artist, by others, by the viewer or by a combination of all three. Others offer cryptic fragments that encourage us to complete and enact the narrative in our own minds.

Since the early 1970s Belgrade-born artist Marina Abramović has been at the forefront of performance art and has defined, probably more than anyone else, the force of this particular medium. In *Balkan Baroque*, which she presented at the 1997 Venice Biennale, Abramović connected the tragic story of the civil war in her native Yugoslavia with her own personal history. Next to a three-channel video installation on which one could see her father, her mother and herself, the artist sat among thousands of bloody beef bones. She scrubbed the flesh off the bones for five days, six hours a day, while singing, almost hypnotically, songs she remembered from her childhood. Many aspects of Abramović's work come together in this visually stunning piece – the body-based works she produced at the beginning of her career, the endurance performances she did in the late 1970s with her partner Ulay, her work in theatre, and her interest in sculpture, installation, video and narrative, which forms her most recent body of work.

'*Balkan Baroque* is a work about wars and deep shame caused by the killing. It is not specifically located in the Balkans. It could be placed anytime anywhere.'

Marina Abramović

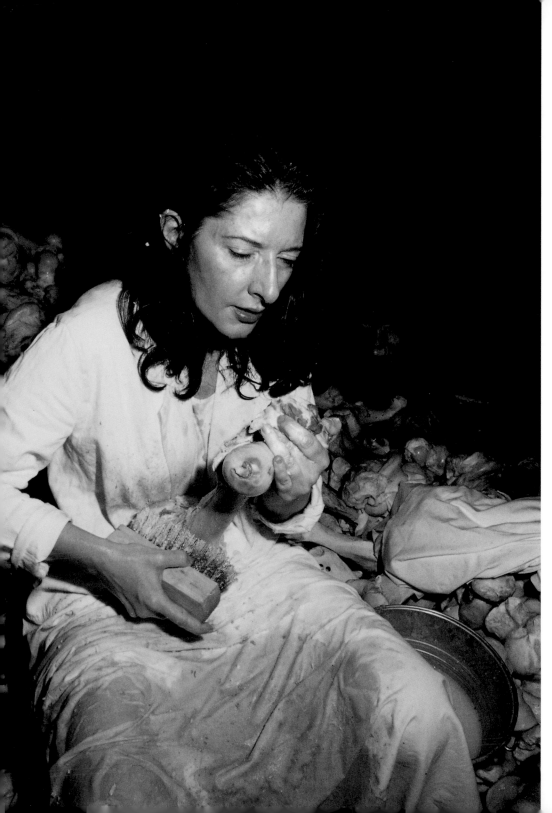

Balkan Baroque
Marina Abramović, 1997

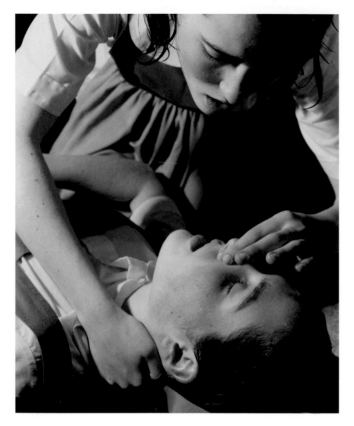

Untitled #2 (wonder)
Anna Gaskell, 1996

Although Anna Gaskell's work is mainly based on photography, it would not be accurate to call her a photographer – not only because her work includes film and drawing as well, but because her use of photography is of rather a conceptual nature.
The starting-points for most of her works are texts – fairy tales and stories such as *Frankenstein*, *Alice in Wonderland* and Henry James's *The Turn of The Screw*. Gaskell does not illustrate the stories but extracts the essence of them to create new stories only vaguely related to the original narrative. What is characteristic of many of Gaskell's pieces is the uneasiness we experience when looking at them. They are stunningly beautiful but repeatedly confront us with moments of fear, assault or death.

'My work moves around and through many different stories and characters, but at the heart of it all, it is about the suspension of disbelief, the possibility of the impossible, the absence of doubt, the completeness of faith.'
Anna Gaskell

Untitled #3 (wonder)
Anna Gaskell, 1996

Untitled #4 (wonder)
Anna Gaskell, 1996

Dictio Pii
Markus Schinwald, 2001

Everything in Markus Schinwald's film *Dictio Pii* feels like a transitory gesture somewhere between the past, the present and the future: nothing can be clearly pinpointed. The film – which Schinwald shot on 35mm film and later transferred onto DVD – is non-narrative: it has no beginning and no end, only moments of in-between. The different sections present various characters that move around in what looks like a hotel, the transitory nature of which holds particular interest for Schinwald. A voiceover commentates on the cast: 'Unfamiliarized with isolated activity. Traitors of privacy.' Also conveying the impression of transference are the long hallways and corridors of the building, and the way in which actors appear and disappear into elevators that come and go. Schinwald is clearly interested in the flexibility of identity, in the transformation of the body in a purely physical way, and in a definition of sexuality that is not prepared to settle for an easy corporeal human/human classification but goes beyond to look for an omnisexual and psychological state. In many of his works Schinwald constructs closed artificial worlds to address the underlying instability of our contemporary condition. He does this in a highly unusual manner and discloses that his take on reality is controlled by an obsessive curiosity about the relationship between mind, body and imaginable extensions.

How I Became a Ramblin' Man is the second film in a set of three that Canadian artist Rodney Graham refers to as 'short costume pictures'. Similar to *City Self/Country Self* (2000) and his famous *Vexation Island* (1997), *How I Became a Ramblin' Man* reflects the artist's interest in the genre film. It perfectly embodies most of the tropes that one identifies with the Western genre: the frontier scenario of the lone iconoclast wandering through a vast landscape which he takes possession of as he travels through it. If one looks at the three films, the broad similarity is that they all depict the artist caught between nature and culture: Graham plays either the urban sophisticate trapped in a pastoral setting, or the country hick antagonized by the city. The crisis of nature imparted by modernity is one of the main threads of narrative in all of the artist's work.

top
How I Became a Ramblin' Man
Rodney Graham, 1999

Vexation Island
Rodney Graham, 1997

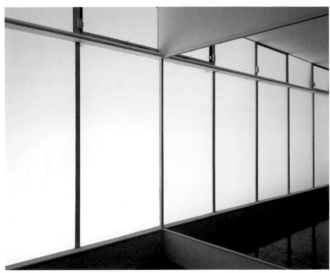

Untitled (Miller House)
Luisa Lambri, 2002

Italian artist Luisa Lambri's photographs are highly subjective traces of the artist's encounter with architectural spaces. Since the late 1990s, she has been travelling across the globe to photograph landmarks of modernist architecture. She has taken images of buildings by architects such as Mies van der Rohe, Oscar Niemeyer, Alvar Aalto, Richard Neutra, Philip Johnson, Le Corbusier, Giuseppe Terragni and many other renowned master builders. The artist uses these historically significant architectural structures to reveal her own sensitivity as a woman in a male-dominated world. The performative aspect of the work is expressed through the artist's appropriation of the buildings to form a very personal and fragmented narrative. Capturing her own individual relationship to the spaces on photographic film, she actively deconstructs the architecture by making the images become her own chronicle of feelings, emotions and desires.

Monday 16 February 1981. I go into Room 28 (painted wood, predominant colours green and pink). Just one unmade bed. I find, on the right along the wall, an impressive amount of luggage. Four 'Vuitton' suitcases piled up, three holdalls, a row of shoes; eight pairs for the woman (size 38) and five pairs for the man (size 42). I open the wardrobes. On the right, some men's clothing, including three new pairs of shoes in felt bags, one hat, two pairs of white underpants and one pair of trousers with wide suspenders. Everything is of good quality. I imagine people of a certain age, well-off. In the bathroom nothing of note except a pink flannelette nightdress. I perfume myself with their 'Chanel No. 5'. I furtively open one of the suitcases. I catch a glimpse of the magazine 'The Economist', some bananas in a plastic bag. The room done, I go out.

Hotel, Room No. 28, 1981
Sophie Calle, 1981

In 1981 the French artist Sophie Calle worked as a maid in a Venice hotel for a period of three weeks. She was assigned twelve rooms on the fourth floor. During the course of her cleaning duties she began to explore the belongings of the hotel guests. She kept a precise notebook of her experiences and impressions, as well as documenting the work with photographs of the rooms. The point of the exercise was to gather as much information as possible just by looking at the guests' personal effects, and to create an archaeology of the present.

above and opposite
The Lake
Peter Land, 1999

The Lake by Peter Land is the story of a hunter, played by the artist, on his way through an idyllic forest. To the sound of Beethoven's Symphony No. 6, the 'Pastoral', Land introduces us to a romantic location, a stereotypical idea of a peaceful setting in nature. With a rifle over his shoulder, the hunter gets into a boat and rows to the middle of a lake, only to shoot a large hole in the boat. The gunshot breaks the silence and the boat starts to sink while the hunter sits impassive and still. Finally he and the boat disappear under the water and the film ends. Among the works that Land has made over the years – telling, short but highly metaphorical stories of ludicrous situations – *The Lake* is probably the most complex. The narrative of other works is even more condensed, such as *The Ride* in which a person falling off his bicycle forms the whole of the action and story. The melancholy that Land's characters convey is as important as the artist's deadpan, slapstick humour and belief that our lives are full of constant failure.

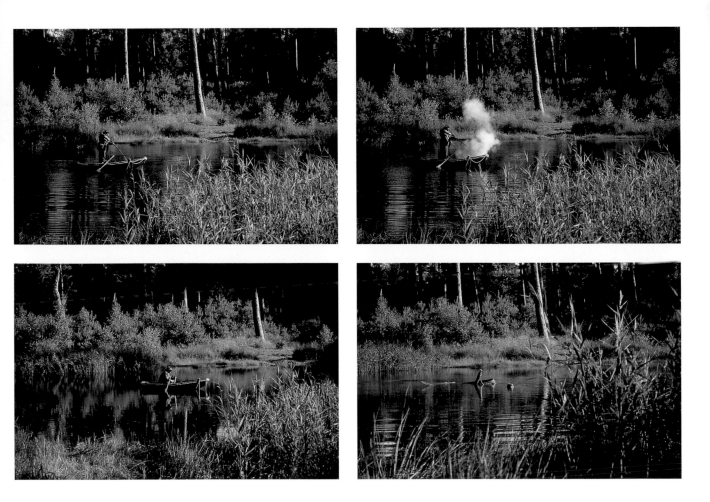

'You can compare [my work] to a drunk man who comes home and discovers that he has forgotten his front door key, so he crawls up to the fifth floor, smashes his balcony door, only to discover that he didn't forget his key after all!'

Peter Land

'The ancestor of every action is a thought.'

Ralph Waldo Emerson

The American artist Bruce Nauman is generally considered to be one of the most important artists of the second half of the twentieth century, working with a vast diversity of media, styles and concepts. The core of his work lies in his desire to challenge traditional notions surrounding his discipline, often the dematerialization of art objects or the opposite practice, making the immaterial material. His work with performance, which is closely related to film, has been crucial to generations of artists working within this medium up to the present day. One of his earliest pieces is *Fishing for Asian Carp* (1966), a perfect example of early Minimalist performance. Nauman went to a stream together with fellow artist William Allen in order to fish for a carp. The film was to last exactly as long as it took Allen to catch the first fish, a little under three minutes. In a similar vein is *Setting a Good Corner*, a 59-minute video showing the artist setting the corner of a fence on his property in New Mexico. As with *Fishing for Asian Carp*, this piece starts with an idea for an action – the 'setting of a good corner' – of which the execution ultimately determines the length of the film. In a clear, documentary style recorded with a static camera, the film shows all the actions that need to be performed in order to put up the corner of a fence – the digging of holes, the setting up of the poles, placing the wire, and so on. That Nauman seems rather an amateur at the business of fence-setting becomes clear at the end of the film when, instead of credits, the voices of his neighbours can be heard commenting on his method of putting up the fence.

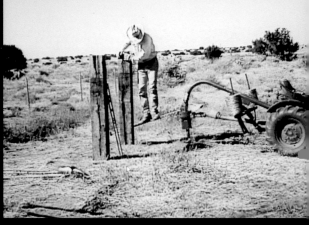

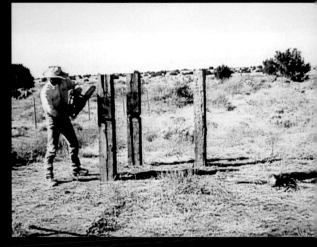
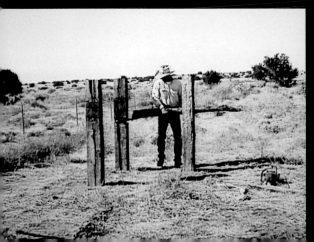
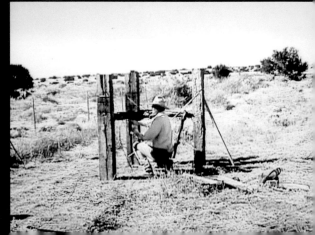

Have you ever had the urge to disappear? To escape from your own life, even for just a little while? Like walking out of one room and into a different one. I remember the first time I said it. We were driving to the mountains. Sometimes I just want to disappear I said. He freaked out. Afterwards I only thought it to myself.

Turn left onto Brick Lane and follow the sidewalk up. I'm behind someone else now. A new companion. They have a duffel coat, running shoes, red shopping bag. Looks like an artist. My shadow is on their back.

**The Missing Voice
(Case Study B)**
Janet Cardiff, 1999

Detective – The shopkeeper at 36 Brick Lane described her as tall with long red hair and an American accent.

This is the street I saw in the book, narrow lane with children watching the camera, only there was a lot of fog in the air, and cobblestones.

How is it that we can walk over their footsteps and not remember?

I sometimes follow men late at night, when I'm coming home from the tube station. I pick a man that is going my way and then stay behind him. It makes me feel safer going through the dark tunnels to have someone near me, in case I get attacked. Like a secret protector.

(church bell or horse bell) (sound of horse goes by)
(creepy music – violin player walks by, kids singing song)

I'm standing in the library with you. You can hear the turning of newspaper pages, someone talking softly. There's a man standing beside me. He's looking in the crime section now. He reaches to pick up a book, opens it, leafs through a few pages then puts it back on the shelf.

(sound of person next to you, the turning of pages, then the movements of someone passing you)

I started these recordings as a way to remember, to make life seem more real. I can't explain it but then the voice became someone else … a separate person hovering in front of me like a ghost.

There's a convenience store with a big Coca-Cola sign on it. Cross the street and follow the sidewalk beside it straight ahead. Look both ways.

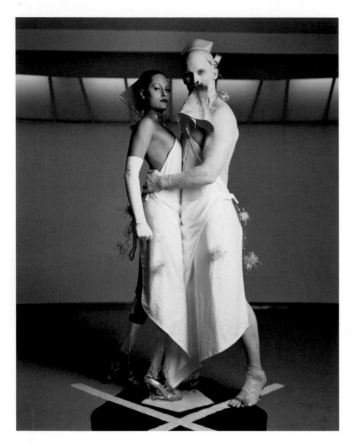

CREMASTER 3
Matthew Barney, 2002

In his work the American artist Matthew Barney combines visual art, theatre, film-making, music, choreography and architecture, constantly trespassing on different artistic territories to create a deeply cryptic *Gesamtkunstwerk* of epic dimensions. His *CREMASTER* series (1996–2002) is without a doubt among the most opulent and lavish art works created in recent times. Its five episodes, with their rich symbolism and deliberate inconsistencies, seem to explode with meaning but without ever reaching any conclusion, a cycle endlessly expanding in all directions. The *CREMASTER* in its totality is like the unrestricted transformation of an organism, a mysterious and heterogeneous creature with a life of its own that can never be completely rationalized in its complex entirety. It is a creature – just like the characters Barney portrays in the various episodes – over which perhaps even its creator does not have full control when it constantly shifts and expands, leaving audiences mesmerized and bewildered by its heretofore-unseen visual power and complex levels of meaning.

THE PERFORMER IS IN ALL OF US

If all the world's a stage, then each of us is a performer. These artists take this thought and present works in which ordinary people, members of the public or the audience attending an art exhibition become the main protagonists of the piece. Sometimes the artists aim simply to capture the roles and rituals of our daily lives; at other times, they create situations and scenarios that invite us to behave in certain ways. In these cases, the spectator becomes not a passive observer but an integral part of the creative process, enacting and completing the work and revealing the artistic potential in all of us.

top
Untitled
Richard Billingham, 1996

Untitled
Richard Billingham, 1996

The shockingly honest photographs taken by Richard Billingham depicting his impoverished family have caused great debate around the issue of so-called 'social pornography'. In 1995 Billingham began to take portraits of his chronically alcoholic father and overweight mother in a series of astonishing photographs showing the artist's socially challenged and underprivileged family living in a social housing estate in Stowbridge, a predominantly working-class town in the West Midlands. Somewhere in this sad scenario we also see the artist's brother Jason and several undernourished pets: particularly tragic is a dog that grows up to look just like the artist's father. As much as Billingham might play with pure spectacle and the sensation of the shocking, he also – while working to comprehend his own experiences of family life – brings to the surface the hidden and supposedly non-existent social discrepancies in contemporary society. But the work goes much further than a simple critique of social conditions in the United Kingdom. Billingham presents a complex web of relationships between different members of his family under extreme conditions but they might ultimately not be very different from what we all encounter with regard to familial patterns of power and dependency.

Untitled
Richard Billingham, 1996

'Life has no rehearsals, only performances.'
Anonymous

Early in his career Los Angeles-born Cameron Jamie worked on films in which he can be seen wrestling with people inside their houses, fighting on the kitchen table or living room floor. For his powerful black-and-white film *BB*, he further investigated the suburban phenomenon of backyard wrestling, particularly in the San Fernando Valley where he grew up, and filmed a whole series of fights among teenagers, many of whom would wear specially made costumes and fighting outfits. Jamie is fascinated by what he calls 'situations of social theatre', conditions that can be described as outlets for people to express their fantasies and ideas about themselves, while at the same time commenting on social and cultural issues surrounding American society.

'I think the San Fernando Valley is very cultured in many ways because most suburban cultures tend to absorb the influence of the outside world to create an interesting and odd phenomenon, which often stays trapped in the sphere of suburbia.'
Cameron Jamie

 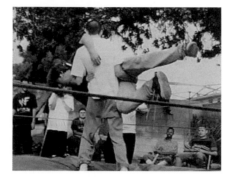 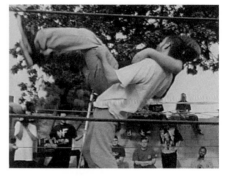

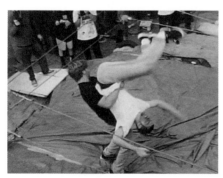

Amorales vs. Amorales (My Way)
Carlos Amorales, 2001

Originally from Mexico City, Carlos Amorales has lived in Amsterdam since 1996. Over the last five years, he has developed a series of works that deal with a particular phenomenon of Mexican culture – wrestling. Just like the similar sport from the United States, which has gained popularity in Europe, Asia and Africa, Mexican wrestling is an essential part of popular culture. Its history and traditions, however, are quite different from those of its US counterpart. Instead of being a commercial undertaking of global proportions, Mexican wrestling is closely linked to local issues within small communities throughout the country. Objects of identification for many young Mexican kids, wrestlers appear on television to fight for the rights of the oppressed. Amorales has made a variety of works on this topic. He has staged several real-life fights in museums and other art institutions, as well as in wrestling arenas in Mexico; he has studied the making of the wrestlers' costumes and he has conducted interviews with wrestlers of all ages. He has also produced designs based on the graphics found on posters and leaflets for matches. For him, the interest in wrestling lies in its being a form of popular entertainment that has a strong sense of the performative and ritual. It involves the transformation of one's identity through make-up, masks and costumes, and it includes ambivalent actions that are both made-up and real at the same time. It is a world of make-believe that for many young Mexicans provides solace and hope.

Untitled #113 (bougainvillea)
Jeff Burton, 2000

Jeff Burton's photographs bear a very intimate, quiet and cautious relationship to the field of pornography. At first glance many of his photographs look like rejects, images seemingly fallen off a desk in the editorial office of a magazine, as they are out of focus or appear simply to have missed their target. Burton is a photographer on the film sets of pornographic, mostly gay, movies. His carefully taken images reflect his very personal relationship to this film genre – a bystander with a romantic longing for subtlety within the explicit imagery of X-rated films. Like the classic voyeur, Burton is mesmerized by what he sees, yet for his work he only dares to take a peek at the overall scenarios. He repeatedly asks his viewers to complete his photographic compositions: we can often only see a head or torso of a protagonist in deep sexual arousal but we do not know what is happening in the rest of the scene.

'Let your performance do the thinking.'

H. Jackson Browne, Jr.

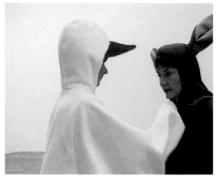

Peter Friedl
Peter Friedl, 1998

For the only piece featured in a retrospective, Austrian artist Peter Friedl asked each of the employees of the Palais des Beaux-Arts in Brussels to name an animal they would like to be, and to think of a name for it. Friedl proposed a challenging way of dealing with the idea of a retrospective exhibition, deciding to focus solely on one work that could express everything while at the same time following his desire to create a strongly site-specific work. Animal costumes were created in various sizes to fit adults as well as children, and these were placed in one of the exhibition spaces as an invitation to the audience to use them and dress up like their favourite animal. Next to the costumes was a wall text displaying all the names the employees had given their animals. By offering the audience the chance to see his exhibition wearing an animal costume, and in that way actually *becoming* the exhibition, since it was the only piece in the show, Friedl turned the art institution into a temporary zoo, employing all of its mechanisms of representation and display to deconstruct our notion of identity to activate a surreal world. The following costumes were available: a lion, a gorilla, a unicorn, a crocodile, a duck, an ostrich, a giraffe, a blue bear, a cat, a white bird, a donkey, a penguin and a kangaroo.

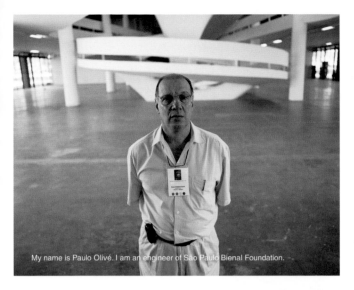

My name is Paulo Olivé. I am an engineer of São Paulo Bienal Foundation.

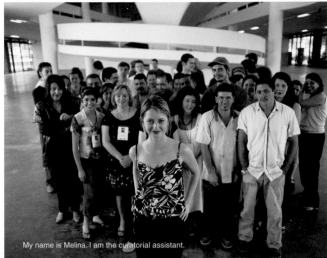

My name is Melina. I am the curatorial assistant.

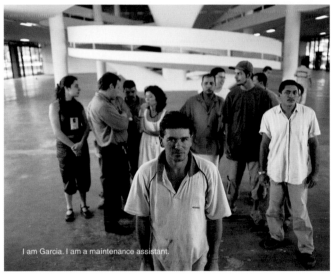

I am Garcia. I am a maintenance assistant.

Staff at the 25th São Paulo Bienal
Annika Eriksson, 2002

Staff at the 25th São Paulo Bienal is the third film in an on-going series by Annika Eriksson presenting the staff of several distinctly dissimilar art institutions. The first film, *Staff at Moderna Museet*, was made for an exhibition at the Stockholm museum in 2000. It starts with a space filled with benches, chairs, stools and other seating arrangements, a room seemingly hidden behind the scenes of the museum, inaccessible to the regular public. Eriksson asked each member of staff, from technicians, educational and curatorial departments, to executives, to step in front of a camera and introduce themselves by name and give a short description of their job. In contrast to the first film, the latest addition to the series was shot outside the socially and culturally homogenous society of Sweden and reveals new complexities of authority and hierarchy. Once again, however, the film turns museum employees into the performative nucleus of the artistic investigation.

The Italian artist Patrick Tuttufuoco re-evaluates the relationship between art and viewer by basing his works on interactions with the public and with his many collaborators. One example of this is *Velodream*, which he made in collaboration with the music group BHF, a duo from Milan who work with electronic sounds, for the group exhibition 'Casino 2001' at the SMAK in Ghent, Belgium. The artist designed and constructed ten bicycle-like vehicles that looked as if they had come straight out of a science-fiction cartoon, each one apparently a portrait representing one of his close friends. The project was presented on the racetrack of a cycling arena, with the audience being invited to 'use' the vehicles while BHF played a live soundtrack relating to their motion and tempo. *Velodream* exemplifies the increasingly common kind of art project today that combines the public and the personal. Not only is it a ritualized social event involving an audience and a team of collaborators, but it is also the artist's reflection on the personalities of his friends, who, metaphorically at least, are shouldering the weight of others.

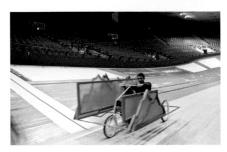 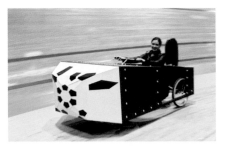 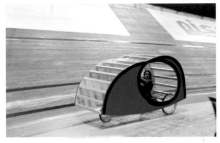

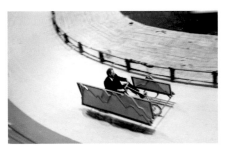

 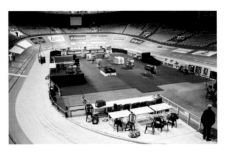 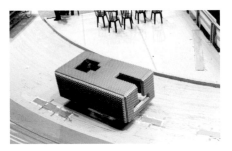

 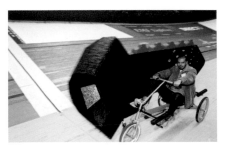 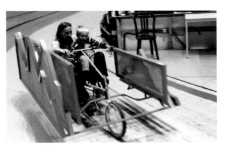

Drawing upon the Thai custom of cheerfulness and distinguished hospitality, Thai artist Surasi Kusolwong has in recent years concentrated on works that create strong links to the audience by offering various services and by involving the audience in a very direct and obvious manner. A recent piece is *Lucky Tokyo* (2001), for which the artist staged a lottery in a gallery in Tokyo and gave various prizes to the members of the audience that participated in the event. The first prize was a round-trip ticket from Japan to Thailand, including accommodation in a first-class hotel and a visit to the artist's hometown. Another time, for his piece *Happy Berlin (Free Massage)* (2001), he created a massage parlour in which visitors could get a free massage after their often exhausting walks through large art institutions. For *1,000 Lire Market (La vita continua)*, presented during the exhibition 'Art all'Arte 6' in the small town of Casole d'Elsa, the artist placed fifteen coloured tables in the market square and filled them with hundreds and hundreds of everyday objects from Thailand, which he then sold to the inhabitants for 1,000 Italian lire each. Other objects were to be found hanging on ropes in the streets of the city leading the way to the Thai market in the middle of Tuscany.

'Forget everything about art and anything else for a while.'
Surasi Kusolwong

opposite and left
1,000 Lire Market (La vita continua)
Surasi Kusolwong, 2001

Art works that relate to their immediate context and to their spectators in a more engaged way than simply commenting on social, cultural or political subjects in forms of visual metaphors have been key to the development of art created over the last decade. Thai artist Rirkrit Tiravanija is certainly the most prominent protagonist of this expansion, having worked with relational strategies since the early 1990s. His work is often considered the essence of an approach that would open up the sphere of art to the public realm, focusing on inter-personal relations, diverse forms of exchange, and connections between the work of art and the social sphere in which it is produced, perceived and exhibited. In one of his earlier pieces, shown at the 1993 Venice Biennale, Tiravanija exhibited a cooking pot with boiling water. The audience could use the water to make a soup based on a powder that was placed next to the pot along with spoons and cups. Over the course of the years that have followed, Tiravanija has expanded his ideas into many directions, creating various relational pieces such as his trademark Thai meals served in galleries or museums, and pieces such as *Rehearsing Room* (1995) or *Apartment* (1997). For *Apartment*, first presented in the Kunstverein in Cologne and later in a gallery in New York, the artist used construction-site plywood to rebuild his New York apartment inside the gallery space and he invited the audience to inhabit it and use it for their own purposes. With his interest in creating situations involving encounter and events, and his rejection of a strong commodification of art, Tiravanija's practice is doubtless among the most influential of the last fifteen years.

'It is not what you see that is important but what takes place between people.'

Rirkrit Tiravanija

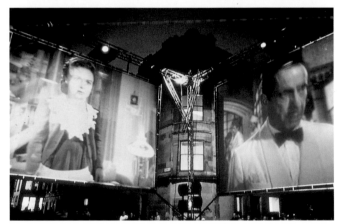

opposite and above

**community cinema for a quiet intersection
(against oldenburg)**
Rirkrit Tiravanija, 1999

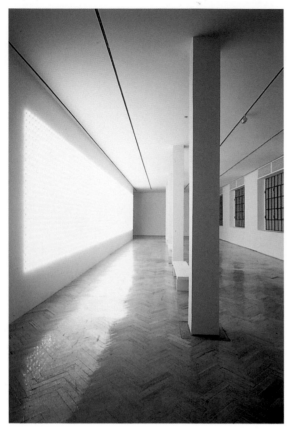

above and opposite
Light Wall
Carsten Höller, 2000

Light Wall, by the German artist Carsten Höller, was originally conceived for the exhibition 'Synchro System' at the Prada Foundation in Milan. The exhibition title refers to the artist's desire to create a synchronicity between the audience and the exhibited objects. The exhibition consisted of several large installations and objects, three of which suggested a form of experimental circuit. Entering the main space of the gallery, the visitor was confronted with the *Light Wall*, a large installation that incorporated more than a thousand light bulbs going on and off in a precise rhythm, producing a tranquil, hallucinatory effect. The idea of synchronization is most obvious in this piece: our brain activity synchronizes with the frequency of the blinking lights, thus generating phenomena such as colour vision and trance-like states of mind. The path through the exhibition continued with a completely dark passage approximately ten metres (33 ft) long, a transit into a different sphere, directing the visitors into the bright *Upside Down Mushroom Room*, in which, as the title of the piece suggests, everything was upside down and, moreover, out of scale, with huge mushrooms, up to three metres (10 ft) tall, rotating on the ceiling. As the German psychologist Baldo Hauser recently said about the artist, 'Höller produces a very peculiar state of mind, something near to a loss of orientation, a kind of perplexity of not knowing what to do, a reduced ability to manoeuvre while, at the same time, experiencing joyful, happy, self-sufficient, purified and introspective feelings.'

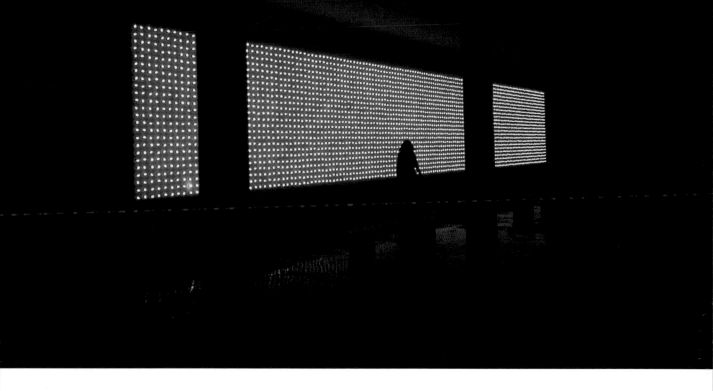

'All elements of "Synchro System" are meant to work in conjunction with you, to shake your foundations, to make you feel different. They are devices, or tools, or machines. Their meaning is not contained within; it is their function and the specific results that might be achieved. The object becomes an extension of the body. You extend your phenotype. It is not you and the object, but the object and you are you. It is all you.'

Carsten Höller

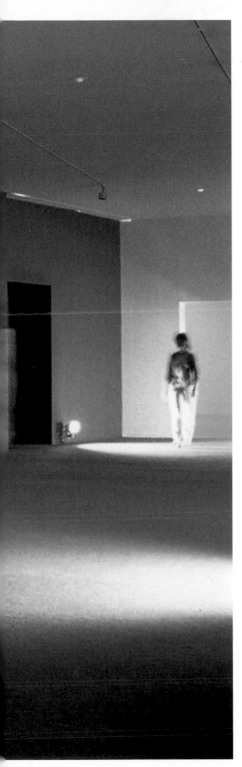

During the 1990s Dominique Gonzalez-Foerster created various spaces and rooms, designed to be activated by the audience's presence so that the viewer would become a part of the work. With many of these installations, the artist set out to expand the perception of the visual arts to include both a temporal element and the viewer's experience. The intention was to fill the exhibition space with time and specially created atmospheres, rather than with objects or materials, so that the room is understood as a form of narrative space. For *Séances de Shadow*, industrial lamps with motion sensors project silhouettes of the viewers onto the walls, which are painted in the same deep blue as the carpet that covers the floor. The blue walls and carpet generate a cinematographic feeling that evokes the early ages of film-making. This primitive form of projection amplifies the viewer's immersion in the process of creating the situation before them. But Gonzalez-Foerster wants not only to transform each viewer into an actor; she wants also to suggest an exploration of space and time and its visual construction.

'The creative act is not performed by the artist alone; the spectator brings the work in contact with the external world by deciphering and interpreting its inner qualifications and thus adds his contribution to the creative act.'
Marcel Duchamp

Séance de Shadow II
Dominique Gonzalez-Foerster, 1998

Newsreader, Newspaper
Agency, 2001

DESCRIPTION

The texts of newspaper articles from different daily newspapers like *Politika*, *Vecernje Novosti*, *Blic*, *Glas*, *Danas*, *Nedeljni Telegraf* and others in the state of Serbia in the Federal Republic of Yugoslavia.

REGULATION

The new Federal Republic of Yugoslavia Copyright and Neighboring Rights Act was established in 1998, based on the GATT regulations of the World Trade Organization. Since 1999, the Federal Republic of Yugoslavia is a member of the WIPO (World Intellectual Property Organization), an international organization headquartered in Geneva, Switzerland. This implies that the Federal Republic of Yugoslavia recognizes the Bern Convention for the Protection of Literary and Artistic Work (1886), updated by the Paris Act (1971). This international treaty includes the following article about public recitation: 'Article 11ter [Certain Rights in Literary Works: 1. Right of public recitation and of communication to the public of a recitation.
2. In respect of translations] (1) Authors of literary works shall enjoy the exclusive right of authorizing (i) the public recitation of their works, including such public recitation by any means or process; (ii) any communication to the public of the recitation of their works. (2) Authors of literary works shall enjoy, during the full term of their rights in the original works, the same rights with respect to translations thereof.'

USE

A woman in the streets of Belgrade is using the texts from the daily newspapers and reading them loud. This informal newsreader makes the information in newspapers accessible by reciting the texts from different journals for passers-by. This informal newsreading is related to transitions in the former Yugoslavia. Due to the war and the sanctions, access to information was very limited. Many people could not afford newspapers. The newspaper circulation was often as low as a few thousand copies. Also, press freedom in Serbia was restricted. Since the 1991 war in Croatia, the former Yugoslavia's official economy has collapsed. The huge increases in the price of oil, falling imports and exports, inflation, shortages of food and medicine, insolvent banks, unemployment and unpaid pensions led to a lot of informal economic activity. Illegal trade flourished and the unofficial economy provided numerous jobs and additional incomes. During the international boycott (1992–5 and 1999), the amount of people working in this informal economy escalated. Common informal jobs are trading without paying for rights, licenses, taxes, tariffs, etc. Informal economic activity is carried out beyond state control.

JUDGMENT

The new government of the Federal Republic of Yugoslavia has brought in measures to stop the informal economy but many people still work informally. The informal newsreader takes advantages of the weak legal enforcement by the Federal Republic of Yugoslavia, in this case the copyright law. From the point of view of copyright law, it is generally assumed that text belongs to the one who writes the text down. According to Article 11, 'Authors of literary works shall enjoy the exclusive right of authorizing (i) the public recitation of their works, including such public recitation by any means or process.' By uttering the words aloud in the street, the informal newsreader recites the copyright-protected text. But of course it is almost impossible to define when reading out loud in the street can be considered a public recitation.

TALK

Carlos Amorales, Ritsaert ten Cate, Michael Elmgreen and Ingar Dragset, Tim Etchells, Coco Fusco, Dorothea von Hantelmann, Jens Hoffmann, Chrissie Iles, Joan Jonas, Lisette Lagnado, Xavier Le Roy, Tim Lee, Yvonne Rainer, Martha Rosler

TALK

Carlos Amorales is a visual artist based in Amsterdam and Mexico City.

Ritsaert ten Cate is a visual artist and the former director of the Mickery Theater, Amsterdam.

Michael Elmgreen and Ingar Dragset are artists based in Berlin.

Tim Etchells is a writer and director and the artistic director of Forced Entertainment based in Sheffield.

Coco Fusco is an artist, writer and curator based in New York.

Dorothea von Hantelmann is an art historian, writer and curator based in Berlin.

Jens Hoffmann is a curator and writer, and the director of exhibitions at the Institute of Contemporary Arts, London.

Chrissie Iles is curator of artists' film and video at the Whitney Museum of American Art, New York.

Joan Jonas is a visual artist based in New York.

Lisette Lagnado is an art historian, writer and curator based in São Paulo. She is also the coordinator of the Hélio Oiticica archives in Rio de Janeiro.

Xavier Le Roy is a choreographer based in Berlin.

Tim Lee is a visual artist based in Vancouver.

Yvonne Rainer is an artist, choreographer and film-maker based in New York.

Martha Rosler is a visual artist based in Brooklyn, New York.

Joan Jonas: I want to begin by asking what does 'performance' mean to you?

Coco Fusco: My performance work takes me to so many different places, where I encounter widely divergent traditions and practices. Many kinds of performance art are still alive, from body art to Fluxus actions to staged autobiographical monologues to street actions. And to these earlier forms we can now add net.performances using streaming video and so on. I'm also an avid student of performativity outside the art context, and those 'vernacular' modes have really nourished my own practice. While I recognize a difference in form and purpose between artists doing performance and non-artistic performativity, I don't try to extricate my own gestures from their non-art origins.

Chrissie Iles: I enter this discussion as a curator. My own focus is very specific and deals with the relationship between performance and the performative; that is, the difference between live performance and performative works made for the still or moving camera. I feel strongly that an acknowledgment of what could be termed the 'performative' is absolutely necessary within the museum context, in which temporality and ephemerality has always been suppressed.

JJ: Do you think the relationship of the 'performative' and the institution has shifted over the years you have been involved with this art form? Is the ephemeral taken seriously or is it just an evening's entertainment in the art world, and would it be possible to reach a more diverse audience?

CI: Performance has always operated as an irritant within the newly hardened shell of the cultural elite. One of the most important functions of this 'irritation' is the shift that takes place, in a strong performance, in the viewer, from removed observer to involved participant – anything from actual participation to an engaged observer who becomes part of what could be described as a performative 'field'. My most recent experience of it was in Berlin, where a young student of Marina Abramović's made a highly sexual performance in which physical and emotional contact between artist and viewers articulated a sense of true involvement which, whether one participated or not, articulated the dividing line between observation and engagement, and risk. Specific to most performance is, furthermore, the full engagement of the artist themselves, which allows us to have an intimate connection to the artist which is otherwise rare. It is the only time when the artist and their audience are in the same place at the same time, and it is one of the most vulnerable, demanding actions an artist can make.

Ritsaert ten Cate: A predominant aspect of my background is theatre. Theatre in all shapes and forms, tastes, colours, smells. Coco provides a much more inspiring picture of performance than performance proper as I know it, however limited that may be. From where I am now, aged sixty-four, and two years after having embarked on visual art as a sole activity, I would happily settle for a term 'performative response' as an area in which performance art, but much more, could be placed. The catch is of course the word 'response', which minimally suggests that the activity on hand must be more than a demonstration of self. I get the impression that with performance art you can get away with anything, that it is self-centred, narcissistic and only needs to be (or could be) done once, so that no specific skills are necessary (although standing rock steady for one hour is by no means a sinecure). I'm aware that the suggestion is blasphemous, subjective to the extreme or, worse, not particularly informed. Because performance art takes place only once,

Performance indicates how society and social relations are continuously produced and reproduced through actions performed by every individual, constantly anew.

there is no interest in repetition. Another version of the same performance would be another performance, not the same. Mostly performance is what it is, without reference to its surroundings, or a need to communicate, other than its being, for its duration.

Dorothea von Hantelmann: I would say that performance makes us aware that meaning takes place in the present. As an art form with a beginning and an end, it implies a specific temporality, spatiality and embodiment of the production and reception of art. But in a more general sense the paradigm of performance indicates how society and social relations are continuously produced and reproduced through actions performed by every individual, constantly anew, though within certain rules. We get dressed in the morning, we communicate, we go to museums, we materialize ideas in art objects, we perform on stage, we are an audience, we constitute a public, we fall in love, we affirm, we criticize – and all these actions, in their quotidianity or speciality, are based on our decisions and intentions, and at the same time they become understandable, readable only by picking up features of previous ones they repeat and relate to. In this sense performance is always 'a doing and a thing done', as Elin Diamond wrote. It points towards the particularities of the subject as producing and produced; to the 'I' as a performing agent and the 'I' constituted in and by these performances. It poses the question of agency as a continuing process of negotiation of social relations – and that marks its political nature. By offering a different mode of production, performance could be crucial to understanding the specific political potential of art's encounter with society, as a way of communicating meaning through certain acts between subjects and objects.

Tim Etchells: Performance is indeed connected to temporality – to its own disappearance in the moment and to the unique unfolding of stretches of time. The event (or the work) articulates an awareness of its own contingency. We understand while watching (or reading or interacting or participating) that things could be different. We understand that this event could be shifting differently, that we could be reading it differently, that it could be constructed differently. We become aware, if we are lucky, of the incomparable and special nature of each instant of time. That 'now' is the product of human presence and human labour. We become aware that now is now.

I think this understanding of now – a moment of time shared by human beings in a space, in a context – is always political, always connected to ethics. In that respect, I agree with Dorothea. In this 'now' we become aware not simply of its uniqueness, its contingency but, more significantly, of our own role in reading, shaping and understanding the event, and by implication, the world.

DvH: Conceptualism shifted art towards the model of the text, while the performative might shift it in the direction of theatre. Not towards theatre as an art form based on text, actors and role-playing, but towards the idea of culture as

a social practice; towards theatre as an art form that understands the space between the artistic phenomenon and its reception as a present and therefore social space. And the latter's specific potential could lie in new definitions for the viewer, the spectator, the public. In this sense, performance could take us away from the fixation on the art work, its intentions, significations and interpretations, towards the social situation in which art takes place. Beyond the frontal artwork–viewer relationship, the exhibition could be thought, perceived and staged as a social space, which 'performatively' produces a sort of cartography of existence, not in terms of fixed roles of subjects and objects, but rather in flexible roles as producers, consumers, users and participants.

Performance is part of the anti-art spirit: a strong attitude against art as commodity and the object cult.

Lisette Lagnado: That idea is very closely allied to the work of the Brazilian artist Hélio Oiticica. I have always been puzzled by the junction of two of his most famous sentences: how come, in different moments of his life, he said that 'All I do is music' and then 'All I do is performance'? In 1964, Oiticica formulated his 'Ambiental Program', which was based on the Brazilian term 'Parangolé' – a concept strongly influenced by the aspirations of early twentieth-century artists such as Kandinsky, Malevich and Mondrian to create a broader space for art. In one sense, this consisted of the performative use of banners and capes by professional samba dancers and also non-specialist participants. The involvement of non-artists was extremely important to Oiticica, as it was to others in the 1960s who understood that the realization of the work would only be 'completed' by the action of the other. Years before the publication of Guy Debord's *The Society of the Spectacle* in 1967, Oiticica was concerned with the problem of the passivity of the spectator. For him, performance had a political connotation: it meant 'participation' in life. It was also part of the anti-art spirit: a strong attitude against art as a commodity and the object cult.

TE: But performance is also rooted in play. Play shows us that the 'now' can be transformed using language, using action, using unexpected rules or codes of behaviour, using image – that what *is* is mutable, shadable by fiction, pretence, mischief, reinvention, action and desire. In this sense, performance endlessly enacts the journey between what is and what might be, what was and what could be. Looked at in this way, performance is a device for measuring the distance between these two things – the material real and the phantasmagorical. The distance is always bigger and, at the same time, always smaller than expected.

Yvonne Rainer: I entered the field of performance as a dancer in 1960. The postmodern dance movement that was about to thrive at Judson Church had emerged from the work of composer John Cage, choreographer Merce Cunningham, and Cage pedagogue Robert Dunn. Although this movement was part of the contemporary art world nexus, the impetus for us was not so much a response to static sculptural and graphic objects – which motivated people like Claes Oldenburg, Jim Dine and Robert Whitman to start making performances, or 'Happenings', as they were commonly known – as our own ossified dance history.

But here the 'static-versus-kinetic' dichotomy gets interesting. There was definitely a cross-fertilization going on in the early 1960s between the Happenings people and some of the dancers. In December 1960 Simone Forti presented two pieces at the Reuben Gallery on the Lower East Side, New York City. In one, I believe called *Rollers*, she and Lamonte Young sat scrunched up in two wooden boxes that were wheeled around the cramped space by means of attached ropes pulled by assistants. In the other piece, *See Saw*, Robert Morris and I cavorted on a seesaw. Forti was invited to take part, I surmise, in part because of the 'undancerliness' of her work, which fitted with her hosts' affinity for the manipulation of objects. Steve Paxton, who was then dancing in the Merce Cunningham Company, is another example of a dancer influenced by sculptural practice. His use of 'inflatables' in his performance pieces challenged the notion that a dance must 'move'. One might say that the painters and sculptors were expanding the parameters of visual art, while the dancers were expanding – or closing down – those of choreography.

The introduction of everyday movement was also a way to challenge previous assumptions of 'dance' as such. It is interesting for me at this point to contemplate Lisette's citing of Hélio Oiticica: 'Performance is part of the anti-art spirit: a strong attitude against art as commodity and the object cult.' This very aptly characterizes the attitude of Happening-makers in 1960. But from a dancer's point of view during the same period, to make dances that were object-like achieved the same end. Already working in an art form that did not lend itself to commodification (no one expected to make money at it back then), we stood still, carried bricks, ate sandwiches, allowed our bodies to become inanimate and equivalent to boxes – all to evade what we then perceived as the inflated and overworked clichés of our enshrined predecessors.

Martha Rosler: For me, contemporary performance developed out of certain manoeuvres by postwar avant-gardists (including painters, sculptors, and dancers) at the end of High Modernism. It became a preferred form among feminist artists on the West Coast (where I was living and working in the late 1960s and '70s). Performance provided a handy sketchbook and a way to sidestep audience expectations of theatrical professionalism in text, production or acting, while retaining the possibility of conveying content. Artists who were early to pick up video cameras were already familiar with this way of working as well as with the proto-conceptualism of Fluxus-type 'actions' and perhaps with European Situationism. The writings of Symbolic Interactionist Erving Goffman, especially *The Presentation of Self in Everyday Life* (1959), *Stigma* (1963) and *Interaction Ritual* (1967), among many others, commanded a broad readership. Goffman, using a 'dramaturgical approach', identified social interactions as performances, even if unconscious ones. In a surveillance society where performance measures a person's value as a producer of economic wealth and social capital, a dramaturgical analysis of everyday life struck a powerful chord.

Speaking personally, when I began to look beyond a dying modernism that had informed my early training as a painter, one of the first realities I had to face was the loss of (the search for) authenticity. It seemed clear that the adoption of performance is in part a reflection of the broad abandonment, in most of Western culture, of the search for self apart from its formation in social situations (except, perhaps, in pop psychology, where the idea of the solitary, essential self has fled for refuge). I did performances to

> I did performances to bypass audience expectations, to shake up perceptions about where an 'art object' might be found and what was an appropriate subject for an art audience.

bypass audience expectations, to shake up perceptions about where an 'art object' might be found (i.e. staged) and what was an appropriate subject for an art audience. Ultimately, the point was to elicit a different range of responses from audiences than the business-as-usual of the art world. The art object as a text, a 'social text', that the audience must make their own and act upon is behind most of what I do. I have always orientated my work on women's lives, although not every work or every performance invokes women's experience explicitly; but it is a question of whose perspective do I take in the balance of social and political power and agency. From the beginning I have wanted to 'repoliticize' the most invisible elements of everyday life – to suggest that these things are worthy of attention and, most importantly, subject to change, by the agency of those very participants in the event who constitute the audience.

Tim Lee: The search for self … well, the truth – and joke – of my work is that I'm a lousy performance artist. A few years ago, when I first started to make art, I had terrible inhibitions about performing, much less the thought of simply appearing in my videos and photographs. A lot of this was due to the very ordinary fact that I'm not a natural performer and that I've always had a lot of peculiar anxieties about even having my picture taken. Of course, having said that, the other, bigger joke of my work is that I'm in everything I make. Not only that, but that the 'fantastic' nature of the acts I compose – whether it's me levitating in the studio or appearing as all four members of a guitar rock band – come off as being so heroic and grandstanding it's ridiculous.

Looking at my videos and photographs, a distinguishing characteristic of my work is that the performances are hardly there – it's almost like I want to get the whole thing over with as quickly as possible. This, in large part, is due to the measured quality of the gestures themselves. Self-restraint, imposed like wilful constraints of theatre, flattens expressive acting towards the Brechtian notion of 'just doing'. I identified this transition from acting to doing with Bruce Nauman and the heavy concentration he put into his work. He seemed less concerned with dramatizing ways to behave than getting the job done. The importance of his production is personally significant to me. Yet while I looked towards the new-found potential of the amateur that emanated from his work, I only started with this conceit in order to move past it. My initial fascination with historical modes of performance art became a starting point for my production, and in the end, this provided the larger trajectory for my approach to art-making. By turns, this meant that if being the amateur gave me the licence to start being bad, it also gave me the greater urge to get better.

Xavier Le Roy: I think I have more questions than answers to propose to the discussion. I find it interesting that so far we have needed two or more definitions to the question 'What is performance?' – one for the field of art and another in a more general sense. As Coco puts it: 'I recognize a difference in form and purpose between artists doing performance and non-artistic performativity.'

I also feel a need to give at least two descriptions of how performance is practised by me (dancer-choreographer, French/European living in Berlin, jumping from one city to another most of the time, 39 years old, heterosexual) because the use or the understanding of the word is often a source of confusion in some of the environments I am involved with. For example, it is very often used in its historical sense to designate a certain kind of aesthetic, which from my point of view is problematic.

Anecdote: on the dance scene, I often hear people telling me 'What you do, it's performance but it's not dance.' Sometimes, I feel I have to answer, 'What do you mean? I don't have blood in my shows, I'm not always naked,

I don't spit or pee or shit on stage. It's not usually a very long show but more often the conventional one hour. I don't touch the audience with my skin. Most of the time I use a frontal theatre situation with an audience. I don't invite the audience to come on stage. It is not always about me or the expression of my self. My performances take place more than once and I do have interest in the repetition

Performance (art or not) is a medium that has a very emotional quality, because it happens in the present as a direct experience.

of my performances....' Or more regularly I answer, 'It is a choreography, it is a dance performance.' It is probably, as Dorothea said, because the term 'performance' can be used as or has become a paradigm. It has different understandings and different meanings, and the slide or the shifts between those meanings is probably another performance I try to understand in my practice. It is a slippery field.

JJ: I have the same list of 'nots' for my work, but I am interested in how your work goes beyond this initial definition. I think one point of this discussion is to show that the performative includes many approaches.

XLR: I think that at the moment the concerns of my work don't go beyond these definitions. For some years now I have tried to work as closely as possible to these definitions, which are like tools for my projects. The concerns of my work are mostly analytical in the first place and that's maybe why I am not really interested in showing that the 'performative includes many approaches'. I am more interested in the different ways concepts like 'performativity' and 'performance' are understood and what this understanding can produce. This is not to try to come to a statement like 'performance is _____' or to reduce performance to one thing. But more to discover what performance and performativity are able to do. According to my experience, these questions are rarely raised and put

into practice. On stage, in theatres, museums, galleries, and conferences, I mostly see the repetition of the same clichés. There might be 'many different approaches' but actually they produce quite similar performances, or is it the other way round?

Carlos Amorales: As someone who spent the 1980s as a teenager in Mexico City, performance as art was not so much an important issue at that time, although some of us were involved in what we called 'performance groups'. What really mattered was our longing for experiencing foreign rock concerts, which at the time were forbidden by the government. We were thirsty for information, music and images, and we contemplated our post-punk icons as heroic performers. We heard rumours, we desired, we animated them in our imagination and in a naive way we tried to imitate them. We were influenced by Bauhaus and Cabaret Voltaire, the bands, not the art events. On the other hand, we had around us some strong popular forms of entertainment, which involved a sense of the performative, like free wrestling and folk-derived dances. We were also familiar with the use of performance strategies by political activists like Superbarrio.

For me, this early experience was important as a base for what later, when I moved to Europe, shaped my performance art work, as it contained the following elements: an interest in popular forms of performative ritual and entertainment, as distinct from art; issues about transforming one's identity by using devices such as disguise, make-up and masking; the reenactment of ambivalent actions that could be considered as both fictional and real at the same time; an awareness of communication media; and finally an interest in what is social – rituals, politics, different professions and a wish to belong temporarily to another subcultural group.

As a performance artist I have approached my subject by adopting different working strategies. Sometimes I take the role of a cultural researcher and interviewer, others as a producer or a manager. At times, I am the director and then I am the performer itself. So far, my performances are thought of as a series of similar events which are repeated in different places, like a delayed rock band tour, happening

sometimes in a museum, then in a wrestling arena or in a concert hall. The idea behind this concept of repetition is to banalize the act of performing and to focus on the audience's behaviour, to observe how the specific context impacts on the narrative that is presented.

By working in such a manner I have found that the same performance piece can be interpreted by the performers and the audience in very different ways, depending on their culture and the situation where it is presented. Following this logic, I realize that performance (art or not) is a medium that has a very emotional quality, because it happens in the present as a direct experience. It can touch us, it can provoke us beyond our rationality. It is the only art form you can shout back at. It can be very open.

It can touch us, it can provoke us beyond our rationality. It is the only art form you can shout back at it. It can be very open.

LL: When I started working in the art circuit, at the beginning of the 1980s, performance art in Brazil was in the most pathetic decay. It had turned into a form of institutionalized manifestation. The decline of performance provoked in the audience a painful sense of shame. People were invited to 'see' narcissist exhibitions, deprived of any logic of difference towards the production of objects. Just as voyeurs. The emergence of the neo-avant-garde created a perverse dilemma: how to be 'marginal' when anything is allowed? In the 1960s and until 1979, we could say that performances had political and sensorial directions, whereas, at the end of the 1980s, it was artificial. Actually it was just producing spectacles – and decadent ones.

I would hesitate to use the term 'performance' to designate what is actually happening in Brazil today. I am friendly with the artist Laura Lima, who is also dissatisfied with the category of 'performance'. Instead, she aspires to create a 'live painting'. I am interested in the way she manipulates others' desire, giving a task to her performers. Laura is working to reduce more and more the gap between subject

and object, between who sees and what is being seen. Recently, she told me she was going to dislocate a cow from its context of origin so as to 'perform' in a seashore. What is a cow far from the imagery of the valley? Is it an element of a mere landscape or still life (once more, the emphatic experience of a live painting) or is it the performer of the action?

Another contemporary Brazilian move against 'traditional performance' (if you permit me to use such paradoxical terminology) are the *Acontecimento poético-urbano* (poetic urban happenings). These have strong affinities with Oiticica's ideas concerning his experiences with popular events such as Carnival, blending the activities of dancers, musicians, dramatists, architects and social scientists.

We all know the meaning of a door: you enter or leave a room through it. But asking about the performativity of this door points to the *situation* it produces, which might be integrative, segregative or exclusive.

'Performance art' sounds a bit bourgeois. But artists like Cabelo and Jarbas Lopes, based in Rio de Janeiro, and Marepe, from Bahia, are integrally compromised with their social reality. What links them together is their roaming of the streets. They perambulate. But there is no illusion of a flânerie. It is not 'walking with a purpose'. But neither is it 'aimless walking'. Marepe's 'time-wasting' is his work. His creative process emerges both from an intense observation of his close reality and from a 'laziness'. In September 2001, he invited a guy from his town who earns his living selling candy floss to make almost four thousand bags of the stuff. These were then hung on the trunk of a palm tree. In a few moments, the local population had assaulted and devoured his proposition. The group Chelpa Ferro has also made an important contribution. In the last São Paulo Bienal, they destroyed a red Maverick car installed in the centre of the building with all kinds of instruments. It is linked to Cage's experiments to extract new sounds for music, but

Luiz Zerbini, one of the members of the group, gained this excellent insight: 'I took some time to understand why Oiticica, who started as a painter and was so concerned to establish a new basis for Painting (it is a mistake to interpret him as a destroyer of the activity of painting), used to say that what he does is music. And now, I understand this sentence and I can, myself, say that what I do is painting.'

Jens Hoffmann: Dorothea, you recently curated an exhibition at the Museum Ludwig in Cologne entitled 'I Promise It's Political' in which you tried to explore the idea of performativity in visual arts. Performativity has become such an overused term that I wanted to ask you if you could speak about your definition of the expression and how this was investigated in your exhibition. Furthermore, could you talk about the title of the exhibition?

DvH: The notion of performativity, as I relate to it, centres around the possibilities and limits of productivity – the ability to produce a meaning, to provide an experience or to create a situation. We all know, for example, the meaning of a door: you enter or leave a room through it. But asking about the performativity of this door points to the *situation* it produces, which might be integrative, segregative or exclusive. Or towards the actions that can take place with or through this door, like slamming it and thereby performing a certain culturally coded convention of arguing. So, in a nutshell, performativity leads us towards a situational understanding of culture, to a situational aesthetics, and I am interested in the social and political dimension of this perspective.

Asked about art and politics, Daniel Buren once said that an artwork that is produced for a public and exposed to a public always also has a political impact, as an action that inscribes itself into a certain social order. It does not just represent a situation in pictures or words, but also produces it. Instead of just commenting on society in visual or textual metaphors, it also creates, performs, a social relation. This is the performance that I am interested in and this is what 'I Promise It's Political' was about. It was about the moment in which art encounters society, in which it creates a relation towards a viewer, an audience, a public. What kind of communication is taking place here? Is this an active or a passive process?

What does participation mean in this context?

Adrian Piper speaks in relation to her visual art works, which she calls 'confrontational performances', of the indexical present, referring to speech indicatives such as 'I', 'You', 'Here' that situate the artwork and the viewer in the same time and place. Piper is dealing with racism and xenophobia, but the interesting thing for me is how she relates these issues to the policy of address, of directness. She communicates them as a phenomenon that takes place here and now, in the concrete situation. Carsten Höller's work, such as his light installations or flying machine (which we showed in our exhibition), also engages in the actual situation by changing and manipulating the way you perceive and experience it. The performance, if you want to call it that, becomes the togetherness of the object and you. Although Höller and Piper of course have very different political positions, they both produce a situation in which the conventional subject–object relation of the exhibition space is transformed, differentiated into a situation in which there is no recipient, no outside, only actors and actions that perform from within.

I am very interested in ideas of the performative, as I explained before, as a possible starting-point for modes of critique. However, the notion of performance art is something that I am rather sceptical towards. It is loaded with artistic, aesthetic and ideological conventions that without any doubt have their historical legitimization and relevance but today seem so cliché (in terms of anti-market, object, objectification) and restrictive. It's now decades after the rise and fall of performance art: what other ideas and concepts could the performative refer to today? The title of your book, 'Perform', suggests a broader approach but these genre labels, like performance art, are still so powerful.

JH: Joan, let us just talk a little about practice. Maybe you can say something about your piece at Documenta 11 in 2002. How would you define it? Is it an installation or a performance?

JJ: The installation you saw in Documenta 11, 'Lines in the Sand', is definitely that, an installation which remains. I am not there live, and I like that – that I don't have to be in it.

It is good to sit outside. A performance is a live event. I made the performance version later, re-fashioning the material. It was in the mid-1960s, after studying art history and sculpture, that I became inspired by the idea of performance and began to work with time as material, transferring my concerns with drawing and the object into movement. At the time I didn't see a major difference between a poem, a sculpture, a film or a dance. Now, working in video/performance/installation/ sculpture/ drawing, I continue to experience the forms as overlapping. I looked at the space of painting, film and sculpture, noting

An art work does not just represent a situation in pictures or words, but also produces it. Instead of just commenting on society in visual or textual metaphors, it also creates, performs, a social relation.

how illusions are made within a frame – how depth and distance are perceived. When I switched to performance I went directly to real space. I would look at it imagining how it would look to an audience – how they would perceive ambiguity and illusion. An idea would come from looking. For me, performance as a medium exists on a sliding scale between 'conceptual art' and 'theatre'. The critical medium is time in the context of the visual arts. In exploring ways to extend a language of time, I referred to childhood memories of the circus and the magic show, as well as to poetic form. I have always been interested in the rituals of other cultures – the dance, the music, the objects – because they are part of everyday life. I thought of my pieces (as I called them) as rituals for an audience of the present time, and from the beginning I studied other cultures. I am interested in how we interpret and borrow from others. In 1970, after visiting Japan, I began to work with video in relation to performance and as a separate medium translating performances. The video, in a live closed circuit set-up, reflected a detail of the performance in the projected image and/or the monitor. The monitor was an ongoing mirror. At that time I was exploring the idea of the female. I invented an alter ego or persona 'Organic Honey', working with disguise, masks and costumes.

UNIVERSITY OF WINCHESTER
LIBRARY

I was trying to move from the minimal. After exploring various ways of working with video and performance I switched in the late 1970s to exploring storytelling and narrative. There was always the desire to transform or transmit the image – not to simply represent. The media of the mirror, video and deep landscape space have allowed me to develop and explore more complex narratives.

For the past ten years, while continuing to perform live, I have shifted my concentration to work that can exist on its own as an installation without my live presence. This interests me. The work was always a kind of installation or stage set made with objects, drawings, constructions, projections. Now I make the stage or performance space from a slightly different viewpoint. I have also re-edited or reconfigured some early works, circulating unedited material from the 1970s. In a way, the work becomes more specific, giving me a way to speak about the present state of things.

While always interested in the work of younger artists, I became more aware – involved – when I began teaching full-time about ten years ago. It was evident that the language of the 1960s and '70s had filtered down, resulting in the performative aspect that one sees in so many time-based works today. Lately, I ask students to read Susan Sontag's description of a Happening. I also would use the word 'action' instead of performance because it represents what some do.

I am also interested in how things are now in different countries (in relation to performance) and what the links might be. Coco, you said earlier that 'I don't try to extricate my gestures from their non-art origins.' Could you be more specific? And what is important for you in the work of younger artists?

CF: I mean many things by this. First, some artists who work with popular cultural elements, and/or with aspects of 'non-Western' cultures are often afraid to admit those connections. The main fear is that they don't want to be exoticized, or assumed to be 'primitives' who cannot operate at the level of abstraction that is supposedly the exclusive property of Euro-American modernism. They might not want to be considered minority artists or artists who deal with identity. All of these categories are negatively charged in today's global art scene and can lead to an artist's being derided, misunderstood, and reductively anthropologized. So people sometimes lie. They say in public that their 'rituals' have nothing to do with religion, or that their subject matter is 'universal', or that they are only concerned with purely aesthetic questions. But if you look at the work, and know something about the world they come from, you can tell what they are trying to mask to gain entry to a very Eurocentric and formalist art scene. And since most of the people doing the choosing know very little about non-European cultures, they are easy to fool.

I've chosen not to play that game. Instead I try to relativize the questions that are systematically levied at artists from non-Western backgrounds and demonstrate how those questions could also be asked of white artists in Europe and America. White people have religions and rituals, too,

Not everyone knows if I am doing a performance when they first see it – and sometimes that is the point of the action. I've performed in shopping malls, public plazas…. Whatever works, I say.

and their performances often derive from them. The history of the Euro-American avant-garde in relation to performance barely makes sense if one does not also understand how the art form was developed *in dialogue* with non-Western traditions – the Dadaist fascination with African and Oceanic oral poetry, the Surrealist obsession with totemism and indigenous rituals, Brecht's analysis of Chinese acting, Cage's interest in Buddhism, Beat poets' fascination with jazz and black oral culture, 1960s avant-gardes' interest in indigenous rituals, shamanisms of all kinds, and so on. The other answer to this question is that I have incorporated performance into extra-artistic contexts. I've used it in political protests, on-line political actions, guerrilla actions on the street, and so on. Not everyone knows if I am doing

a performance when they first see it – and sometimes that is the point of the action. I've performed in shopping malls, public plazas, and even in the offices of the Organization of American States. Whatever works, I say. As for what's interesting to me about the work of younger artists, it is hard for me to generalize. Sometimes I see work that interacts in a fascinating way with media-based image culture. I realize I am looking at work by people who grew up channel-surfing and watching videos, for whom the cut-and-paste approach to processing history is normal and standard. This phenomenon can also produce a lot of facile and meaningless play, so I am not arguing that everything about it is great. But every once in a while that paradigm shift makes itself manifest and when it does I am made more aware of generational distinctions.

YR: I agree totally that white Western art-making owes much to other cultures. But I'd like to point out several elements that affected my work in the 1960s and 1970s that lie somewhat outside of the ritualistic/shamanistic/Buddhist influences on performance – in theatre, dance and music – in those decades. Ideas around disruption and detritus are another side of Cage, going back to Italian Futurist Luigi Russolo's 'Art of Noise' and Arnold Schoenberg's atonality. The investigation of sounds from the 'real' world, movements from everyday life, random organization, disruption of prevailing aesthetic systems – in the avant-garde legacy that I inherited – no longer had a religious base. In hindsight, that may have been its weakness: it lacked a broad-based connection to social life or history outside of an aesthetic coterie. Though this, in part, was why I turned to film-making in the early 1970s, these early assimilated ideas of disruption and detritus continued to be crucial to my practice. Yes, the European-American avant-garde has culled and appropriated from many different sources, but it can by now be said to constitute a tradition, oxymoron that that may seem, that you and I and everyone in this discussion are part of.

CF: I would never want to reduce Euro-American traditions to a single point of influence. I realize that Dadaists were also interested in a critique of capitalism, that Surrealists were interested in psychoanalysis, and that many experiments by artists in the 1960s had nothing to do with 'non-Western'

sources of influence. However, there was never a concerted effort to obfuscate the connection to those Western ideas and themes the way there has been a blind spot about the relationship to the so-called non-Western. My point has to do with the politics of hiding those connections. In the present, many artists from ethnic minorities in the US, immigrant communities in Europe and from Latin America, Asia and Africa feel compelled to disassociate their art practice from 'identity'-based concerns. They are told by curators, dealers and other artists that this will lower the value of their work or make them less attractive to arbiters in search of signs of 'pure' modernism everywhere on the planet. Many artists resent the anthropological lens through which their work is seen by European and American artists and curators and therefore adopt a descriptive language that is strictly formalist and devoid of identification with a specific place, culture or extra-aesthetic tradition. They conflate identity with segregation and modernism with democracy – mistakenly, I would add. The very fact that to this day even many enlightened thinkers still believe that all concern about race, identity, non-Western traditions, difference and so on emerged and can be restricted to the late 1980s is the best evidence of the massive cover-up that enables art history to continue to perpetrate falsehoods about the roots of modernism.

JH: I would quickly like to go back to something Dorothea said a little earlier. As we have discussed, 'performance art' is a specific moment and form in the wide spectrum of what performance is and can be, and it is a very European and North American condition. This is a fact we try to question and overcome in the book, not only as a definition but, moreover, as a point of reference, since it is so loaded with clichés, as so many of you have already pointed out. I think we need to keep this in mind in order to understand fully what performance actually is and where it can occur. For me, many of these questions and ideas occur in Elmgreen and Dragset's work, which is why I would like them to wrap up the talk. Can you tell us how you got started?

Michael Elmgreen and Ingar Dragset: Our starting-point was the very topic of collaboration – the give-and-take situation – and the in-between-ness. But, in a rather old-

school way, these performances were based on our being a couple in our private life. Our first performances took shape as complicity exercises, like simple acts through which we tried to find each other's rhythm, such as by knitting and undoing the knitting in alternating patterns. Inspired by an early feminist vocabulary, we were trying to redefine a gay sensibility. The problem was that these early performances of ours ended up confirming a gay identity which no longer felt valid to us. One could say that our first performances were exactly as embarrassing to watch as only performance art can be. You know, when it comes to a point where the toes of the audience really start to hurt and everyone but the performers gets soaking wet from sweating.

Soon we moved in a more conceptual direction and in 1997 we did our first 'painting performance'. For twelve hours we painted the walls of a white cube gallery, using two hundred litres of white paint, frequently washing the thick layers of paint off the walls and repainting them until the interior architecture gradually dissolved and this supposedly neutral space turned into a messy and blurred image of itself. Suddenly the material and the action was the focal point and not ourselves nor the interaction between us. The human bodily presence became solely a catalyst for the process, but was no longer an issue in itself. And since the body thing was now of less importance for our performances we could even exchange our own presence with the presence of others – anybody could do these acts which we were 'performing', so why not have somebody else do them?

JH: And how has that worked itself out? What are you doing now?

ME and ID: Since 1997, our actions have been proposals for how a transformation of certain spatial conditions could take place, of how the physical features and social structures of a room could change step by step through a simple human interference and with a minimal set of gestures. We have somehow tried to make the room perform itself.

'The potential of change' is still our main topic, and we use almost any medium that implies the possibility of showing such a potential. With all due respect to the history of performance art, we have been thrilled by the idea of developing a performance language that does not position itself in opposition to object-based visual art. To claim that immaterial aesthetics are nobler than an object-based approach is, in fact, a highly romantic view. It goes along with the tradition of saying that the spirit is above the material, the soul is worth more than the flesh. We have continually worked with this idea of combining totally non-happening performances with highly performative objects and installations. We make no major distinction between our installations, our sculptural works and our live acts. They are all part of the same experiment. Often the installations turn out to be more performative than our performances – performative in the sense that the spectator might play the main part, or in the sense that the action is just happening in the imagination of the audience. Sometimes the most thrilling action is the one that happens in your imagination.

THE ARTISTS

MARINA ABRAMOVIĆ
b. 1946, Belgrade (Yugoslavia); lives in Amsterdam (Netherlands)

Select exhibitions
'Artist Body – Public Body', Kunstmuseum Bern, 1998
'Ulay/Abramović Video Performances 1976–1998', Musée d'Art Contemporain, Lyon, 1999
'Marina Abramović', Kunstverein Hannover, 2000
'The Hero', Hirshhorn Museum and Sculpture Garden, Washington DC, 2001

Select publications
Marina Abramović: Performing Body (exh. cat.), Milan, 1998
Marina Abramović: Artist Body, Kunstmuseum Bern (exh. cat.), Milan, 1998
Marina Abramović, Ponte (exh. cat.), Milan, 1998

VITO ACCONCI
b. 1940, New York, NY (USA); lives in New York, NY (USA)

Select exhibitions
'Vito Acconci: Public Places', Museum of Modern Art, New York, 1988
'Theatre Project for a Rock Band', Dia Center for the Arts, for the Brooklyn Academy of Music, New York, 1995
'Vito Acconci: Living Off the Museum', Centro Galego de Art Contemporánea, Santiago de Compostela, 1996
'Vito Acconci: Public Art', University of the Arts, Philadelphia, 1999

Select publications
Kirschner, Judith, *Vito Acconci: A Retrospective 1969–1980*, Museum of Contemporary Art (exh. cat.), Los Angeles, 1980
Sobel, Dean, Sandford Kwinter & Vito Acconci, *Vito Acconci: Acts of Architecture*, Milwaukee Museum of Art (exh. cat.), Milwaukee, 2001
Moure, Gloria & Vito Acconci, *Vito Acconci: Writings, Works, Projects*, Barcelona, 2002
Ward, Frazer, *Vito Acconci*, London, 2002
Volk, Gregory & Vito Acconci, *Vito Acconci*, Milan, 2004

BORIS ACHOUR
b. 1966, Marseille (France); lives in Paris (France)

Select exhibitions
'Flash forward', Galerie Chez Valentin, Paris, 2002
'Cosmos', Kunstverein Freiburg; Palais de Tokyo, Paris, 2002
'Brume', Remo – Osaka Contemporary Art Centre, 2003
'Paysage 24/24–7/7', FRI-ART Centre d'art Contemporain, Fribourg, 2003

Select publications
Bourne, Cécile, 'Boris Achour', *Flash Art*, No. 6, Jan–Feb 1998
Piron, François, 'Boris Achour, il le peut', *Mouvement*, No. 9, Dec 1998–Feb 1999
Wetterwald, Elisabeth, 'Boris Achour, Economie de moyens', *Parachute*, No. 218, 2001
Mangion, Eric & François Piron, 'Boris Achour hypothèse de travail', *Art Press*, No. 220, Nov 2002

BAS JAN ADER
b. 1942, Winschoten (Netherlands); d. 1975, between Cape Cod, MA (USA) and Land's End (UK)

Select exhibitions
'Bas Jan Ader', The Art Gallery, University of California, Irvine (touring exh.), 1999
'Implosion: Bas Jan Ader', Kunstverein Braunschweig (touring exh.), 2000
'Bas Jan Ader 1970–74', Portikus, Frankfurt, 2003

Select publications
Bas Jan Ader: Kunstenaar, Flanders, 1988
Roberts, James, 'Bas Jan Ader: The Artist who Fell from Grace with the Sea', *Frieze*, 17, June–Aug 1994
Müller, Christopher (ed.), *Bas Jan Ader: Filme, Fotografien, Projektionen, Videos und Zeichnungen aus den Jahren 1967–1975*, Cologne, 2000
Spence, Jan, *Bas Jan Ader*, New York, 2000

AGENCY
International collaborative network founded in 1992

Select exhibitions
'smuggle', Neuer Aachener Kunstverein, Aachen, 2000
'access 121', Kaaitheatre, Brussels, 2001
'register confusing uses of trademarks', CASCO, Utrecht, 2002
'legal space/public space', établissement d'en face, Brussels, 2003

Select publications
Laboratorium, Museum voor Fotografie e.a. (exh. cat.), Antwerp, 1999
Culturas de Archivo, Fundació Antoni Tàpies (exh. cat.), Barcelona, 2000
Mutations, Arc en Rêve Centre d'Architecture (exh. cat.), Bordeaux, 2001

Interarchiv, Kunstraum der Universität (exh. cat.), Lüneburg, 2002

EIJA-LIISA AHTILA
b. 1959, Hämeenlinna (Finland); lives in Helsinki (Finland)

Select exhibitions
Museum of Contemporary Art, Chicago, 1999
Neue Nationalgalerie, Berlin, 2000
Documenta 11, Kassel, 2002
Tate Modern, London (touring exh.), 2002

Select publications
Erkintalo, Tiina, 'End of the Story/Between Self And Other', 48th Venice Biennale (exh. cat.), 1999
Vetrocq, Marcia E., 'Eija-Liisa Ahtila Is Not Going Crazy', *Art in America*, Oct 2002
Iles, Chrissie, 'Thinking In Film; Eija-Liisa Ahtila in conversation with Chrissie Iles/Denken in Form von Film: Eija-Liisa Ahtila im Gespräch mit Chrissie Iles', *Parkett*, No. 68, 2003

PAWEL ALTHAMER
b. 1967, Warsaw (Poland); lives in Warsaw (Poland)

Select exhibitions
Bródno 2000, Warsaw, 2000
Manifesta 3, Ljubljana, 2000
'Ausgeträumt…', Secession, Vienna, 2002
50th Venice Biennale, Venice, 2003

Select publications
Przywara, Andrzej, 'Ein Regisseur de Wirklichkeit', in *In Freiheit – endlich: Polonische Kunst nach 1989*, Kunsthalle Baden-Baden, 2000
Cameron, Dan, 'Manifesta 3', *Artforum* XII, 2000
Bonami, Francesco, 'Requiem for a dream', *Flash Art*, March–Apr 2002
Prinzhorn, Martin, 'Looking back without being able to see' and Szymczyk, Adam, 'The Annotated Althamer', in *Afterall*, May 2002

FRANCIS ALŸS
b. 1959, Antwerp (Belgium); lives in Mexico City (Mexico)

Select exhibitions
'The Modern Procession', Museum of Modern Art Queens, New York, 2002
Lima Biennial, Lima, 2002
'Obra Pictorica, 1992–2002', Centro Nazionale per le Arte Contemporanea, Rome (touring exh.), 2002–03

Select publications
Iorres, David G., Cuauhtemoc Medina & Mario
Flecha, *Francis Alÿs: The Last Clown*, Fundació La
Caixa (exh. cat.), Barcelona, 1999
Medina, Cuauhtemoc, Thierry Davila & Carlos
Basualdo, *Francis Alÿs*, Musée Picasso (exh. cat.),
Antibes, 2001
Lampert, Catherine (ed.), *The Prophet and the Fly*
(exh. cat. 'Obra Pictorica, 1992–2002'), Rome,
Zurich & Madrid, 2003

CARLOS AMORALES
b. 1970, Mexico City (Mexico); lives in Mexico City
(Mexico) and Amsterdam (Netherlands)

Select exhibitions
'Let's Entertain', Walker Art Center, Minneapolis
(touring exh.), 2000
'CABARET AMORALES', Migros Museum, Zurich,
2001
'Stage for an Imaginary Friend', Galerie Yvon Lambert,
Paris, 2003
'Amorales vs Amorales', Tate Modern, London, 2003

Select publications
Fresh Cream, London, 2000
Los Amorales, Artimo Foundation, Amsterdam, 2001
*Mexico City: An Exhibition about the Exchange
Rates of Bodies and Values*, PS1 (exh. cat.), New
York; Kunst-Werke, Berlin, 2002
We Are the World, Dutch Pavilion, Venice Biennale
(exh. cat.), Artimo Foundation, Amsterdam, 2003

MATTHEW BARNEY
b. 1967, San Francisco, CA (USA); lives in New York,
NY (USA)

Select exhibitions
'CREMASTER 5', Fundació La Caixa, Barcelona, 1998
'CREMASTER 2: The Drones' Exposition', Walker Art
Center, Minneapolis; San Francisco Museum of
Modern Art, 2000
'Matthew Barney: The CREMASTER Cycle', Solomon
R. Guggenheim Museum, New York (touring exh.),
2002–03
50th Venice Biennale, Venice, 2003

Select publications
Kimmelman, Michael, 'The Importance of Matthew
Barney', *New York Times Magazine*, 10 Oct 1999
Wakefield, Neville, 'The Passenger', *Frieze*, 67, May
2002
Holden, Stephen, 'Racing Dead Horses. Dental
Torture. The Usual', *New York Times*, 15 May 2002
Kimmelman, Michael, 'Free to Play and be Gooey',
New York Times, 21 Feb 2003

JÉRÔME BEL
b. 1968, Montpellier (France); lives in Paris (France)

Select performances
'Nom donné par l'auteur', Lisbon, 1994
'Jérôme Bel', Brussels, 1995
'Xavier Le Roy', Ghent, 1999
'The Show Must Go On', Hamburg & Paris, 2001

Select publications
Tim Etchells (ed.), *Certain Fragments*, London, 1999
Alphant, Marianne & Nathalie Léger (eds), *R/B:
Roland Barthes*, Editions du Centre Pompidou, Paris,
2002
Pavlova, Adriana & Roberto Pereira, 'Coreografia de
um década', in *O Panorama RIOARTE de Dança*,
Rio de Janeiro, 2002

LAURA BELÉM
b. 1974, Belo Horizonte (Brazil); lives in Belo
Horizonte (Brazil)

Select exhibitions
'Programa Rumos Visuais', Instituto Itaú Cultural,
São Paulo, Recife & Fortaleza, 2000–01
'Coreografia para Figuras Infláveis' (collaboration with
Thomas Kampe), Paço das Artes, São Paulo, 2002
'Projeto Pampulha', Museu de Arte da Pampulha, Belo
Horizonte, 2002
1st Prague Biennial, Prague, 2003

Select publications
Moura, Rodrigo, 'Beyond Sculpture: New Perspectives
on Space in Brazil', *Flash Art*, No. 230, May–June
2003

RICHARD BILLINGHAM
b. 1970, Birmingham (UK); lives in London (UK)

Select exhibitions
'New Pictures', Anthony Reynolds Gallery, London,
2003
Trafo – House of Contemporary Arts, Budapest, 2003
50th Venice Biennale, Venice, 2003

Select publications
Ray's a Laugh, Zurich, 1996
Richard Billingham, Ikon (exh. cat.), Birmingham, 2000
Turner Prize 2001 (exh. cat.), Tate Britain, London,
2001

JOHN BOCK
b. 1965, Gribbohm (Germany); lives in Berlin (Germany)

Select exhibitions
'Four Lectures', Museum of Modern Art, New York,
2000

'A Little Bit of History Repeated', Kunst-Werke Berlin,
2001
Documenta 11, Kassel, 2002
'Schwarzsauer Knilch', Museum Boijmans van
Beuningen, Rotterdam, 2003
The Carnegie International, Pittsburgh, 2004

Select publications
Schmidt, Eva (ed.), *John Bock: Gribbohm*,
Gesellschaft für Aktuelle Kunst (exh. cat), Bremen,
2000
Hoffmann, Jens, Daniel Birnbaum & Jan Avgikos, in
Parkett, No. 67, 2003
Hoffmann, Jens, 'The World is a Stage', in *John Bock:
Koppel*, Museum for Moderne Kunst (exh. cat.),
Arken, 2004

JENNIFER BORNSTEIN
b. 1970, Seattle, WA (USA); lives in Los Angeles, CA
(USA)

Select exhibitions
'Exit: International artist-made film and video',
Chisenhale Gallery, London, 2000
'Greater New York', PS1, New York, 2000
'A Passion for Art: The Disaronno Originale
Photography Collection', Museum of Contemporary
Art, Chicago, 2001
'Celestial Spectacular', Blum & Poe, Los Angeles,
2002

Select publications
Gingeras, Alison, 'The Problem of Historiography',
ArtPress, Issue 246, May 1999
Myers, Terry, 'You Keep It Moving But You're
Standing Still', in *Standing Still and Walking in Los
Angeles* (exh. cat.), New York, 1999
Corris, Michael, 'Face On', *Art Monthly*, Oct 2000
Hainley, Bruce, 'Jennifer Bornstein, Blum and Poe',
Artforum, 2000

DELIA BROWN
b. 1969, Berkeley, CA (USA); lives in Los Angeles,
CA (USA)

Select exhibitions
'What, Are You Jealous?', D'Amelio Terras, New York,
2000
'No Place Like Home', Margo Leavin Gallery, Los
Angeles, 2001
'Forsaken Lover', Il Capricorno, Venice, 2002
'Pastorale', D'Amelio Terras, New York, 2002

Select publications
Frankel, David, 'David Frankel on Delia Brown',
Artforum, Jan 2001
Pagel, David, 'Strength in Subtlety', *Los Angeles
Times*, 23 Nov 2001

Gaines, Malik, 'Delia Brown', *Artext*, Spring 2002
Cohen, Michael, 'Delia Brown: Artificial Life', *Flash Art*, March–Apr 2003

CHRIS BURDEN
b. 1946, Boston, MA (USA); lives in Los Angeles, CA (USA)

Select exhibitions
Galerie Anne de Villepoix, Paris, 1998
Arts Club of Chicago, Illinois, 2001
Museum Moderner Kunst, Vienna, 2002
Gagosian Gallery, New York, 2003

Select publications
'Out of Actions, between performance and the object, 1949–1979', Museum of Contemporary Art (exh. cat.), Los Angeles, 1998
'Chris Burden: When Robots Rule: The Two Minute Airplane Factory', Tate Gallery (exh. cat.), London, 1999
Dagen, Philippe, 'Un futur en forme de désastre', *Le Monde*, 1 July 1999

VICTOR BURGIN
b. 1941, Sheffield (UK); lives in London (UK)

Select exhibitions
'Nietzsche's Paris', Architectural Association, London; Christine Burgin Gallery, New York, 2000–01
'Victor Burgin', Fundació Antoni Tàpies, Barcelona, 2001
'I Promise It's Political', Museum Ludwig, Cologne, 2002
'Listen to Britain: Works by Victor Burgin', Cornerhouse, Manchester, 2003
'Room', Christine Burgin Gallery, New York, 2003

Select publications
Burgin, Victor (ed.), *Thinking Photography*, London, Basingstoke & New Jersey, 1982
Burgin, Victor, *The End of Art Theory: Criticism and Postmodernity*, London, Basingstoke & New Jersey, 1986
Victor Burgin: Robert Gwathmey Lectures, Cooper Union for the Advancement of Science and Art, New York, 2000
Burgin, Victor, *The Remembered Film*, London, 2003

JEFF BURTON
b. 1963, Anaheim, CA (USA); lives in Los Angeles, CA (USA)

Select exhibitions
Sadie Coles HQ, London, 2000
'The Americans: New Art', Barbican, London, 2001
Galerie Emmanuel Perrotin, Paris, 2001
Galleria Franco Noero, Turin, 2002

'Kevin', Casey Kaplan, New York, 2003

Select publications
Jeff Burton: Untitled, Tokyo, 1998
Wakefield, Neville (ed.), *Jeff Burton: Dreamland*, New York, 2001
Waters, John & Bruce Hainley, *Art – A Sex Book*, London, 2004

CAI GUO-QIANG
b. 1957, Quanzhou City, Fujian Province (China); lives in New York, NY (USA)

Select exhibitions
48th Venice Biennale, Venice, 1999
'I Am the Y2K Bug', Kunsthalle Wien, Vienna, 1999
'Transient Rainbow', Museum of Modern Art, New York, 2002
'Cai Guo-Qiang', Shanghai Art Museum, 2002

Select publications
Fei Dawei, *Cai Guo-Qiang*, London, 2000
An Arbitrary History, Musée d'Art Contemporain (exh. cat.), Lyon, 2002
Cai Guo-Qiang, London, 2002
Heartney, Eleanor, 'Cai Guo-Qiang: Illuminating the New China', *Art in America*, May 2002

SOPHIE CALLE
b. 1953, Paris (France); lives in Malakoff (France) and New York, NY (USA)

Select exhibitions
'The Birthday Ceremony', Tate Gallery, London, 1998
'L'erouv', Jewish Museum, New York, 1999
Sprengel Museum, Hannover, 2002
Toyota Municipal Museum of Art, Toyota Aichi, 2003
Centre Pompidou, Paris, 2003

Select publications
Calle, Sophie & Paul Auster, *Gotham Handbook*, London, 1998
Calle, Sophie, in collaboration with Paul Auster, *Double Game*, London, 1999
The Detachment/Die Entfernung, Kulturwissenschaftliches Institut (exh. cat.), Essen, 1999
Die wahren Geschichten der Sophie Calle, Museum Fridericianum (exh. cat.), Kassel, 2000
Calle, Sophie, *L'absence*, Editions Actes Sud, 2000

JUAN CAPISTRAN
b. 1976, Guadalajara (Mexico); lives in Los Angeles, CA (USA)

Select exhibitions
'Over the Hills and Far Away', Action Space, Los Angeles, 1998

'Working Classics', Side Street Projects, Los Angeles, 2001
'One Planet Under a Groove: Hip Hop and Contemporary Art', The Bronx Museum of the Arts, New York, 2001
'A Show That Will Show That A Show Is Not Only A Show', The Project, Los Angeles, 2002

Select publications
Yee, Lydia, 'Breaking and Entering', *One Planet Under a Groove: Hip Hop and Contemporary Art* (exh. cat.), New York, 2001
McCaffery, Damien, 'Under the Influence', *Vibe*, Jan 2002
Smith, Roberta, 'Out of the Vociferous Planet and in the Orbit of Funk and Hip-Hop', *New York Times*, 18 Jan 2002
Cotter, Holland, 'Doing Their Own Thing, Making Art Together', *New York Times*, 19 Jan 2003

JANET CARDIFF
b. 1957, Brussels, ON (Canada); lives in Berlin (Germany)

Select exhibitions
'The Missing Voice', Artangel, London, 1999
49th Venice Biennale, Venice, 2001
'Janet Cardiff and George Bures Miller: The Berlin Files', Portikus, Frankfurt, 2003
'Janet Cardiff and George Bures Miller: Recent Work', Whitechapel Art Gallery, London, 2003

Select publications
Elusive Paradise: The Millennium Prize, National Gallery of Canada, Ottawa, 2001
Christov-Bakargiev, Carolyn, *Janet Cardiff: A Survey of Works including Collaborations with George Bures Miller*, PS1 Contemporary Art Center (exh. cat.), Long Island, New York, 2001
Janet Cardiff – George Bures Miller, Astrup Fearnley Museet for Moderne Kunst, Oslo, 2003

FRANKLIN CASSARO
b. 1962, Rio de Janeiro (Brazil); lives in Rio de Janeiro (Brazil)

Select exhibitions
'A metamorfose das Coisas', Universidade Federal fluminense, Niterói, Rio de Janeiro, 1998
'Abrigo', Galeria Cândido Portinari, Universidade do Estado Rio de Janeiro, 1999
'Razão & Desejo', Galeria Baro Sena, São Paulo, 2000
'Franklin Cassaro', Greenaway Art Gallery, Adelaide, 2001
'Franklin Cassaro', Museu de Arte da Pampulha, Belo Horizonte, 2002

Select publications
Sexta feira, Editora Hedra, Spring 1999
Pedrosa, Adriano, 'Passim, inc.', *TRANS>arts.
cultures.media*, August 2000
Cream3, London, 2002
Vergne, Philippe, 'How Latitudes Become Forms:
Art in a Global Age', Walker Art Center (exh. cat.),
Minneapolis, 2003

MAURIZIO CATTELAN
b. 1960, Padua (Italy); lives in New York, NY (USA)

Select exhibitions
'Project #65', Museum of Modern Art, New York,
2001
'Felix', Museum of Contemporary Art, Chicago, 2001
'Maurizio Cattelan', Marian Goodman Gallery, New
York, 2002
'Maurizio Cattelan', Museum of Contemporary Art,
Los Angeles, 2003

Select publications
Bonami, Francesco, 'Every Artist can be a Man, The
Silence of Beuys is Understandable' and Bourriaud,
Nicolas M., 'A Grammar of Visual Delinquency',
Parkett, No. 59, 2000
Gioni, Massimiliano, 'Maurizio Cattelan, "Him"',
Flash Art, May–June 2001
Vogel, Carol, 'Don't Get Angry. He's Kidding.
Seriously', *New York Times*, 13 May 2002
Lageira, Jacinto, 'Absurdity for all, belonging to
Nobody, Maurizio Cattelan', *Parachute, #109*,
Jan 2003

LYGIA CLARK
b. 1920, Belo Horizonte (Brazil); d. 1988, Rio de
Janeiro (Brazil)

Select exhibitions
1st Exposição Nacional de Arte Concreta, Museu de
Arte Moderna, São Paulo, 1956
1st Exposição Neoconcreta, Museu de Arte
Moderna, Rio de Janeiro, 1959
30th and 31st Venice Biennals, Venice, 1960/
1962
Documenta 10, Kassel, 1997
24th São Paulo Bienal, São Paulo, 1998

Select publications
Brett, Guy, 'Lygia Clark: the borderline between art
and life', *Third Text*, No. 1, Autumn 1987
Milliet, Maria Alice, *Lygia Clark: obra-trajeto*, EDUSP,
São Paulo, 1992
Bois, Yve-Alain, 'Nostalgia of the Body: Lygia Clark',
October, No. 69, 1994
Borja-Villel, Manuel et al. (eds), *Lygia Clark*, Fundació
Antonio Tàpies, Barcelona, 1997

COLECTIVO CAMBALACHE
Collective founded in 1998 by Carolina Caycedo,
Adriana García Galán, Alonso Gil and Federico
Guzmán; based in England, France and Spain

Select exhibitions
7th International Istanbul Biennial, Istanbul, 2001
'Da Adversidade Vivemos', Musée d'Art Moderne de
la Ville de Paris, 2001
I Ceara Biennial, Museo Dragao do Mar, Fortaleza,
2002
'Shadow Cabinets in a Bright Country', Kunsthalle
Fridericianum, Kassel, 2003

Select publications
Basualdo, Carlos, 'Colectivo Cambalache', *Flash Art*,
No. 214, Oct 2000
Here, There, Elsewhere, London, 2002
Gabri, Rene, 'Looking for the Big Idea',
www.16beavergroup.org/journalisms052802.htm,
2002

MINERVA CUEVAS
b. 1975, Mexico City (Mexico); lives in Mexico City
(Mexico) and Berlin (Germany)

Select exhibitions
'Mejor Vida Corp', Museo Rufino Tamayo, Mexico
City, 2000
24th Biennial of Graphic Arts, Ljubljana, 2001
'Exchange Rates of Bodies and Values', Kunst-Werke,
Berlin; PS1, New York, 2002
'Hardcore', Palais de Tokyo, Paris, 2003

Select publications
Medina, Cuauhtemoc, 'Recent Political Forms.
Radical Pursuits in Mexico', *TRANS> #8
arts.cultures.media*, 2000
Da Adversidade Vivemos, Musée d'Art Moderne de
la Ville de Paris (exh. cat.), Paris, 2001
Cuenca, Alberto Lopez, 'Presents of Mind', *ARTnews*,
Vol. 101, No. 3, March 2002

ROBERTO CUOGHI
b. 1973, Modena (Italy); lives in Milan (Italy)

Select exhibitions
'Guarene Arte 99', Fondazione Sandretto Re
Rebaudengo, Guarene d'Alba, 1999
'Il dono – The Gift', Palazzo delle Papesse, Siena, 2001
'Exit, Nuove geografie della creatività italiana',
Fondazione Sandretto Re Rebaudengo, 2002
Manifesta 4, Frankfurt, 2002
'Roberto Cuoghi foolish things', Galleria d'Arte
Moderna e Contemporanea, Bergamo, 2003

Select publications
De Cecco, E., 'Roberto Cuoghi', *Guarene Arte 99*,

Palazzo Re Rebaudengo, Guarene d'Alba, 1999
Hoffmann, Jens, 'Roberto Cuoghi', *Flash Art*, No.
214, Oct 2000
Rabottini, A., 'Roberto Cuoghi', *Flash Art*, No. 238,
Feb–March 2003

TRISHA DONNELLY
b. 1974, San Francisco, CA (USA); lives in Los
Angeles, CA (USA)

Select exhibitions
'The Dedalic Convention', MAK Museum, Vienna,
2001
'Moving Pictures', Solomon R. Guggenheim Museum,
New York (touring exh.), 2002
50th Venice Biennale, Venice, 2003
'Young Scene', Secession, Vienna, 2003
Biennale de Lyon, 2003

Select publications
Cream3, London, 2002
Hoffmann, Jens, 'Trisha Donnelly', *Flash Art*,
March–Apr 2002
Miller, John, 'Openings: Trisha Donnelly', *Artforum*,
Summer 2002

DUCHA (EDUARDO MENEZES PACHECO)
b. 1977, Rio de Janeiro (Brazil); lives in Rio de Janeiro
(Brazil)

Select exhibitions
Museu de Arte Moderna, São Paulo, 2001
'After Sherrie Levine', Mostra Rio Arte
Contemporanea, Museu de Arte Moderna, Rio de
Janeiro, 2002
'Faraway from the wild heart', Cinema Capacete,
Escola de Cinema Darcy, Ribeiro, Rio de Janeiro,
2002
'Laranja Video. Public Disturbance', Saw Gallery,
Ottawa, 2002
'Silogismos', Galeria Sérgio Porto, Rio de Janeiro,
2003

MARIA EICHHORN
b. 1962, Bamberg (Germany); lives in Berlin
(Germany)

Select exhibitions
'Museum Street', Sprengelmuseum, Hannover, 1999
'May Day Film Media City', Portikus, Frankfurt, 1999
'Money at the Kunsthalle Bern', Kunsthalle Bern, 2001
Documenta 11, Kassel, 2002

Select publications
Eichhorn, Maria, *Wie entsteht eine Stadt?, What is
the origin of a city? Skulptur.Projekte in Münster
1997*, Westfälisches Landesmuseum Münster, 1997

Eichhorn, Maria, 'The Artist's Reserved Rights Transfer and Sale Agreement' by Seth Siegelaub and Robert Projansky, Salzburg Kunstverein (exh. cat.), Salzburg, 1998
'Maria Eichhorn, Curtain (Denim)/Lectures by Yuko Fujita', Mika Obayashi Centre of Contemporary Art, Kitakyushu, 1999

OLAFUR ELIASSON
b. 1967 Copenhagen (Denmark); lives in Berlin (Germany)

Select exhibitions
Manifesta 1, Rotterdam, 1996
48th Venice Biennale, Venice, 1999
'Everything can be different', Art Museum, University of Memphis, Tennessee, 2001
50th Venice Biennale, Venice, 2003
'The Weather Project', Tate Modern, London, 2003

Select publications
Olafur Eliasson: your real thing is time, Institute of Contemporary Art (exh. cat.), Boston, 2001
Olafur Eliasson, London, 2002
Weibel, Peter (ed.), Surroundings Surrounded, Cambridge, MA, 2002
Olafur Eliasson: chaque matin je me sens différent, chaque soir je me sens le même, Musée d'Art Moderne de la Ville de Paris (exh. cat.), Paris, 2002

MICHAEL ELMGREEN AND INGAR DRAGSET
Michael Elmgreen, b. 1961, Copenhagen (Denmark) and Ingar Dragset, b. 1969, Trondheim (Norway), collaborating since 1995; live in Berlin (Germany)

Select exhibitions
'Zwischen anderen Ereignissen', Galerie für Zeitgenössische Kunst, Leipzig, 2000
25th São Paulo Bienal, São Paulo, 2002
50th Venice Biennale, Venice, 2003
'Untitled', Tate Modern, London, 2004

Select publications
A Room Defined by its Accessibility, Statens Museum for Kunst (exh. cat.), Copenhagen, 2001
Birnbaum, Daniel, 'White on white: The Art of Michael Elmgreen & Ingar Dragset', Artforum, No. 8, Apr 2002
Ruf, Beatrix (ed.), Taking Place: The Works of Michael Elmgreen & Ingar Dragset, Kunsthalle Zurich (exh. cat.), Zurich, 2002
Spaced Out, Portikus (exh. cat.), Frankfurt, 2003

ANNIKA ERIKSSON
b. 1956, Malmö (Sweden); lives in Berlin (Germany)

Select exhibitions
'Collectors', Moderna Museet, Stockholm, 1998

'Democracy', Royal College of Art, London, 2000
'Everything can be different', Independent Curators International, New York, 2001
'VI–Intentional Communities', Rooseum, Malmö; CAC, Vilnius, 2001
25th São Paulo Bienal, São Paulo, 2002

Select publications
Fresh Cream, London, 2000
Stjernstedt, Mats, 'This moment and these people', in Wiederaufnahme, Neuer Aachener Kunstverein, Aachen; Revolver Archiv für Aktuelle Kunst (exh. cat.), Frankfurt, 2001
Hoffmann, Jens, 'Connecting', in Staff at the 25th São Paulo Bienal, Moderna Museet, Stockholm, 2002
Kamiya, Yukie, 'Conversation with Annika Eriksson', in Curator's Egg, Shiseido Gallery, Tokyo, 2003

PETER FRIEDL
b. 1960, Oberneukirchen (Austria); lives in Berlin (Germany)

Select exhibitions
'Peter Friedl', Palais des Beaux-Arts, Brussels, 1998
48th Venice Biennale, Venice, 1999
'Let's Entertain', Walker Art Center, Minneapolis (touring exh.), 2000
'luttesdesclasses', Institut d'art contemporain, Villeurbanne, 2002

Select publications
Buergel, Roger M., Peter Friedl, Dresden, 1999
Friedl, Peter, Der Fluch des Leguans. Über Genre und Macht/The Curse of the Iguana. On Genre and Power, Revolver Archiv für Aktuelle Kunst, Frankfurt, 2000
Friedl, Peter, Kromme Elleboog, Witte de With, Centre for Contemporary Art, Rotterdam, 2001
Peter Friedl (exh. cat.), Luxembourg, Bremen, Cape Town & Frankfurt, 2001
Stange, Raimar, Zurück in die Kunst, Hamburg, 2003

HAMISH FULTON
b. 1946, London (UK); lives in Canterbury (UK)

Select exhibitions
Stadtische Galerie Nordhorn; Kunstverein Dusseldorf (with Peter Hutchinson), 1998
Palais Thurn und Taxis, Bregenz, 1999
Galerie Mueller-Roth, Stuttgart, 1999
'Placing One Foot in Front of the Other', Bawag Foundation, Vienna, 2002–03

Select publications
Hamish Fulton, Edition Galerie Stadtpark, Krems, 1997
Hamish Fulton, Art Museum (exh. cat.), Missoula, 1999

Hamish Fulton: Walking Artist, Dusseldorf, 2001
Walking Journey, Tate Britain (exh. cat.), London, 2002
Placing One Foot in Front of the Other, Bawag Foundation, Vienna, 2002

ANNA GASKELL
b. 1969, Des Moines, IA (USA); lives in New York, NY (USA)

Select exhibitions
'Anna Gaskell', Museum of Contemporary Art, Miami (touring exh.), 1998–99
'by proxy', Aspen Art Museum, Colorado, 2000
'future's eve', New Langton Arts, San Francisco, 2001
'resemblance', Des Moines Art Center (touring exh.), 2001–02
'Moving Pictures', Solomon R. Guggenheim Museum, New York, 2002

Select publications
Basualdo, Carlos, Francesco Bonami et al, Cream: Contemporary Art in Culture, London, 1998
Windsor, Esther (ed.), The Citibank Private Bank Photography Prize 2000, Photographers' Gallery, London, 2000
Anna Gaskell, New York, 2001
Drutt, Matthew, half life, Menil Collection (exh. cat.), Houston, 2002

ALEXANDER GERDEL
b. 1966, Caracas (Venezuela); lives in Caracas (Venezuela)

Select exhibitions
'Made in Mexico – Made in Venezuela', Art Metropole, Toronto, 1999
'Demonstration Room/Ideal House', Gallery 400, Chicago (touring exh.), 2000–02
'Utopolis', Galeria de Arte Nacional, Caracas, 2001
1st Prague Biennial, Prague, 2003
'Still lifes', Museo de Bellas Artes, Caracas, 2003

Select publications
Rangel, Gabriela, 'Legitimar lo infra leve', in Re-Readymade, Museo Alejandro Otero (exh. cat.), Caracas, 1997
Fuenmayor, Jesús, 'Change Life, Transform Society, Aperto Venezuela', Flash Art, Vol. XXXI, No. 198, Jan–Feb 1998
Fajardo, Cecilia, IX Edición Premio Eugenio Mendoza, Sala Mendoza (exh. cat.), Caracas, 1998

GILBERT & GEORGE
Gilbert, b. 1943, Dolomites (Italy) and George, b. 1942, Devon (UK); live in London (UK)

Select exhibitions
'Gilbert & George', Solomon R. Guggenheim Museum, New York, 1985
'Pictures 1982–85', Hayward Gallery, London, 1987
'The Naked Shit Pictures', South London Art Gallery, London, 1995
'Enclosed and Enchanted', Museum of Modern Art, Oxford, 2000
'The Dirty Words Pictures', Serpentine Gallery, London, 2002

Select publications
Jahn, Wolf, *The Art of Gilbert & George*, London, 1989
Farson, Daniel, *With Gilbert & George in Moscow*, London, 1991
Ratcliff, Carter & Robert Rosenblum, *Gilbert & George: The Singing Sculpture*, London & New York, 1993
Rosenblum, Robert, Nonomura Fumihori & Sumikura Yoshiki, *Gilbert & George: Art for All 1971–1996*, Sezon Museum of Art, Tokyo, 1997
Rosenblum, Robert, *Introducing Gilbert & George*, London, 2004

GOB SQUAD
Collective founded in 1994: core members Johanna Freiburg, Berit Stumpf, Sarah Thom, Sean Patten and Simon Will; based in Berlin and Nottingham

Select performances
'Calling Laika', Das TAT, Frankfurt (touring), 1998
'What Are You Looking At?', Berlin Biennale (touring), 1998
'Where Do You Want To Go To Die?', Hannover EXPO (touring), 2000
'Dun Roamin'', South Bank Centre, London (touring), 2002–03
'Room Service: Help Me Make It Through The Night', Intercity Hotel, Hamburg (touring), 2003–04

Select publications
Goldberg, RoseLee, *Performance: Live Art since the 60s*, London, 1998
Lehmann, Hans-Thies, *Postdramatisches Theater*, Frankfurt, 1999
Matzke, Annemarie, *Spielen, Testen, Tricksen, Scheitern – Selbst-Inszenierung im zeitgenössischen Performance-Theater*, Hildesheim, New York & Zürich, 2004

DOMINIQUE GONZALEZ-FOERSTER
b. 1965, Strasbourg (France); lives in Paris (France)

Select exhibitions
'88:88', Kaiser Wilhelm Museum, Krefeld, 1998
'Riyo Central', Portikus, Frankfurt, 2001
Documenta 11, Kassel, 2002
50th Venice Biennale, Venice, 2003
'Multiverse', Kunsthalle Zurich, 2004

Select publications
Dominique Gonzalez-Foerster, Pierre Huyghe, Philippe Parreno, Musée d'Art Moderne de la Ville de Paris, 1998
Moisdon-Trembley, Stéphanie, *Dominique Gonzalez-Foerster*, Paris, 2002
Films: Dominique Gonzalez-Foerster, Portikus, Frankfurt & Le Consortium, Dijon, 2003

FELIX GONZALEZ-TORRES
b. 1957, Guaimaro (Cuba); d. 1996, New York, NY (USA)

Select exhibitions
Solomon R. Guggenheim Museum, New York, 1995
Sprengel Museum, Hannover (touring exh.), 1997
'Felix Gonzalez-Torres', Serpentine Gallery, London, 2000
'Felix Gonzalez-Torres', Andrea Rosen Gallery, New York; Sadie Coles HQ, London, 2002

Select publications
Bartman, William S. (ed.), *Felix Gonzalez-Torres*, New York, 1993
Watney, Simon, 'In Purgatory: The Work of Felix Gonzalez-Torres', *Parkett*, No. 39, 1994
Elger, Dietmar (ed.), *Felix Gonzalez-Torres Catalogue Raisonné*, New York, 1997
Spector, Nancy, *Felix Gonzalez-Torres*, New York, 1999
Corrin, Lisa, *Felix Gonzalez-Torres*, London, 2000

DOUGLAS GORDON
b. 1966, Glasgow (UK); lives in New York, NY (USA) and Glasgow (UK)

Select exhibitions
Dia Center for the Arts, New York, 1999
Museum of Contemporary Art, Los Angeles (touring exh.), 2001
'Douglas Gordon', Kunsthaus Bregenz, 2002
'Douglas Gordon. What Have I Done', Hayward Gallery, London, 2002–03

Select publications
Schneider, Eckhardt (ed.), *Douglas Gordon, Kunstverein* (exh. cat.), Hannover, 1998
Debbart, Jan & Marente Bloemheuvel, *Kidnapping/Douglas Gordon*, Stedelijk Van Abbemuseum, Eindhoven, 1999
Feature Film, a book by Douglas Gordon, Artangel/Bookworks/Agnes b, 1999
Francis, Mark (ed.), *Douglas Gordon*, Tate Liverpool, 2000
'Douglas Gordon', LA MOCA, Los Angeles, 2002

DAN GRAHAM
b. 1942, Urbana, IL (USA); lives in New York, NY (USA)

Select exhibitions
'Dan Graham', Fundació Antoni Tàpies, Barcelona, 1998
'Dan Graham, Architekturmodelle', Kunst-Werke Berlin, 1999
'Dan Graham Works 1965–2000', Museu Serralves, Porto (touring exh.), 2001
'Dan Graham Works 1965–2000', KIASMA, Helsinki, 2002
'Dan Graham Retrospective', Chiba City Museum of Art, 2003

Select publications
'Dan Graham and Wanas 2000', *Tema Celeste*, Oct–Dec 2000
Gingeras, Alison M., 'Dan Graham/Musée d'art moderne de la ville', *Art Press*, No. 271, Sept 2001
Dan Graham: Works 1965–2000, D.A.P., Dusseldorf, 2001

RODNEY GRAHAM
b. 1949, Vancouver, BC (Canada); lives in Vancouver, BC (Canada)

Select exhibitions
'Rodney Graham: Cinema, Music, Video', Kunsthalle Wien, Vienna, 1999
'Rodney Graham, Some Works with Sound Waves, Some Works with Light Waves and Some Other Experimental Works', Kunstverein Munich (touring exh.), 2000
'Rodney Graham', Milwaukee Art Museum, Wisconsin, 2001
'Rodney Graham', Whitechapel Art Gallery, London (touring exh.), 2002–03

Select publications
Rodney Graham: Vexation Island and Other Works, Art Gallery of York University (exh. cat.), Toronto, 1998
Alberro, Alexander, 'Rodney Graham Vexation Island: Loop Dreams', in *Loop*, 2001
Rodney Graham, Whitechapel Art Gallery (exh. cat.), London, 2002

JOSEPH GRIGELY
b. 1956, East Longmeadow, MA (USA); lives in Chicago, IL (USA)

Select exhibitions
'The Pleasure of Conversing', Wadsworth Atheneum, Hartford, 1999
Whitney Biennial, Whitney Museum of American Art, New York, 2000
Index, Stockholm, 2000
'White Noise', Whitney Museum of American Art, New York, 2001
'Zeitmaschine', Kunstmuseum Bern, 2002

Select publications

'Postcards to Sophie Calle', *Michigan Quarterly Review*, 37.2, Spring 1998, reprinted in Tobin Siebers (ed.), *The Body Aesthetic: From the Body in Fine Arts to Body Modification*, Ann Arbor, 2000
Maar, Christa, Ernst Pöppel & Hans Ulrich Obrist (eds), 'Joseph Grigely im Gespräch mit Hans Ulrich Obrist: Dazwischen entsteht das Wissen', *Weltwissen Wissenwelt: Das globale Netz von Text und Bild*, Cologne, 2000
Fraistat, Neil & Beth Loizeaux (eds), *Reimagining Textuality and Reproduction of the Text*, Madison, 2002
Beil, Ralf (ed.), *Zeitmaschine*, Kunstmuseum Bern, 2002

JENS HAANING
b. 1965, Hoersholm (Denmark); lives in Copenhagen (Denmark)

Select exhibitions

Galleri Nicolai Wallner, Copenhagen, 1994
Gallery Mehdi Chouakri, Berlin, 1997
'I Promise It's Political', Museum Ludwig, Cologne, 2002
Gwangju Biennial, Gwangju, 2002
Documenta 11, Kassel, 2002

Select publications

Larsen, Lars Bang, '25 Swiss francs and a coconut', in *Art/Text*, No. 66, Aug–Oct 1999
Fricke, Harald, 'Jens Haaning', in Charles Esche, Mark Kremer & Adam Szymczyk (eds), *Amateurs*, Göteborg Art Museum (exh. cat.), Göteborg, 2000
Haaning, Jens, 'Jens Haaning's Talk', in Henrik Plenge Jakobsen, Lars Bang Larsen & Superflex (eds.), *Remarks on Interventive Tendencies*, Copenhagen & Cologne, 2001
Pécoil, Vincent & Jens Haaning (eds), *Hello, my name is Jens Haaning: If you don't want to buy this catalogue but are interested in reading or looking in it you will find its entire content on this address: www.jenshaaning.com*, Dijon & Cologne, 2003

NATASCHA SADR HAGHIGHIAN
b. 1967, Denmark; has no studio

Select performances

2002 in an italian restaurant
2002 in a hotel lobby
2002 at the zoo
2001 in a cab
2000 at a busstop
1999 in a cafe
1999 in a thai restaurant

Select publications

Sadr Haghighian, Natascha, 'Waiting for Alfred', in *The Next Documenta Should be Curated by an Artist*, Frankfurt, 2004

Helweg Ovesen, Solvej, 'Interview with Natascha Sadr Haghighian', in *Quicksand*, De Appel (exh. cat.), Amsterdam, 2004
Sadr Haghighian, Natascha & Stefan Heidenreich, 'Petrodollar', in *Mute Magazine* (M27), Berlin, 2004
Lind, Maria, 'Natascha Sadr Haghighian', in *OOTAL*, No. 16, Stockholm, 2004

DUANE HANSON
b. 1925, Alexandria, MN (USA); d. 1996, Boca Raton, FL (USA)

Select exhibitions

Whitney Museum of American Art, New York, 1979
Montreal Museum of Fine Arts, 1994
Saatchi Gallery, London, 1997
Whitney Museum, New York, 1998
National Gallery of Art, Washington DC, 2002–03

Select publications

Documenta 5 (exh. cat.), Kassel, 1972
Varnedoe, Kirk, *Duane Hanson*, New York, 1985
Duane Hanson: Sculpturen/Sculptures, Galerie Neuendorf (exh. cat.), Frankfurt, 1992
Duane Hanson, Montreal Museum of Fine Arts (exh. cat.), Montreal, 1994
Buchsteiner, Thomas & Otto Lenze (eds), *Duane Hanson More Than Reality*, Zurich, 2002

JEPPE HEIN
b. 1974, Copenhagen (Denmark); lives in Berlin (Germany)

Select exhibitions

'Take a walk in the forest at moonlight', Musée d'Art Contemporain, Bordeaux, 2002
'I Promise It's Political', Museum Ludwig, Cologne, 2002
'Take a walk in the forest at sunlight', Kunstverein Heilbronn, 2003
50th Venice Biennale, Venice, 2003

Select publications

Neue Welt, Frankfurter Kunstverein (exh. cat.), Frankfurt, 2001
49th Venice Biennale (exh. cat.), Venice, 2001
Jeppe Hein, Frankfurter Positionen (exh. cat.), Frankfurt, 2001
Auf eigene Gefahr, Schirnkunsthalle (exh. cat.), Frankfurt, 2003

FEDERICO HERRERO
b. 1978, San José (Costa Rica); lives in San José (Costa Rica)

Select exhibitions

'Recuadros', Galerie Jacob Karpio, San José, 2000

'Puertos y Costas Ricas', M.M. Proyectos, San Juan, 2000
'Artistmos', Museum of Fine Arts, Taipei, 2002
'Urgent Painting', Musée d'Art Moderne de la Ville de Paris, 2002

Select publications

Auerbach, Ruth, 'Federico Herrero', 49th Venice Biennale (exh. cat.), Venice, 2001
Diaz Bringas, Tamara, 'Ciudad (in) visible' (exh. cat.), Publicaciones TEORèTica No. 17, San José, 2002
Hans Ulrich Obrist, 'Federico Herrero', in *New Perspectives in Painting*, London, 2002

CARSTEN HÖLLER
b. 1961, Brussels (Belgium); lives in Stockholm (Sweden)

Select exhibitions

'Synchro System', Fondazione Prada, Milan, 2000
'INSTRUMENTE aus dem Kiruna Psycholabor', Schipper & Krome, Berlin, 2001
25th São Paulo Bienal, São Paulo, 2002
50th Venice Biennale, Venice, 2003

Select publications

Neue Welt, Museum für Gegenwartskunst Basel (exh. cat.), Basel, 1999
Carsten Höller. Registro, Fondazione Prada (exh. cat.), Milan, 2000
Spiritus, Magasin 3, Stockholm Konsthall (exh. cat.), Stockholm, 2003

EVAN HOLLOWAY
b. 1967, La Mirada, CA (USA); lives in Los Angeles, CA (USA)

Select exhibitions

Marc Foxx, Los Angeles, 1999
'The Americans', Barbican, London, 2000
The Approach, London, 2001
Whitney Biennial, Whitney Museum of American Art, New York, 2002
'Baja to Vancouver: The West Coast in Contemporary Art', Seattle Art Museum (touring exh.), 2003

Select publications

Hainley, Bruce, 'Evan Holloway: Infinity and Beyond', *Frieze*, 47, June–Aug 1999
Intra, Giovanni, 'Evan Holloway: When Bad Attitude Becomes Form', *Art/Text*, No. 72, Feb–Apr 2002
O'Reilly, Sally, 'Evan Holloway', *Frieze*, March 2002
Hainley, Bruce, 'Towards a Funner Laocoon', *Artforum*, Summer 2002
Pagel, David, 'Around the Galleries: A Video Exhibit that Mocks Video', *Los Angeles Times*, 17 Jan 2003

ZHANG HUAN
b. 1965, An Yang City, He Nan Province (China),
lives in New York, NY (USA)

Select exhibitions
'My America', Deitch Projects, New York, 2000
'Zhang Huan', The Power Plant Contemporary Art
Gallery, Toronto, 2001
'Zhang Huan', Luhring Augustine Gallery, New York,
2001
'Zhang Huan', Kunstverein Hamburg, 2003

Select publications
Anton, Saul, 'Zhang Huan: Maoist Mask of an
Anonymous Everyman', *Flash Art*, Vol. 32, No. 207,
Summer 1999
Olesen, Alexa, 'Making Art of Masochism and Tests
of Endurance', *New York Times*, 11 Nov 2001
'Zhang Huan', *Artforum*, March 2002

CAMERON JAMIE
b. 1969, Los Angeles, CA (USA); lives in Paris
(France)

Select exhibitions
'Au-delà du spectacle', Centre Pompidou, Paris
(touring exh.), 2000
'BB', O.K. Centrum für Gegenwartskunst, Linz,
2000
'Contemporary Projects 5: Legitimate Theater', Los
Angeles County Museum of Art, 2001
'The Fourth Sex: The Extreme People of
Adolescence', Stazione Leopoldo, Florence, 2003
Galerie Christine König, Vienna, 2003

Select publications
Indiana, Gary, 'Cameron Jamie', *Artforum*, Summer
2001
Angus, Denis, 'A Man for All Extremes', *Art Press*,
No. 274, Dec 2001
Hoffmann, Jens, 'Comparative Anatomy', *Flash Art*,
March–Apr 2003
Vergne, Philippe, 'How Latitudes Become Forms',
Walker Art Center (exh. cat.), Minneapolis, 2003

SARAH JONES
b. 1959, London (UK); lives in London (UK)

Select exhibitions
'Painting Pictures', Kuntsmuseum, Wolfsburg, 1999
Huis Marseille Foundation for Photography,
Amsterdam, 2000
'Quotidiana', Castello di Rivoli, Turin, 2000
'Die Wohltat der Kunst: Post-Feministische
Positionen der 90er Jahre aus der Sammlung Goetz',
Staatliche Kunsthalle, Baden-Baden, 2002
Maureen Paley Interim Art, London, 2002

Select publications
Sarah Jones, Museum Folkwang (exh. cat.), Essen,
1999
Sarah Jones, Universidad Salamanca (exh. cat.),
Salamanca, 1999
Sarah Jones, Le Consortium (exh. cat.), Dijon, 2001

AINO KANNISTO
b. 1973, Espoo (Finland); lives in Helsinki (Finland)

Select exhibitions
'Photographs', Fotografisk Center, Copenhagen,
2000
'In a Lonely Place', National Museum of Photography,
Film and TV, Bradford, 2001
'Staged Photographs', m Fotografie, Bochum, 2002
'Trasparente/Transparent', Museo Nazionale delle Arti
del XXI Secolo, Rome, 2003

Select publications
The built and the living, Café Crème (exh. cat.),
Luxembourg, 2002
Moi, toi, nous, Finland's Paris Cultural Institute (exh.
cat.), Paris, 2002
Mois de la Photo a Paris (exh. cat.), Paris, 2002
Narrating space, time and stories, Pontevedra Art
Biennial (exh. cat.), Deputación de Pontevedra, 2002

ALLAN KAPROW
b. 1927, Atlantic City, NJ (USA); lives in Encinitas,
CA (USA)

Select exhibitions
'Out of Actions: Between Performance and the
Object, 1949–79', Museum of Contemporary Art,
Los Angeles (touring exh.), 1998
'Off-Limits: Rutgers University and the Avant-Garde,
1957–63', Newark Museum, 1999
'Over the Edges: The Corners of Ghent', Stedelijk
Museum voor Actuele Kunst, Ghent, 2000
'Made in California: NOW', Los Angeles County
Museum of Art, 2000
'Les Années Pop', Centre Georges Pompidou,
Paris, 2001

Select publications
Kaprow, Allan, *Assemblage, Environments and
Happenings*, New York, 1966
Kaprow, Allan, 'Some Recent Happenings. A Great
Bear Pamphlet', New York, 1966
Kaprow, Allan, *7 Environments*, Fondazione Mudima,
Milan & Studio Morra, Naples (exh. cat.), 1991
Kaprow, Allan, in Jeff Kelley (ed.), *Essays on the
Blurring of Art and Life*, Berkeley, 1993
Kaprow, Allan, 'Just Doing', *The Drama Review*, Vol.
41, No. 3, Fall 1997

ON KAWARA
b. 1933, Aichi (Japan); lives in New York, NY (USA)

Select exhibitions
'On Kawara: One Million Years (Past)', Konrad
Fischer Galerie, Dusseldorf, 2002
'On Kawara: One Million Years (Future)', NRW –
Forum Kultur und Wirtschaft, Dusseldorf, 2002
Ikon Gallery, Birmingham, 2002
'On Kawara, Consciousness, Meditation, Watcher on
the Hills', Centre d'Art Contemporain, Geneva, 2003

Select publications
One Million Years, Antwerp, 1998
Pure Consciousness, 11th Sydney Biennial (exh.
cat.), Sydney, 1998
Quotidiana, Castello di Rivoli, Museo d'arte
Contemporanea (exh. cat.), Turin, 2000
Jonathan Watkins & René Denizot, *On Kawara*,
London, 2002

ELKE KRYSTUFEK
b. 1970, Vienna (Austria); lives in Vienna (Austria)

Select exhibitions
'Protest & Survive', Whitechapel Art Gallery, London,
2000
'I am Your Man', Ars Futura Galerie, Zurich, 2001
'Naakt & Mobil', Sammlung Essl, Vienna, 2002
'Elke Krystufek', Kunstverein Innsbruck, 2003

Select publications
I Am Your Mirror, Secession (exh. cat.), Vienna,
1997
Elke Krystufek: Sleepingbetterland, Galerie Georg
Kargl (exh. cat.), Vienna, 1999
Elke Krystufek: Nobody Has To Know, Galerie
Georg Kargl (exh. cat.), Vienna, 2000
Hoffmann, Jens, *A Little Bit of History Repeated*,
Kunst-Werke Berlin (exh. cat.), Berlin, 2001

SURASI KUSOLWONG
b. 1965, Ayutthaya (Thailand); lives in Bangkok
(Thailand)

Select exhibitions
11th Sydney Biennial, Sydney, 1998
'Cities on the Move', Louisiana Museum of Modern
Art, Humlebaek (touring exh.), 1999
2nd Berlin Biennial, Berlin, 2001
'Shopping', Schirn Kunsthalle, Frankfurt; Tate
Liverpool, 2002
50th Venice Biennale, Venice, 2003

Select publications
Sans, Jérôme, 'Poor Minimal: A Conversation with
Surasi Kusolwong', *Trans>, 9/10*, 2001
Hanru, Hou, 'Surasi Kusolwong, a triggering agent

of love affairs', *ARS 01—Unfolding Perspectives*, KIASMA Museum of Contemporary Art (exh. cat.), Helsinki, 2001
'Energy Storage', Palais de Tokyo, Paris, 2004

LUISA LAMBRI
b. 1969, Como (Italy); lives in Milan (Italy) and London (UK)

Select exhibitions
48th Venice Biennale, Venice, 1999
'Luisa Lambri', Palazzo Re Rebaudengo, Guarene d'Alba, 2001
50th Venice Biennale, Venice, 2003
'Living Inside the Grid', New Museum of Contemporary Art, New York, 2003
'Locations', Menil Collection, Houston, 2004

Select publications
Bonami, Francesco, '34 Questions About Memory and Senses', in *Luisa Lambri*, Fondazione Sandretto Re Rebaudengo per l'Arte, (exh. cat.), Turin, 2001
Gioni, Massimiliano, 'The Shadow Line', in *Untitled (the Experience of Place)*, London and Cologne, 2003
Zabel, Igor, 'Luisa Lambri', in *Form-Specific*, Revolver (exh. cat.), Frankfurt, 2003
Pedrosa, Adriano, *Untitled (Casa das Canoas, 1953), 2003–2004*, Coleção Teixeira de Freitas, Rio de Janeiro, 2004
Drutt, Matthew, 'Luisa Lambri: Locations', in *Luisa Lambri: Locations*, Menil Collection (exh. cat.), Houston, 2004

PETER LAND
b. 1966, Aarhus (Denmark); lives in Copenhagen (Denmark)

Select exhibitions
'Let's Entertain', Walker Art Center, Minneapolis (touring exh.), 2000
'Peter Land', Villa Merkel, Galerie der Stadt Esslingen, 2001
Musée d'art Moderne et Contemporain, Geneva, 2002
'The Ride', Salzburger Kunstverein Salzburg, 2003

Select publications
Step Ladder Blues, Galleri Nicolai Wallner, Copenhagen, 1995
Peter Land, Pordenone, 1998
Larsen, Lars Bang, *Peter Land, Idiot*, Secession, Vienna, 2000
Art at the Turn of the Millennium, Cologne, 2000

XAVIER LE ROY
b. 1963, Juvisy sur Orge (France); lives in Berlin (Germany)

Select performances
'Self-Unfinished', Berlin, 1998
'Product of Circumstances', Berlin, 1999
'Xavier le Roy' (with Jérôme Bel), Ghent, 2000
'Giszelle' (with Eszter Salamon), Berlin, 2001
'Project', Lisbon, 2003; all touring

Select publications
Le Roy, Xavier, 'Product of Circumstances', in Hans Ulrich Obrist & Barbara Vanderlinden (eds), *Laboratorium*, Cologne 2000
'The Science of Movement', interview with Jens Hoffmann in *NU: The Nordic Art Review*, Vol. II, No. 5/00, Stockholm, 2000
'Penser les contours du corps', interview with Jacqueline Caux in *Art Press*, No. 266, March 2001
Goldberg, RoseLee, *Performance Art: From Futurism to the Present*, London & New York, 2001
Bel, Jérôme, 'Qu'ils crèvent les artistes', in *Art Press*, No. 23, Oct 2002

NIKKI S. LEE
b. 1970, Kye Chang (Korea), lives in New York, NY (USA)

Select exhibitions
Leslie Tonkonow Artworks + Projects, New York, 1999
The Institute of Contemporary Art, Boston, 2001
The Museum of Contemporary Photography, Chicago, 2002
The Cleveland Museum of Art, Cleveland, 2003
'Nikki S. Lee', Printemps de Septembre, Toulouse, 2003

Select publications
'Photography', *Chicago Reader*, 6 July 2001
'Nikki S. Lee', *Boston Phoenix*, 20 July 2001
'I'm Everybody', *Dutch*, Issue 36, Nov/Dec 2001
'Taking it to the Streets', *Museums Washington*, Spring/Summer 2002
'Carnegie Museum of Art Introduces Emerging Artists Through Their Self-Portraits', *Antiques & The Arts Weekly*, 5 July 2002

TIM LEE
b. 1975, Seoul (Korea); lives in Vancouver, BC (Canada)

Select exhibitions
'Louie Louie', Or Gallery, Vancouver, 2002
'Sight Gags', YYZ Artists Outlet, Toronto, 2003
'Baja to Vancouver: The West Coast in Contemporary Art', Seattle Art Museum (touring exh.), 2003
1st Prague Biennial, Prague, 2003

Select publications
'Front Exhibitions', *Front*, May/June 2001

Brayshaw, Christopher, 'Hello Nasty', *Last Call*, Summer 2001
'Tim Lee, The Move', *Mix*, Fall 2001
Hackett, Regina, 'Binocular Parallax', *Seattle Post-Intelligencer*, 20 Sept 2002
DeVuono, Frances, 'Binocular Parallax at Consolidated Works', *ArtWeek*, Dec 2002

LAURA LIMA
b. 1971, Governador Valadares (Brazil); lives in Rio de Janeiro (Brazil)

Select exhibitions
'Project Rooms', Arco-Madrid, 2000
'M=f/W=f and Costumes', Museu de Arte da Pampulha, Belo Horizonte, 2002
'Body', Paço das Artes, São Paulo, 2003
'Costumes Shop', Casa Triângulo, São Paulo, 2003
'Brazilian Artists', Galerija Skultz, Ljubljana, 2004

Select publications
Zaya, Octavio, 'Laura Lima', in *Fresh Cream*, London, 2000
Basbaum, Ricardo, 'The Artist As Predator' in *Trans#8*, New York, 2000
Piskur, Bojana, 'Laura Lima', Costumes: Exhibition Folder, Mala Galeija – Modern Art Museum of Ljubljana, May 2002

MAREPE (Marcos Reis Peixoto)
b. 1970, Santo Antônio de Jesus (Brazil); lives in Santo Antônio de Jesus (Brazil)

Select exhibitions
Centro de Arte Reina Sofia, Madrid, 2000
25th São Paulo Bienal, São Paulo, 2002
'Supletivo Manual é Natal', Galeria Luisa Strina, São Paulo, 2002
50th Venice Biennale, Venice, 2003
'How Latitudes Become Forms', Walker Art Center, Minneapolis (touring exh.), 2003

Select publications
Órgão, *No Existen Los Límites*, Fundação Armando Álvares Penteado, São Paulo, 1998
Cocchiarale, Fernando, 'Os 90', Paço Imperial (exh. cat.), Rio de Janeiro, 1999–2000
Canton, Kátia, 'Novíssima Arte Brasileira/Um guia de tendências', *MACSP*, Iluminuras e FAPESP, São Paulo, 2000
Bercht, Fatima, 'O Fio da Trama/The thread unraveled: Contemporary Brazilian Art', El Museo del Barrio (exh. cat.), New York, 2001–02

PAUL McCARTHY
b. 1945, Salt Lake City, UT (USA); lives in Los Angeles, CA (USA)

Select exhibitions
'Out of Actions: Between Performance and the Object, 1949–1979', Museum of Contemporary Art, Los Angeles; MAK, Vienna, 1998
'Paul McCarthy', Museum of Contemporary Art, Los Angeles (touring exh.), 2000–02
'Paul McCarthy: Videos and Photographs', Kunstverein Hamburg (touring exh.), 2001–03
Tate Modern, London, 2003
Whitney Biennial, 2004

Select publications
Rugoff, Ralph et al., *Paul McCarthy*, London, 1996
Puvogel, Renate, 'Paul McCarthy, Dimensions of the Minds: The Denial and the Desire in the Spectacle', *Kunstforum International*, Bd 147, Sept–Nov 1999
Paul McCarthy, New Museum of Contemporary Art (exh. cat.), New York, 2000
Holert, Tom, 'Schooled for Scandal', *Artforum*, Nov 2000
Knight, Christopher, 'Compelling sold by the Gross', *Los Angeles Times*, 14 Nov 2000

AERNOUT MIK
b. 1962, Groningen (Netherlands); lives in Amsterdam (Netherlands)

Select exhibitions
47th Venice Biennale, Venice, 1997
'Primal Gestures, Minor Roles', Van Abbe Museum, Eindhoven, 2000
Stedelijk Museum Bureau, Amsterdam, 2002
Caixa Forum, Barcelona, 2003

Select publications
Guldemond, Jaap, *Hongkongoria. A project by Aernout Mik and Marjoleine Boonstra, 'Ironisch/Ironic'*, Museum für Gegenwartskunst (exh. cat.), Zurich, 1998
Berrebi, Sophie, 'Rat Race', *Frieze*, 52, 2000
Monk, Philip, *Aernout Mik: Reversal Room*, The Power Plant (exh. cat.), Toronto, 2002
Birnbaum, Daniel, *elastic*, Koninklijke Nederlandse Akademie van Wetenschappen (exh. cat.), Amsterdam, 2002

JONATHAN MONK
b. 1969, Leicester (UK); lives in Berlin (Germany) and Paris (France)

Select exhibitions
'In Search of Gregory Peck', Lisson Gallery, London, 1998
'Our trip out west' (with Pierre Bismuth), CAC, Vilnius, 2001
'1+1=2', Galerie Meyer Riegger, Karlsruhe, 2002
'Roundabout', Art Gallery of Ontario, Toronto, 2002
'The Unrealised Realised', Galerie Yvon Lambert, Paris, 2003

Select publications
Lying Judas, Tramway, Glasgow & Frac des pays de la Loire, Nantes, 1996
Meeting #13, bookworks, London & Galerie Yvon Lambert, Paris, 2000
P, Frankfurt, 2002
The Project Book Project, Arnolfini, Bristol, 2003
Hoffmann, Jens, 'In Search of Trivialities and Other Important Details', in Matthew Higgs (ed.), *Jonathan Monk*, Lisson Gallery, London & Galerie Yvon Lambert, Paris, 2003

ROBERT MORRIS
b. 1931, Kansas City, KS (USA); lives in New York, NY (USA)

Select exhibitions
Leo Castelli Gallery, New York, 1967
Tate Gallery, London, 1971
Stedelijk Museum, Amsterdam, 1977
'Robert Morris: The Mind/Body Problem', Solomon R. Guggenheim Museum & Soho Guggenheim, New York, 1994
'Robert Morris: Recent Felt Pieces and Drawings', Henry Moore Institute, Leeds, 1997

Select publications
Berger, Maurice, *Labyrinths: Robert Morris, Minimalism, and the 1960s*, New York, 1989
Karmel, Pepe & Maurice Berger, *Robert Morris: The Felt Works*, Grey Art Gallery and Study Center (exh. cat.), New York, 1989
Morris, Robert. Continuous Project Altered Daily: The Writings of Robert Morris, Cambridge, MA & Guggenheim Museum, New York, 1993

ALEX MORRISON
b. 1971, Redruth (UK); lives in Vancouver, BC (Canada)

Select exhibitions
'Geometers', Nylon Gallery, London, 2002
'Housewrecker', Catriona Jeffries Gallery, Vancouver, 2003
'Alex Morrison', Kunstverein Frankfurt, 2003
'Alex Morrison', Henry Art Gallery, Seattle, 2004
'Alex Morrison', Künstlerhaus Bethanien, Berlin, 2004

Select publications
Kent, Sarah, 'From Memory', *Time Out: London's Living Guide*, No. 1509, 21–28 July 1999
Schultz, Deborah, 'Belvedere', *Art Monthly*, Issue 235, April 2000
Turner, Michael, 'These Days', *Art/Text*, #75, Nov 2001–Jan 2002
Kitamura, Katie, 'Geometers', *Contemporary*, March 2002

Meyers, Holly, 'Turning Impulses into Works of Art', *Los Angeles Times*, 16 August 2002

BRUCE NAUMAN
b. 1941, Fort Wayne, IN (USA); lives in New Mexico (USA)

Select exhibitions
'Bruce Nauman, Four Works', Denver Art Museum, 1999
'Bruce Nauman: Mapping the Studio', Museum für Gegenwartskunst, Basel, 2002
'Bruce Nauman: Mapping the Studio (Fat Chance John Cage)', Dia Center for the Arts, New York, 2002
'AC: Bruce Nauman: Mapping the Studio I (Fat Chance John Cage)', Museum Ludwig, Cologne, 2003

Select publications
Simon, Joan (ed.), *Bruce Nauman*, Walker Art Center, Minneapolis, 1994
Bruce Nauman, Hayward Gallery, London, 1998
Glasmeier, Michael, Christine Hoffmann, Sabine Folie et al. (eds), *Samuel Beckett/Bruce Nauman*, Kunsthalle Wien, Vienna, 2000
Zutter, Jörg (ed.), *Gary Hill/Bruce Nauman: International New Media Art*, National Gallery of Australia, Canberra, 2002
Nauman, Bruce, 'A Thousand Words: Bruce Nauman Talks about Mapping the Studio', *Artforum*, March 2002

RIVANE NEUENSCHWANDER
b. 1967, Belo Horizonte (Brazil); lives in São Paulo (Brazil)

Select exhibitions
'Spell', Portikus, Frankfurt, 2001
Museu de Arte da Pampulha, Belo Horizonte, 2002
'Superficial Resemblance', Palais de Tokyo, Paris, 2003
50th Venice Biennale, Venice, 2003
'Rivane Neuenschwander', St Louis Art Museum, St Louis, 2004

Select publications
24th São Paulo Bienal (exh. cat.), São Paulo, 1998
To/From: Rivane Neuenschwander, Walker Arts Center (exh. cat.), Minneapolis, 2002
Land, Land, Kunsthalle Basel (exh. cat.), Basel, 2003

HÉLIO OITICICA
b. 1937, Rio de Janeiro (Brazil); d. 1980, Rio de Janeiro (Brazil)

Select exhibitions
Whitechapel Art Gallery, London, 1969

'Hélio Mangueira Oiticica, Uerj', Rio de Janeiro, 1990
'Hélio Oiticica: retrospective', Witte de With Center
of Contemporary Art, Rotterdam (touring exh.), 1992
'Bloco – Experiências in Cosmococa – Programa in
Progress', Galeria de Arte São Paulo, 1994
'Quase-Cinemas', Wexner Center for the Arts,
Columbus (touring exh.), 2001–02

Select publications
Osthoff, S., 'Lygia Clark and Hélio Oiticica: a legacy
of interactivity and participation for a telematic future',
Leonardo, No. 4, 1997
Basualdo, Carlos et al., *Hélio Oiticica*, Ostfildern-
Ruit, 2001
Braga, P., 'Hélio Oiticica and the Parangoles
(Ad)dressing Nietzche's Ubermensch', *Third Text*,
No. 1, March 2003
Canejo, C., 'The Resurgence of Anthropophagy:
Tropicalia, Tropicalismo and Hélio Oiticica,' *Third Text*,
No. 1, Jan 2004

DAN PETERMAN
b. 1960, Minneapolis, MN (USA); lives in Chicago, IL
(USA)

Select exhibitions
'Ecologies: Marc Dion, Peter Fend, Dan Peterman',
David and Alfred Smart Museum of Art, University of
Chicago, 2000
'7 Deadly Sins', Kunstverein Hannover, 2001
2nd Berlin Biennale, Berlin, 2001
'Arbeit Essen Angst', Kokerei Zollverein, Essen, 2001
Museum Abteiberg, Mönchengladbach, 2002

Select publications
Ecologies: Marc Dion, Peter Fend, Dan Peterman,
David and Alfred Smart Museum of Art (exh. cat.),
Chicago, 2000
7 Deadly Sins and Other Stories, Kunstverein
Hannover (exh. cat.), Hannover, 2001
Waldvogel, Florian, 'Kokerei Finishing Room
(Cheese)', in Marius Babias & Florian Waldvogel
(eds), *Arbeit Essen Angst*, Kokerei Zollverein (exh.
cat.), Essen, 2001
Plug-In. Einheit und Mobilität, Westfälisches
Landesmuseum Münster (exh. cat.), Münster, 2001

KIRSTEN PIEROTH
b. 1970, Offenbach am Main (Germany); lives in
Berlin (Germany)

Select exhibitions
Klosterfelde, Berlin, 2000
1st Tirana Biennial, Tirana, 2001
50th Venice Biennial, Venice, 2003
'From the Laboratory of Thomas A. Edison', Portikus,
Frankfurt, 2003
Contemporary Art Gallery, Vancouver, 2004

Select publications
Politi, Giancarlo (ed.), 'Escape', Tirana Biennial, 2001
Szymczyk, Adam, 'Tirana Biennial', *NU: The Nordic
Art Review*, Vol. III, No. 6, 2001
Stange, Raimar, 'Raimar Stange über Kirsten Pieroth',
artist kunstmagazin, No. 53, Apr 2002
Fabricius, Jacob, 'Possible Works: Kirsten
Pieroth/Henrik Olesen', *Flash Art*, May–June 2002
Kirsten Pieroth: Reise um die Erde in 40 Tagen,
Mellemdækket Projektrum, Charlottenborg (exh. cat.),
Copenhagen, 2002

ADRIAN PIPER
b. 1948, New York, NY (USA); lives in Cape Cod,
MA (USA)

Select exhibitions
'Adrian Piper: A Retrospective & MEDI(t)Ations:
Adrian Piper's Videos, Installations, Performances
and Soundworks, 1968–1992', Fine Arts Gallery,
University of Maryland (touring exh.), 1999–2001
'The Color Wheel Series: First Adhyasa:
Annomayakosha' Paula Cooper Gallery, New York,
2000–01
'Prayer Wheel', Andy Warhol Museum, Pittsburgh,
2001
'Adrian Piper Over the Edge', Emi Fontana Gallery,
Milan, 2002–03
'Adrian Piper: seit 1965', Generali Foundation, Vienna
(touring exh.), 2002–04

Select publications
Maurice Berger, 'Styles of Radical Will'; Jean Fisher,
'The Breath Between Words'; Maurice Berger, 'The
Critique of Pure Racism'; and Kobena Mercer,
'Decentering and Recentering: Adrian Piper's
Spheres of Influence', in *Adrian Piper: A
Retrospective*, Baltimore, 1999
Piper, Adrian, 'Whiteless', *Art Journal*, 60, 3, Winter
2001

PAOLA PIVI
b. 1971, Milan (Italy); lives in London (UK) and
Alicudi (Italy)

Select exhibitions
'100 Cinesi', Galleria Massimo De Carlo, Milan, 1998
48th Venice Biennale, Venice, 1999
Sonsbeek 9, Arnhem, 2001
'Signature of the Invisible', Centre d'Art
Contemporain, Geneva, 2002
'Paola Pivi', Wrong Gallery, New York, 2003

Select publications
'Globale Positionen', Museum in Progress, *Der
Standard*, 30 August 1999
Lowe, G., 'Paola Pivi', *Log 15*, Issue Fifteen, The X
Issue, 2002

*Art Now 137: Artists at the Rise of the New
Millennium*, Cologne, 2002
Frieze, B., 'Work in Progress', *Artforum*, Feb 2003

CHARLES RAY
b. 1953, Chicago, IL (USA); lives in Los Angeles, CA
(USA)

Select exhibitions
'Charles Ray', Whitney Museum of American Art
(touring exh.), 1998–99
'Let's Entertain', Walker Art Center, Minneapolis
(touring exh.), 2000
'Made in California: Art, Image, and Identity,
1900–2000', Los Angeles County Museum of Art,
2000–01
'Tempo', Museum of Modern Art Queens, New York,
2002
50th Venice Biennale, Venice, 2003

Select publications
Storr, Robert & Charles Ray, 'Anxious Spaces', *Art in
America*, May 1999
Wagner, Anne, 'Charles Ray: Museum of
Contemporary Art, Los Angeles', *Artforum*, May 1999
Au-dela du spectacle, Centre Pompidou (exh. cat.),
Paris, 2000
*Jasper Johns to Jeff Koons: Four Decades of Art
from the Broad Collection*, Los Angeles County of
Art (exh. cat.), Los Angeles, 2001
The Fourth Sex, Fondazione Pitti Immagine Discovery
(exh. cat.), Florence, 2003

ROBIN RHODE
b. 1976, Cape Town (South Africa); lives in Berlin
(Germany)

Select exhibitions
'FRESH', South African National Gallery, Cape Town,
2000
'The Score', Artists Space, New York, 2004
'The Animators', The Rose Art Museum, Boston, 2004
'How would you light heaven', Carlier Gebauer,
Berlin, 2004
'Dessins et des Autres', Galerie Anne de Villepoix,
Paris, 2004

Select publications
Kamiya, Y., 'Very New Art 2004', *BT Magazine*, Vol.
56, n. d.
Tancons, C., 'Fugitive: Robin Rhode, Drawings and
Performances' & R. Kerkham, 'Co-Existence,
Contemporary Cultural Production in South Africa',
NKA Journal of Contemporary African Art, No. 18,
Spring/Summer 2003
Trainor, J., 'How Latitudes Become Forms: Art in a
Global Age', *Frieze*, Issue 76, 2003

MARK ROEDER
b. 1974, Whittier, CA (USA); lives in Los Angeles, CA (USA)

Select exhibitions
'Mink Jazz', Marc Foxx, Los Angeles, 2001
'Group Show 2001', Fifth International, New York, 2001
'Mark Roeder', Low, Los Angeles, 2001
'Unreal Estate Opportunities', PKM Gallery, Seoul, 2003
1st Prague Biennial, Prague, 2003

Select publications
Hawkins, Richard, 'Top Ten', Artforum, v. 39, No. 3, Nov 2000
Hainley, Bruce, 'Best of 2001', Artforum International: Best of 2001: A Special Issue, v. 40, No. 4, Dec 2001
Hainley, Bruce, 'Mark Roeder, Low, Los Angeles', Frieze, 64, Feb 2002
Knight, Christopher, 'Pandora's box, Opened', Los Angeles Times, 27 Oct 2002
Moon, Iris, 'Views Far From Maddening Crowds', Korea Herald, 17 Apr 2003

TRACEY ROSE
b. 1974, Durban (South Africa); lives in Johannesburg (South Africa)

Select exhibitions
'South Meets West', National Museum of Ghana, Accra, 1999
'Videodrome', The New Museum of Contemporary Art, New York, 1999
'Cross + Over', CPC Path Studios, Johannesburg, 2000
'DAK'Art', Dakar Biennial, Dakar, 2000
'Ciao Bella', The Goodman Gallery, Johannesburg, 2002

Select publications
7. Triennial der Kleinplastik, 1998: Zeitgenössische Skulptur Afrika, Cantz (exh. cat.), Ostfildern/Stuttgart, 1998
Guarene Arte 98, Fondazione Sandretto Re Rebaudengo per l'Arte (exh. cat.), Guarene, 1998
Video cultures: Multimediale Installationen der 90er Jahre (exh. cat.), Cologne, 1999
In the mean time..., De Appel (exh. cat.), Amsterdam, 2001
The Hope I Hope: Faces of Truth, Ayloul Festival (exh. cat.), Beirut, 2001

MARTHA ROSLER
b. New York, NY (USA); lives in New York, NY (USA)

Select exhibitions
'Martha Rosler: Positions in the Life World', Ikon Gallery, Birmingham (touring exh.), 1998–2000
'Modern Starts: Objects', Museum of Modern Art, New York, 1999
'Romances of the Meal', performance for 'Indiscipline' project, Brussels, 2000
'Martha Rosler', Maison Européenne de la Photographie, Paris, 2002
50th Venice Biennale, Venice, 2003

Select publications
Cotter, Holland, 'An Iconoclast to Whom the Personal Is Always Political', New York Times, 4 Aug 2000
Vidler, Anthony, 'Martha Rosler', in Anthony Vidler, Warped Space: Art, Architecture and Anxiety in Modern Culture, Cambridge, MA, 2000
Guerrin, Michel, 'Martha Rosler: Fabricant d'images et briseurs d'icônes', Le Monde, 16 Jan 2001
Möntmann, Nina, Kunst als sozialer Raum: Andrea Fraser, Martha Rosler, Rirkrit Tiravanija, Renée Green, Cologne, 2002
Lebovici, Elisabeth, 'Rosler, agitatrice depuis 1967', Libération, 18 Nov 2002

MARKUS SCHINWALD
b. 1973, Salzburg (Austria); lives in Berlin (Germany)

Select exhibitions
Kunstverein Freiburg, 1999
Moderna Museet, Stockholm, 2001
TAV Gallery, Taipei, 2003
'Tableau Twain', Kunstverein Frankfurt, 2004
Manifesta 5, San Sebastian, 2004

Select publications
Stange, Raimar, 'Dem Gehen entgehen', Kunstbulletin, Nov 1998
Zakravsky, Katherina, 'Out of Season', Make Magazine, Aug 2000
Hoffmann, Jens, 'dictio pii', Flash Art, Oct 2001

GREGOR SCHNEIDER
b. 1967, Rheydt (Germany); lives in Rheydt (Germany)

Select exhibitions
'16.9.1993', Konrad Fischer Galerie, Dusseldorf, 1993
'Totes Haus ur 1985–97', Portikus, Kunsthalle Frankfurt, 1997
'Totes Haus ur 85–98', Musée d'Art Moderne de la Ville de Paris, 1998
49th Venice Biennale, Venice, 2001
'Gregor Schneider', Kunsthalle Hamburg, 2003

Select publications
Stecker, Raimund & Ingrid Bacher, Gregor Schneider 1985–1992, Mönchengladbach, 1992
Heynen, Julian, Gregor Schneider Kunsthalle Bern, Bern, 1996
Szymczyk, Adam, Veit Loers, Ulrich Loock & Brigitte Kölle, Gregor Schneider: Totes Haus ur/Dead house ur/Martwy Dom ur 1985–1997, Frankfurt, Warsaw, Mönchengladbach & Paris, 1998
Kittelmann, Udo (ed.), Totes Haus ur. La biennale di Venezia 2001. A photographic documentary by Gregor Schneider, Ostfildern, 2002

TINO SEHGAL
b. 1976, London (UK); lives in Berlin (Germany)

Select exhibitions
Manifesta 4, Frankfurt, 2002
'I Promise It's Political', Museum Ludwig, Cologne, 2002
'Le plein', Galerie Jan Mot, Brussels, 2003
50th Venice Biennale, Venice, 2003
Van Abbemuseum, Eindhoven, 2004

Select publications
Hantelmann, Dorothea von, 'art moving politics', Lesebuch Badischer Kunstverein, 2001
Spangberg, Marten, 'Au commencement était l'équation', artpress spécial, No. 23, 2002
Hoffmann, Jens, 'Ouverture: Tino Sehgal', Flash Art, May–June 2002
Moisdon, Stéphanie, 'moi je dis, moi je dis', Newspaper Galerie Jan Mot, No. 35, Feb 2003
Obrist, Hans Ulrich (interview), in Kunstpreis der Böttcherstrasse, Kunsthalle Bremen (exh. cat.), Bremen, 2003

CINDY SHERMAN
b. 1954, Glen Ridge, NJ (USA); lives in New York, NY (USA)

Select exhibitions
'Cindy Sherman: The Complete Untitled Film Stills', Museum of Modern Art, New York, 1997
'Cindy Sherman: Retrospective', Museum of Contemporary Art, Los Angeles (touring exh.), 1997–2000
Hasselblad Center, Göteborg, Sweden, 2000
'Cindy Sherman: Early Works', Studio Guenzani, Milan, 2001
'Cindy Sherman', Serpentine Art Gallery, London, 2003

Select publications
Krauss, Rosalind, Cindy Sherman: 1975–1993, New York, 1993
Neven Du Mont, Gisela & Wilfried Dickhoff (eds), Cindy Sherman, Cologne, 1995
Sherman, Cindy, Cindy Sherman: Untitled Film Stills, Munich, 1998
Sherman, Cindy, Early Work of Cindy Sherman, New York, 2000
Wiehager, Renate (ed.), Moving Pictures, Cantz (exh. cat.), Ostfildern/Stuttgart, 2001

YINKA SHONIBARE:
b. 1962, London (UK); lives in London (UK)

Select exhibitions
'Yinka Shonibare', Andy Warhol Museum, Pittsburgh, 2001
'Be-muse', The British School in Rome, 2002
'Camouflage', Johannesburg, 2002
'Double Dress', KIASMA, Helsinki, 2003

Select publications
Double Dress, Israel Museum (exh. cat.), Jerusalem, 2002
Unpacking Europe, Museum Boijmans Van Beuningen, Rotterdam, 2001
Enwezor, Okwui, 'Tricking the Mind: the Work of Yinka Shonibare', in *Authentic/Eccentric: Conceptualism in African Art*, 49th Venice Biennale, Venice, 2001

SANTIAGO SIERRA
b. 1966, Madrid (Spain); lives in Mexico City (Mexico)

Select exhibitions
'A person paid for 300 continuous working hours', P.S.1, Contemporary Art Center, Long Island, New York, 2001
'Workers who cannot be paid, remunerated to stay inside cardboard boxes', Kunst-Werke, Berlin, 2001
'Person Saying a Phrase', Ikon Gallery, Birmingham, 2002
'Hiring and Arrangement of 30 Workers in Relation to their Skin Color', Kunsthalle Wien, Vienna, 2002
50th Venice Biennale, Venice, 2003

Select publications
Medina, Cuauhtemoc, 'Recent Political Forms, Radical Pursuits in Mexico', *Trans >arts*, Mexico, 2000
Wagner, Thomas, 'Unbezahlt im Pappkarton', *Frankfurter Allgemeine*, 31 Oct 2000
Pimentel, Taiyana, *Santiago Sierra*, Galerie Peter Kilchmann (exh. cat.), Zurich, 2001
Garcia-Anton, Katya (ed.), *Santiago Sierra, Works 2002–1990*, Ikon Gallery, Birmingham, 2002

ROMAN SIGNER
b. 1938, Appenzell (Switzerland); lives in St Gallen (Switzerland)

Select exhibitions
'Skulptur Projekte', Münster, 1997
'Roman Signer. Works 1971–2000', Bonnefanten Museum, Maastricht, 2000
'Roman Signer', Galleries I, II & III, Camden Arts Centre, London, 2001
'Roman Signer', Galerie Barbara Weiss, Berlin, 2002

'Roman Signer', Sammlung Hauser und Wirth, Lokremise, St Gallen, 2003

Select publications
Bonami, Francesco (ed.), *Unfinished History*, Walker Art Center (exh. cat.), Minneapolis, 1998
Roman Signer, Secession (exh. cat.), Vienna, 1999
Bitterli, Konrad (ed.), *Roman Signer*, 48th Venice Biennale (exh. cat.), Venice, 1999
Roman Signer. Zeichnungen, Kunstmuseum Solothurn; Landesmuseum Nordrhein-Westfalen (exh. cat.), Münster & Cologne, 2001
Good, Paul, *Time Sculpture. Roman Signer's Work in Philosophical Perspective*, Cologne, 2002
Zimmermann, Peter (ed.), *Roman Signer: Werkübersicht 1971–2002*, 3 vols, Zurich, 2003

ANDREAS SLOMINSKI
b. 1959, Meppen (Germany); lives in Hamburg (Germany)

Select exhibitions
Kunsthalle, Zurich, 1998
Metro Pictures, New York, 1999
Deutsche Guggenheim, Berlin, 1999
Galerie Jablonka, Cologne, 2000
'Let's Entertain', Walker Art Center, Minneapolis, 2000
Fondazione Prada, Milan, 2003

Select publications
Rauterberg, Hanno, 'Andreas Slominski: der Fallensteller [Andreas Slominski: the trap setter]', *ART: das Kunstmagazin*, No. 11, Nov 1997
4-article special on Andreas Slominski, *Parkett*, No. 55, 1999
Hoffmann, Jens, 'Andreas Slominski: Adventures', *Flash Art*, Vol. 36, May/June 2003

NEDKO SOLAKOV
b. 1957, Cherven Briag (Bulgaria); lives in Sofia (Bulgaria)

Select exhibitions
'Thirteen (maybe)', Musée National d'Histoire et d'Art, Luxembourg, 1998
'Squared Baroque: Baroqued Square', Ikonen-Museum/Portikus, Frankfurt, 2000
'A (not so) White Cube', P.S.1 Contemporary Art Center, New York, 2001
'Romantic Landscapes with Missing Parts', Neuer Berliner Kunstverein, Berlin; Galerie Arndt & Partner, Berlin, 2002

Select publications
Mr. Curator, please…, Studio I, Künstlerhaus Bethanien, Berlin, 1995

A High Level Show with a Catalogue, Center for Contemporary Art (exh. cat.), Kitakyushu, 2002
A 12 1/3 (and even more) Year Survey, Rooseum Center for Contemporary Art, Malmö & O.K. Centrum für Gegenwartskunst, Linz (exh. cat.), 2004

SIMON STARLING
b. 1967, Epsom (UK); lives in Glasgow (UK) and Berlin (Germany)

Select exhibitions
Blinky Palermo Prize, Galerie für Zeitgenössiche Kunst, Leipzig, 1999
Manifesta 3, Ljubljana, 2000
'Inverted Retrograde Theme, Rescued Rhododendron', Secession, Vienna, 2001
'Kakteenhaus', Portikus, Frankfurt, 2002
'Carbon', Städtische Ausstellungshalle am Hawerkamp Münster, 2003

Select publications
Simon Starling, Camden Arts Centre (exh. cat.), London, 2000
Simon Starling CMYK/ RGB, FRAC Languedoc Roussillon (exh. cat.), Montpellier, 2001
Djungel, Dundee Contemporary Arts (exh. cat.), Dundee, 2002
Mathew Jones/Simon Starling, Museum of Contemporary Art (exh. cat.), Sydney, 2002

SUPERFLEX
Collective founded in 1993 by Bjørnstjerne Reuter Christiansen, Jakob Fenger and Rasmus Nielsen; based in Copenhagen (Denmark)

Select exhibitions
'Superflex Biogas in Africa', Artspace, Sydney, 1999
'Coronation Court/Superchannel', FACT, Liverpool, 2000
2nd Berlin Biennial, Berlin, 2001
'Superflex tools + counter-strike', Rooseum, Malmö, 2002
Gwangju Biennial, Gwangju, 2002
'Social pudding', Rirkrit Tirvanija & Superflex, GFZK, Leipzig, 2003
50th Venice Biennale, Venice, 2003

Select publications
Berger, Doris (ed.), *Tools*, Kunstverein Wolfsburg (exh. cat.), Wolfsburg, 1999–2000
Supermanual – The Incomplete Guide to the Superchannel, Liverpool, 2000
Steiner, Barbara (ed.), *Tools*, Cologne, 2002
Bradley, Will, 'Counter-strike/Self-organize', in *Superflex*, KIASMA Museum for Contemporary Art, Helsinki, 2003

VIBEKE TANDBERG
b. 1967, Oslo (Norway); lives in Oslo (Norway)

Select exhibitions
1st Berlin Biennale, Berlin, 1998
'Organising Freedom. Nordic Art of the 90's',
Moderna Museet, Stockholm, 2000
Gagosian Gallery, London, 2002
'Das zweite Gesicht. Metamorphosen des
fotografischen Portraits', Deutsches Museum, Munich,
2002
13th Sydney Biennial, Sydney, 2002

Select publications
Vibeke Tandberg, Kunstmuseum Thun (exh. cat.),
Thun, 2000
*Ich ist etwas Anderes. Kunst am Ende des 20.
Jahrhundert*, Kunstsammlung Nordrhein-Westfalen
(exh. cat.), Dusseldorf, 2000
Beyond Paradise: Nordic Artists Travel East,
Moderna Museet (exh. cat.), Stockholm, 2002
Grosenick, Uta & Burkhard Riemschneider (eds),
Art Now, Cologne, 2002

SAM TAYLOR-WOOD
b. 1967, London (UK); lives in London (UK)

Select exhibitions
Kunsthalle, Zurich, 1997
Lousiana Museum of Modern Art, Humlebæk, 1997
Espacio Uno, Museo Nacional Centro de Arte Reina
Sofia, Madrid, 2000
'Mute', White Cube, London, 2001
'Sam Taylor-Wood. Films and Photographs', Stedelijk
Museum, Amsterdam, 2002
'Sam Taylor-Wood', Hayward Gallery, London, 2002

Select publications
Ferguson, Bruce, Nancy Spector, Michael Bracewell
& Germano Celant, *Sam Taylor-Wood*, Fondazione
Prada, Milan, 1998
Taylor-Wood, Sam, *Contact*, London, 2001
Carolin, Clare, Michael Bracewell & Jeremy Millar,
Sam Taylor-Wood, Göttingen, 2002

RIRKRIT TIRAVANIJA
b. 1961, Buenos Aires (Argentina); lives in Bangkok
(Thailand), Berlin (Germany) and New York, NY (USA)

Select exhibitions
'Rirkrit Tiravanija', Villa Franck, Kunstverein
Ludwigsburg, 1997
'Untitled, 1998 (Das soziale Kapital)', Migros Museum,
Museum für Gegenwartskunst, Zurich, 1998
'Untitled, 1999 (reading from right to left)', Wexner
Center for the Arts, Columbus, 1999
'Rirkrit Tiravanija: Untitled 2001 (No Fire No Ashes)',
Neugerriemschneider, Berlin, 2001

Select publications
Kittelmann, Udo (ed.), *Rirkrit Tiravanija: Untitled
1996 (tomorrow is another day)*, Kölnischer
Kunstverein (exh. cat.), 1997
Steiner, Barbara, *Rirkrit Tiravanija: Kochbuch*,
Kunstverein Ludwigsburg, 1997
Möntmann, Nina, *Kunst als sozialer Raum*, Cologne,
2002
*Rirkrit Tiravanija: Secession, 5 July–1 September
2002* (exh. cat.), Walther König, Cologne, 2003

PATRICK TUTTOFUOCO
b. 1974, Milan (Italy); lives in Milan (Italy)

Select exhibitions
Studio Guenzani, Milan, 2000
Studio Guenzani, Milan, 2002
50th Venice Biennale, Venice, 2003
'Spectacular: The Art of Action', Museum
Kunstpalast, Dusseldorf, 2003
Manifesta 5, San Sebastian, 2004

Select publications
Gioni, Massimiliano (ed.), *L'Art dans le monde 2000*,
Musées de Beaux Art (exh. cat.), Paris, 2000
Cerizza, Luca (ed.), *Espresso, Arte oggi in Italia*,
Milan, 2000
Casino 2001, I Quadriennale d'Arte Contemporanea
(exh. cat.), S.M.A.K., Ghent, 2001
Molinari Guido, 'Forme in Libertà', *Flash Art Italia*, No.
237, Dec 2002–Jan 2003

JEFF WALL
b. 1946, Vancouver, BC (Canada); lives and works in
Vancouver, BC (Canada)

Select exhibitions
Louisiana Museum, Humlebaek, 1992
Whitechapel Art Gallery, London, 1996
'Jeff Wall: Oeuvres 1990–1998', Musée d'art
contemporain, Montreal, 1999
'Jeff Wall: Figures & Places', Museum für Moderne
Kunst, Frankfurt, 2001
Museum of Modern Art, Ludwig Foundation, Vienna,
2003
'Jeff Wall', Astrup Fearnley Museet for Moderne
Kunst, Oslo, 2004

Select publications
Jardine, Alice, Eric Michaud, Abigail Solomon-
Godeau, Fredric Jameson & David Joselit, *Utopia,
Post-Utopia*, Institute of Contemporary Art, Boston,
1988
Stals, José Lebrero, in *Jeff Wall*, Museo Nacional
Centro de Arte Reina Sofia, Madrid, 1994
Jeff Wall. The Museum of Contemporary Art, Los
Angeles and Scalo, 1997

ERIC WESLEY
b. 1973, Los Angeles, CA (USA); lives in Los
Angeles, CA (USA)

Select exhibitions
'Camper', China Art Objects Galleries, Los Angeles,
1999
'L.A. Edge Festival', Los Angeles, 1999
'Kicking Ass', China Art Objects Galleries, Los
Angeles, 2000
'Sentry Box', California Institute of Technology,
Pasadena, 2001
'More Boots = Many Routes', Transmission Gallery,
Glasgow, 2003

Select publications
Gaines, Malik, 'Eric Wesley to the Bone', *Artext*, No.
75, Nov–Jan 2001
Snapshot, UCLA Hammer Museum (exh. cat.), Los
Angeles, 2001
Freestyle, Studio Museum, Harlem, New York; Santa
Monica Museum of Art (exh. cat.), 2001
Subotnick, Ali, 'Snapshot: New Art From Los
Angeles', *Frieze*, Oct 2001
Schmerler, Sarah, 'One For The Road', *Time Out
New York*, Jan 2003

CAREY YOUNG
b. 1970, Lusaka (Zambia); lives in London (UK)

Select exhibitions
50th Venice Biennale, Venice, 2003
'A Short History of Performance: Part II', Whitechapel
Art Gallery, London, 2003
Viral Marketing, Kunstverein München, Munich, 2004
Index Contemporary Art Centre, Stockholm, 2004
'Disclaimer', Henry Moore Institute, Leeds, 2004

Select publications
Gussin, Graham & Ele Carpenter, *Nothing*, London,
2001
Slyce, John, 'Nothing Ventured', in *fig-1*, Tate, London,
2001
Kelsey, John, 'Carey Young: Business as Usual',
artext, Spring 2002
Alex Farquharson, Liam Gillick, Carey Young, John
Kelsey & Jeremy Millar, *Carey Young, Incorporated*,
John Hansard Gallery and Film & Video Umbrella,
2002

FURTHER READING

About Time: Video, Performance and Installation by 21 Women Artists, Institute of Contemporary Arts (exh. cat.), London, 1980

Action/Performance and the Photograph, Turner/Krull Galleries (exh. cat.), Los Angeles, 1993

The Art of Performance, Palazzo Grassi (exh. cat.), Venice, 1979

Auslander, Philip, *Presence and Residence: Postmodernism and Cultural Politics in Contemporary American Performance,* Ann Arbor, MI, 1992

Austin, J. L., *How To Do Things With Words,* Oxford, 1962

Battcock, Gregory and Robert Nickas (eds), *Performance in Postmodern Culture,* Milwaukee, WI, 1977

Body Works, Museum of Contemporary Art (exh. cat.), Chicago, 1975

Bronson, A. A. and Peggy Gale (eds), *Performance by Artists,* Toronto, 1979

Butler, Judith, *Gender Trouble,* New York, 1990

____, *Bodies That Matter,* New York, 1993

Carlson, Marvin, *Performance: A Critical Introduction,* New York, 1996

Carr, Cynthia, *On Edge: Performance at the End of the Twentieth Century,* Hanover, NH, 1993

Diamond, Elin (ed.), *Performance and Cultural Politics,* New York, 1996

Dupuy, Jean (ed.), *Collective Consciousness: Art Performance in the Seventies,* New York, 1980

Etchells, Tim, *Certain Fragments,* London, 1999

Frank, Peter, *Theater of the Object: Reconstructions, Re-creations, Reconsiderations 1958–1972,* Alternative Museum (exh. cat.), New York, 1988

Fusco, Coco, *The Bodies That Were Not Ours and Other Writings,* London, 2001

Goffman, Erving, *The Presentation of Self in Everyday Life,* Garden City, NY, 1959

Goldberg, RoseLee, *Performance Art from Futurism to the Present,* London, 2001

Gray, John, *Action Art: A Bibliography of Artists' Performance from Futurism to Fluxus and Beyond,* Westport, CT, 1993

Hansen, Al, A *Primer of Happening and Time/Space Art,* New York, 1965

Hantelmann, Dorothea von (ed.), *I Promise It's Political: Performativität in der Kunst,* Museum Ludwig (exh. cat.), Cologne, 2002

Hart, Lynda and Peggy Phelan (eds), *Acting Out: Feminist Performances,* Ann Arbor, MI, 1993

Haskell, Barbara, *Blam! The Explosion of Pop, Minimalism and Performance 1958–1964,* Whitney Museum of American Art (exh. cat.), New York, 1984

Hendricks, Jon (ed.), *Fluxus, Etc,* Cranbrook Academy of Art Museum (exh. cat.), Bloomfield Hills, MI, 1981

Honri, Adrian, *Total Art: Environments, Happenings and Performance,* New York, 1974

Howell, Anthony and Fiona Templeton, *Elements of Performance Art,* London, 1976

Jones, Amelia, *Body Art: Performing the Subject,* Minneapolis, MN, 1998

____ and Andrew Stephenson, *Performing the Body, Performing the Text,* London, 1999

Kelly, Jeff (ed.), *Allan Kaprow: The Blurring of Art and Life,* Berkeley, Los Angeles and London, 1993

Kostelanetz, Richard, *The Theatre of Mixed Means: An Introduction to Happenings, Kinetic Environments and Other Mixed-Means of Performances,* New York, 1968

____, *On Innovative Performance(s): Three Decades of Recollections on Alternative Theatre,* Jefferson, NC, 1994

Kulterman, Udo, *Art-Events and Happenings,* London, 1971

Lagaay, Alice, *Metaphysics of Performance: Performance, Performativity and the Relation Between Theatre and Philosophy,* Berlin, 2001

Marranca, Bonnie et al (eds), *Conversations on Art and Performance,* Baltimore, MD, 1999

Marsh, A. and and J. Kent (eds), *Live Art: Australia and America: Performance Art, Reviews, Criticism, Feminist and Political Art Organizations, Art and Politics, Interviews with American Artists, Artist's Pages,* Adelaide, 1984

Nollert, Angelika (ed.), *Performative Installation,* Siemens Arts Program (exh. cat.), Cologne, 2003

Nuttall, Jeff, *Performance Art,* London and Dallas, 1979

Outside the Frame: Performance and the Object: A Survey History of Performance Art in the USA Since 1950, Cleveland Center for Contemporary Art (exh. cat.), Cleveland, OH, 1994

Parker, Andrew and Eve Kosofsky Sedgwick, *Performativity and Performance,* London and New York, 1995

Performance Art and Video Installation, Tate Gallery (exh. cat.), London, 1985

Phelan, Peggy, *Unmarked: The Politics of Performance,* New York, 1993

Roth, Moira (ed.), *The Amazing Decade: Women and Performance Art in America, 1970–1980,* Los Angeles, 1983

Sayre, Henry M., *The Object of Performance: The American Avant-Garde Since 1970,* Chicago, 1989

Schechner, Richard, *Performance Theory,* New York and London, 1988

Schimmel, Paul (ed.), *Out of Action: Between Performance and the Object,* Museum of Contemporary Art (exh. cat.), Los Angeles, 1998

Schneider, Rebecca, *The Explicit Body in Performance,* New York, 1997

Stern, Carol Simpson, *Performance Studies: Texts and Contexts,* New York and London, 1993

25 Years of Performance Art in Australia, Ivan Dougherty Gallery et al. (exh. cat.), Paddington, Australia, 1994

Vergine, Lea, *Body Art and Performance: The Body as Language,* repr. Milan, 2000

Warr, Tracey and Amelia Jones, *The Artist's Body,* London, 2000

ILLUSTRATION LIST

1 Maurizio Cattelan, *Mother*, 1999. Photo © Armin Linke. Courtesy the artist and Marian Goodman Gallery, New York

2 Anna Gaskell, *Untitled #2 (wonder series)*, 1996 (detail). Courtesy the artist and Casey Kaplan 10-6, New York

3 John Bock, *Klassische Frikasseedekapitation des Logekommissars auf der Melasseplatte*, 2002 (detail). Photo Knut Klassen. Courtesy Galerie Klosterfelde, Berlin

4–5 Cai Guo-Qiang, *Transient Rainbow*, 2002. Photo Hiro Ihara. Courtesy the artist

6 Marepe, *Cabeça Acústica*, 1996. Photo Marcos Dourado. Courtesy Galeria Luisa Strina, São Paulo

10 John Bock, *Klassische Frikasseedekapitation des Logekommissars auf der Melasseplatte*, 2002. Photo Knut Klassen. Courtesy Galerie Klosterfelde, Berlin

13 Natascha Sadr Haghighian, *Remote Production*, 2002. Courtesy the artist

16 John Bock, *Klassische Frikasseedekapitation des Logekommissars auf der Melasseplatte*, 2002 (details). Photo Knut Klassen. Courtesy Galerie Klosterfelde, Berlin

18–19 Jonathan Monk, *Meeting #29*, 2003. Courtesy the artist

22–31 Tino Sehgal, *this sentence already performed*, 2003. Courtesy the artist

32 Mark Roeder, *Suggested Use (Good and Evil)*, 2003. Courtesy the artist

34–5 Gregor Schneider, *Haus Ur*, 2001. Courtesy Galerie Konrad Fisher, Düsseldorf. © DACS 2005

36–7 Michael Elmgreen and Ingar Dragset, *How Are You Today?*, 2002. Photos Studio Blu. Courtesy the artists and Galleria Massimo de Carlo, Milan

38 Dan Graham, *Public Space / Two Audiences*, 1976. Venice Biennale, 1976. Courtesy Lisson Gallery, London

39 Alexander Gerdel, *Workshop 69*, 1997. Photo Ernesto Valladares. Courtesy the artist

40 Jennifer Bornstein, *Projector Stand #3*, 1996. Courtesy the artist and Blum & Poe, Los Angeles

41 Eija-Liisa Ahtila, *The Wind*, 2002. © Crystal Eye Ltd, Helsinki. Courtesy Klemens Gasser & Tanja Grunert Inc, New York

42 Paul McCarthy, *Pinocchio Pipenose Householddilemma*, 1994. Courtesy the artist and Luhring Augustine Gallery, New York

43 Aernout Mik, *Glutinosity*, 2001. 'AM in the LAM', The Living Art Museum, Reykjavik, 2002. Photos Tumi Magnusson. Courtesy the artist and carlier | gebauer, Berlin

44 Martha Rosler, *Monumental Garage Sale*, San Diego, 1973. © the artist

45 (above) Martha Rosler, *Garage Sale*, New Museum, New York, 2000. © the artist

45 (below) Martha Rosler, *Traveling Garage Sale*, San Francisco, 1977. © the artist

46 Jérôme Bel, *Le Dernier Spectacle*, 1998. Photo Herman Sorgeloos. Courtesy the artist

48–9 Chris Burden, *The Flying Steamroller*, 1996. MAK (Museum of Applied Art), Vienna, Austria, 28 February–4 August 1996. Photo Gerald Zugmann/MAK, Vienna. Courtesy the artist

50 Eric Wesley, *Curb Servin'*, 2003. Courtesy the artist and Metro Pictures, New York

51 Kirsten Pieroth, *Berliner Pfütze*, 2001. Photo Carla Åhlander. Courtesy the artist and Galerie Klosterfelde, Berlin

52 Evan Holloway, *Wildly Painted Warped Lumber (#2)*, 2000. Courtesy Marc Foxx Gallery, Los Angeles

53 Felix Gonzalez-Torres, *Untitled (Passport #11)*, 1993. Photo Marc Domage. © Felix Gonzalez-Torres Foundation. Courtesy Andrea Rosen Gallery, New York

54 Jeppe Hein, *Moving Bench #2*, 2000. Courtesy Galerie Johann König, Berlin

55 Jeppe Hein, *Moving Walls 180°*, 2001. Courtesy Galerie Johann König, Berlin

56–7 Cai Guo-Qiang, *Transient Rainbow*, 2002. Photo Hiro Ihara. Courtesy the artist

58 Franklin Cassaro, *Futuristic Shelter*, 2002. Courtesy the artist and Museu de Arte da Pampulha, Belo Horizonte

59 Marepe, *Cabeça Acústica*, 1996. Photos Marcos Dourado. Courtesy Galeria Luisa Strina, São Paulo

60 Victor Burgin, *This Position*, 1969. Courtesy the artist

60 Victor Burgin, *Any Moment*, 1970. Courtesy the artist

61 Victor Burgin, *All Criteria*, 1970. Courtesy the artist

62 Gilbert & George, 1995. Photo © Armin Linke

63 Robert Morris, *Untitled (Standing Box)*, 1961. Courtesy Robert Morris Archive, New York. © ARS, NY and DACS, London 2005

64 Juan Capistran, *The Breaks*, 2000. Courtesy the artist

65 Alex Morrison, *Guerrilla Ramp Building*, 2000. Courtesy the artist and Catriona Jeffries Gallery, Vancouver

66 Gob Squad, *I can…*, 1998. Courtesy the artists

68–9 Simon Starling, *Flaga (1972–2000)*, 2002. Courtesy Neugerriemschneider, Berlin

70 Nedko Solakov, *The Deal*, 2002. Courtesy the artist

71 Maria Eichhorn, *Das Geld der Bundeskunsthalle Bern*, 2001. Photos Jens Ziehe. Courtesy the artist and Galerie Barbara Weiss, Berlin. © DACS 2005

72 Colectivo Cambalache, *Street Museum*, 1998–2002. Paris, May 2001. Photos Colectivo Cambalache. Courtesy the artists

73 Superflex, *Supergas*, bio-gas-project, 1996–2001. © Superflex. Courtesy the artists

75 Xavier Le Roy, *Self-Unfinished*, 1998. Berlin Biennale, 1998. Photos © Armin Linke. Courtesy the artist

76 (above) Elke Krystufek, *J'arrive/Regard, Regard/Life will not go away/Allegory of flying*, 2001. Courtesy GEORG KARGL Fine Arts, Vienna

76 (below) Elke Krystufek, *Calla/Quand on n'a que l'amour/New economy/Imagine god like yourself*, 2001. Courtesy GEORG KARGL Fine Arts, Vienna

77 (above) Vibeke Tandberg, *Living Together #12*, 1996. Courtesy the artist and Galerie Klosterfelde, Berlin

77 (below) Vibeke Tandberg, *Living Together #8*, 1996. Courtesy the artist and Galerie Klosterfelde, Berlin

78 Nikki S. Lee, *The Seniors Project*, 1999. Courtesy Leslie Tonkonow Artworks + Projects, New York

79 (above and below left) Nikki S. Lee, *The Schoolgirls Project*, 2000. Courtesy Leslie Tonkonow Artworks + Projects, New York

79 (above and below right) Nikki S. Lee, *The Exotic Dancers Project*, 2000. Courtesy Leslie Tonkonow Artworks + Projects, New York

80–81 Tim Lee, *The Move, The Beastie Boys*, 1998. Western Front, Vancouver, April 2001. Courtesy the artist

82 (above) Cindy Sherman, *Untitled Film Still #37*, 1978. Courtesy the artist and Metro Pictures, New York

82 (below) Cindy Sherman, *Untitled Film Still #4*, 1977. Courtesy the artist and Metro Pictures, New York

83 (top left) Tracey Rose, *Ciao Bella: Ms Cast Series 'Bunnie'*, 2002. © Tracey Rose. Courtesy The Project, New York and The Goodman Gallery, Johannesburg

83 (top right) Tracey Rose, *Ciao Bella: Ms Cast Series 'Mami'*, 2001. © Tracey Rose. Courtesy The Project, New York and The Goodman Gallery, Johannesburg

83 (centre) Tracey Rose, *Ciao Bella: Ms Cast Series 'Venus Baartman'*, 2002. © Tracey Rose. Courtesy The Project, New York and The Goodman Gallery, Johannesburg

83 (below) Tracey Rose, *Ciao Bella: Ms Cast Series 'Lolita'*, 2001. © Tracey Rose. Courtesy The Project, New York and The Goodman Gallery, Johannesburg

84 Dan Peterman, *Finishing Room (Cheese)*, 1999. Klosterfelde, Berlin, 1999. Photos Jens Ziehe. Courtesy Galerie Klosterfelde, Berlin

86 Jeff Wall, *Dead Troops Talk*, 1991–92. Courtesy Marian Goodman Gallery, New York

87 Jeff Wall, *The Vampires' Picnic*, 1991. Courtesy Marian Goodman Gallery, New York

88–9 Sam Taylor-Wood, *Five Revolutionary Seconds*, 1996. © the artist. Courtesy Jay Jopling/White Cube, London

90 (above) Sarah Jones, *The Bedroom (I)*, 2002. Courtesy Maureen Paley/Interim Art, London

90 (below) Sarah Jones, *The Living Room (I)*, 2002. Courtesy Maureen Paley/Interim Art, London

91 (above) Sarah Jones, *The Park (II)*, 2002. Courtesy Maureen Paley/Interim Art, London

91 (below) Sarah Jones, *Ilex (Holly) (I)*, 2002. Courtesy Maureen Paley/Interim Art, London

92 Maurizio Cattelan, *Mother*, 1999. Photo © Armin Linke. Courtesy the artist and Marian Goodman Gallery, New York

93 Charles Ray, *Oh! Charley, Charley, Charley…*, 1992. Documenta, Kassel, June 1992. Photos © Armin Linke

94 (above) Laura Lima, *Dopada (Doped Woman)*, 1997. Courtesy the artist and Casa Triangolo, São Paulo

94 (centre) Laura Lima, *Quadris (Hips)*, 1996–97 Courtesy the artist and Casa Triangolo, São Paulo

94 (below) Laura Lima, *Marra (Fighting)*, 1996–97 Courtesy the artist and Casa Triangolo, São Paulo

95 Santiago Sierra, *The wall of a gallery pulled out, inclined sixty degrees from the ground and sustained by five people*, 2000. Courtesy carlier | gebauer, Berlin

96 Yinka Shonibare, *Vacation*, 2000. Courtesy Stephen Friedman Gallery, London

98–9 Zhang Huan, *To Raise the Water Level in a Fishpond*, 1997. Courtesy the artist

100 Duane Hanson, *Supermarket Shopper*, 1970s. © Estate of Duane Hanson/VAGA, New York/DACS, London 2005

101 (left) Duane Hanson, *Queenie II*, 1988. © Estate of Duane Hanson/VAGA, New York/DACS, London 2005

101 (right) Duane Hanson, *Tourists II*, 1988. Photo © The Saatchi Collection, London. © Estate of Duane Hanson/VAGA, New York/DACS, London 2005

102 (above) Aino Kannisto, *Untitled (woman smoking cigarette)*, 1999. © Aino Kannisto

102 (below) Aino Kannisto, *Untitled (gate)*, 2001. © Aino Kannisto

105 Robin Rhode, *Coat Hanger*, 2003. Photos Cameron Wittig. Courtesy the artist

106 Roberto Cuoghi, 2000. Photo © Armin Linke. Courtesy the artist

107 Vito Acconci, *Following Piece*, 1969. 'Street Works IV', Architectural League of New York, New York City (various locations), 3–25 October 1969. Courtesy the artist

108 Francis Alÿs, *Re-enactment*, 2001. Courtesy Lisson Gallery, London

109 Minerva Cuevas, *Safety Pills*, 2000. Courtesy of the artist and Galeria Kurimanzuto, Mexico D.F.

110 (above and below right) Adrian Piper, *Catalysis III*, 1970. Collection Thomas Erben, New York

110 (below left and centre) Adrian Piper, *Catalysis IV*, 1970. Collection Thomas Erben, New York

111 (above) Lygia Clark, *Dialogue of Goggles*, 1968. Photo courtesy Cultural Association 'The World of Lygia Clark'. Clark Family Collection

111 (below left) Lygia Clark, *The I And The You*, 1967. Photo courtesy Cultural Association 'The World of Lygia Clark'. Clark Family Collection

111 (below right) Lygia Clark, *Collective Head*, 1975. Photo courtesy Cultural Association 'The World of Lygia Clark'. Clark Family Collection

112 Pawel Althamer, *Film*, 2000. Ljubljana, 2000. Courtesy the artist and Foksal Gallery Foundation, Warsaw

113 Paola Pivi, *Pizza*, 1998. Photo © Armin Linke. Courtesy of the artist and Galeria Massimo de Carlo, Milan

114 Hélio Oiticica, *Parangolé*, 1967. Parangolé 11. Courtesy Galeria Fortes Vilaça, São Paulo

115 Ducha, *Laranja*, 2000. Courtesy the artist

116 Federico Herrero, *Carefully Repainted Yellow Areas*, 2002. Courtesy the artist

117 Olafur Eliasson, *Untitled (green river project)*, Los Angeles, 1998. Courtesy Neugerriemschneider, Berlin

118 Boris Achour, *L'Aligneur de Pigeons*, 1996. Photos Boris Achour. Courtesy Galerie Chez Valentin, Paris

119 Carey Young, *Everything You've Heard is Wrong*, 1999. Courtesy IBID Projects

120 Jens Haaning, *Turkish Jokes*, 1994. P.I.G. Oslo, Norway, 1994. Courtesy Galleri Nicolai Wallner, Copenhagen

122 Delia Brown, *ITHB: Guerilla Lounging no. 4*, 2002. Courtesy the artist and D'Amelio Terras, New York

123 (above) Delia Brown, *GTFO: Guerilla Lounging no. 4*, 2002. Courtesy the artist and D'Amelio Terras, New York

123 (below) Delia Brown, *ITHB: Guerilla Lounging no. 2*, 2002. Courtesy the artist and D'Amelio Terras, New York

124–25 Laura Belém, *Landscape of Leblon at Carnival*, 2002. Leblon, Rio de Janeiro, 2002. Photos Christina Câmara. © the artist

126 Andreas Slominski, *Stolen Bicycle Pump*, 1998. Courtesy the artist and Galerie Neu, Berlin

127 Roman Signer, *Eimer*, 2002. Courtesy the artist and Galerie Hauser and Wirth, Zurich

128 Douglas Gordon, *List of Names*, 1990. Photo Raimund Zabowsky. Courtesy Lisson Gallery, London

129 Hamish Fulton, *Cho Oyu*, 2002. Courtesy the artist

130–31 Bas Jan Ader, *In Search of the Miraculous*, 1975. Courtesy Galerie Chantal Crousel, Paris

132 Allan Kaprow, *Yard*, 1961. Photo Ken Heyman. Courtesy Sammlung Feelisch, Remscheid

133 Allan Kaprow, *Yard*, 1986. Photos Studio Müller & Schmitz, Remscheid. Courtesy Sammlung Feelisch, Remscheid

134–35 Rivane Neuenschwander, *Inventory of Small Deaths (Blow)*, 2000. Courtesy Stephen Friedman Gallery, London, and Galeria Fortes Vilaça, São Paulo

136 Joseph Grigely, *Nicole M.*, 1996. Courtesy the artist

137 (above) Joseph Grigely, *Jenny S.*, 1996. Courtesy the artist

137 (below) Joseph Grigely, *Conversations in Rotterdam*, 1996. Courtesy the artist

139 Trisha Donnelly, *Untitled*, 2002. Courtesy Casey Kaplan 10-6, New York

140 On Kawara, *I Got up at (May 31, 1977)*, 1977. Courtesy Lisson Gallery, London

143 Marina Abramović, *Balkan Baroque*, 1997. Photo © Armin Linke. Courtesy Sean Kelly Gallery, New York

144 Anna Gaskell, *Untitled #2 (wonder)*, 1996. Courtesy the artist and Casey Kaplan 10-6, New York

145 (left) Anna Gaskell, *Untitled #3 (wonder)*, 1996. Courtesy the artist and Casey Kaplan 10-6, New York

145 (right) Anna Gaskell, *Untitled #4 (wonder)*, 1996. Courtesy the artist and Casey Kaplan 10-6, New York

146 Markus Schinwald, *Dictio Pii*, 2001. Courtesy GEORG KARGL Fine Arts, Vienna

147 (above) Rodney Graham, *How I Became a Ramblin' Man*, 1999. Photo Shannon Oksanen. Courtesy 303 Gallery, New York

147 (below) Rodney Graham, *Vexation Island*, 1997. Photo Adi Bereuter. Courtesy Lisson Gallery, London

148 Luisa Lambri, *Untitled (Miller House)*, 2002 (diptych). Courtesy Studio Guenzani, Milan, and Marc Foxx, Los Angeles

149 Sophie Calle, *Hotel, Room No. 28, 1981*. © ADAGP, Paris and DACS, London 2005

150–51 Peter Land, *The Lake*, 1999. Nos. 7, 8, 9, 10 and 12 of a series of 12 photographs. Courtesy Galleri Nicolai Wallner, Copenhagen

153 Bruce Nauman, *Setting a Good Corner (Allegory & Metaphor)*, 1999. Courtesy Donald Young Gallery, Chicago. © ARS, NY and DACS, London 2005

154–55 Janet Cardiff, *The Missing Voice (Case Study B)*, 1999. 40-minute audio walk, East London. Courtesy the artist

156 Matthew Barney, *CREMASTER 3*, 2002. Photo Chris Winget. © 2002 Matthew Barney. Courtesy Gladstone Gallery, New York

158 (above) Richard Billingham, *Untitled*, 1996 (NRAL 43). Courtesy Anthony Reynolds Gallery, London

158 (below) Richard Billingham, *Untitled*, 1996 (NRAL 13). Courtesy Anthony Reynolds Gallery, London

159 Richard Billingham, *Untitled*, 1996 (NRAL 12). Courtesy Anthony Reynolds Gallery, London

161 Cameron Jamie, *BB*, 2000. Courtesy the artist

162 Carlos Amorales, *Amorales vs. Amorales (My Way)*, 2001. Tijuana, Mexico, 2001. Courtesy the artist

163 Jeff Burton, *Untitled #113 (bougainvillea)*, 2000. Courtesy the artist and Casey Kaplan Gallery, New York

164 Peter Friedl, *Peter Friedl*, 1998. Palais des Beaux-Arts, Brussels, 1998. Courtesy the artist

165 Annika Eriksson, *Staff at the 25th São Paulo Bienal*, 2002. Photos Marcelo Soubhia. © the artist

166–67 Patrick Tuttofuoco, *Velodream*, 2001. Courtesy the artist and Studio Guenzani, Milan

168 (above) Surasi Kusolwong, *1,000 Lire Market (La vita continua)*, 2001. Market event, 'Arte all'Arte 6', Casola d'Elsa, Italy. Courtesy the artist

168 (below) Surasi Kusolwong, *1,000 Lire Market (La vita continua)*, 2001. Photo Attilio Maranzano. Courtesy Associazione Arte Continua, San Gimignano

169 (above) Surasi Kusolwong, *1,000 Lire Market (La vita continua)*, 2001. Photo Attilio Maranzano. Courtesy Associazione Arte Continua, San Gimignano

169 (below) Surasi Kusolwong, *1,000 Lire Market (La vita continua)*, 2001. Photo Attilio Maranzano. Courtesy Associazione Arte Continua, San Gimignano

170–71 Rirkrit Tiravanija, *community cinema for a quiet intersection (against oldenburg)*, 1999. Courtesy Neugerriemschneider, Berlin

172–73 Carsten Höller, *Light Wall*, 2000. Fondazione Prada, Milan, 2000. Photos Attilio Maranzano. Courtesy Fondazione Prada, Milan

174–75 Dominique Gonzalez-Foerster, *Séance de Shadow II*, 1998. ARC, Musée d'Art Moderne de la Ville de Paris, 1998–99. Courtesy Schipper und Krome, Berlin

176 Agency, *Newsreader, Newspaper*, 2001. Courtesy the Agency

Every effort has been made to trace the copyright holders of the images contained in this book, and we apologise in advance for any unintentional omissions. We would be pleased to insert the appropriate acknowledgment in any subsequent edition of this publication.

INDEX OF ARTISTS

Page numbers in *italics* refer to illustrations